COURBET
in Perspective

THE ARTISTS IN PERSPECTIVE SERIES
H. W. Janson, general editor

The ARTISTS IN PERSPECTIVE SERIES *presents individual illustrated volumes of interpretive essays on the most significant painters, sculptors, architects, and genres of world art.*

Each volume provides an understanding of art and artists through both esthetic and cultural evaluations.

PETRA TEN-DOESSCHATE CHU received degrees from the Sorbonne, the University of Utrecht, and Columbia University (Ph.D). She is currently teaching at Seton Hall University in South Orange, N. J. Her publications includes a book on *French Realism and the Dutch Masters* and several articles.

COURBET
in Perspective

Edited by

PETRA TEN-DOESSCHATE CHU

A SPECTRUM BOOK

Prentice-Hall, Inc., Englewood Cliffs, New Jersey 07632

Library of Congress Cataloging in Publication Data
Main entry under title:

Courbet in perspective.

(The Artists in perspective series) (A Spectrum
book)
 Bibliography: p.
 1. Courbet, Gustave, 1819–1877—Addresses, essays,
lectures. I. Doesschate Chu, Petra ten.
ND553. C9C58 759.4 76-44418
ISBN 0-13-184432-6
ISBN 0-13-184424-5 pbk.

© 1977 BY PRENTICE-HALL, INC.
ENGLEWOOD CLIFFS, N.J. 07632

A SPECTRUM BOOK

Printed in the United States of America

10 9 8 7 6 5 4 3 2 1

PRENTICE-HALL INTERNATIONAL, INC. (*London*)
PRENTICE-HALL OF AUSTRALIA PTY. LIMITED (*Sydney*)
PRENTICE-HALL OF CANADA, LTD. (*Toronto*)
PRENTICE-HALL OF INDIA PRIVATE LIMITED (*New Delhi*)
PRENTICE-HALL OF JAPAN, INC. (*Tokyo*)
PRENTICE-HALL OF SOUTHEAST ASIA PTE. LTD. (*Singapore*)
WHITEHALL BOOKS LIMITED (*Wellington, New Zealand*)

CONTENTS

PREFACE

The selection of relatively few essays on an artist about whom much has been written is not by any means an easy task. Faced with an *embarras de choix* one must pick according to a predetermined scheme, which, in the case of this book, was ready-cast by the publisher in the mold of the "artist-in-perspective" idea.

Courbet in perspective—how have the artist and his work been judged in the course of the 130 years since he first came to the fore in the 1840s? I have made an attempt to show something of the changing views and opinions, particularly with regard to his most important and outstanding works, the *Funeral at Ornans* and the *Studio,* to which several essays in this volume are devoted.

Other essays deal with Courbet's life and personality, which were so intimately linked with his art, with the nature of Courbet's realism, with the critical reaction to his work, and with the painting genres he practiced (portrait, nude, landscape, and still-life). As it always happens in this type of compilation, some major essays could not be included because of lack of space or copyright difficulties,* whereas others had to be reduced, for which I apologize to the authors in question.

My acknowledgments concern primarily the respective copyright holders for their permission to reprint articles or excerpts in this volume. For advice and assistance, I thank, above all, Professor H. W. Janson, general editor of the *Artists in Perspective Series.* I am also indebted to Professors Louis de Foix-Crenascol, Chantal Lombardi, Linda Nochlin, and Phyllis Stock, Dr. Hanneke Henket, and Ms. Betsy Jaeger.

From the staff members of the Seton Hall University Library and the Fine Arts Library of Columbia University, I have received much

* I regret, in particular, the omission of Meyer Schapiro's brilliant article, "Courbet and Popular Imagery" (for full reference, see bibliography).

practical help, for which I am very grateful. Special thanks must go to Ms. Margaret Marren, who so expertly typed the final version of the manuscript. Lastly, I must express my sympathy with my husband, who has patiently (and at times impatiently) suffered through the genesis of this book.

COURBET
in Perspective

INTRODUCTION

The present collection of essays is only a small portion of the extensive literature on Courbet, which ranges from the time of the artist's first renown in Paris in the late 1840s to our own day. A sampling of this literature gives an idea of its diversity and of the varied and changing approach towards the artist and his oeuvre.

The earliest references to Courbet are found in the reviews of the Salons of 1848 and of the following years—important years for the artist— in which he exhibited major works like the *Afterdinner at Ornans* (Salon 1849; fig. 3), the *Stonebreakers* (Salon 1850–1851; fig. 4), the *Peasants of Flagey Returning from the Fair* (Salon 1850–1851; fig. 5), the *Funeral at Ornans* (Salon 1850–1851; fig. 6), the *Bathers* (Salon 1853; fig. 13), and the *Studio* (Salon 1855; fig. 15).

As might be expected, the opinions about these innovative works were mixed, ranging from complete rejection to enthusiastic praise. In these early reviews, one can already see that most critics, whether favorably or infavorably disposed towards the artist, found it difficult to separate his work from his personality. Courbet, from the late 1840s on, was very much present on the Parisian art scene; he was a key figure in the Bohemian world of his time, one who gathered a motley group of artists, writers, and art lovers around him in his habitual pub, the Brasserie Andler. He was a man who did not wait patiently for renown, but who proclaimed his own greatness and originality from the housetops of Paris. People were irritated but at the same time intrigued by this bragging, good-looking young man from the provinces and, as early as 1856, the art critic Théophile Silvestre tried to analyze the artist's personality in his *Histoire des Artistes Vivants* (partly reprinted in this volume).[1]

[1] Full references to this and other works on Courbet mentioned in the introduction are found in the bibliography at the end of the book.

In the later 1850s and 1860s, as Courbet posed more and more as the uncouth rebel who despises everything but himself and his art, the opinions about the artist became more and more polarized. Many of his former friends and supporters became his antagonists (Baudelaire, Champfleury), and his few remaining and newly-won supporters fought a losing battle against public opinion. Courbet's involvement in the Commune in 1871 and his subsequent imprisonment and voluntary exile to Switzerland brought this polarization to an extreme. Antagonists as well as defenders rushed into print to give their personal opinion in the Courbet "case."

After Courbet's death in 1877, the first biographies of the artist saw the light: at first in the form of memoirs or series of anecdotes (Claudet, d'Ideville, Gros-Kost); then, in the early twentieth century, in the form of more thorough and more objective biographies, like those of Riat (1906), Duret (1918), and Léger (1929, 1948). The projected biography by Courbet's close friend, Castagnary, was unfortunately never finished because of the author's untimely death in 1888; but his notes for this biography can be found in the Bibliothèque Nationale in Paris, and an excerpt of them (partially reprinted in this volume) was published in the *Gazette des Beaux-Arts* of 1911.

Besides the first major biographies, the early twentieth century also witnessed the publication of the first style-critical analysis of Courbet's work, Meier-Graefe's study of 1905. It is interesting to note that in the Courbet literature as a whole, the style-critical approach towards the artist's work is secondary.

In the years after World War II, several new biographies of Courbet have appeared, such as the one by Mack (1951), and, more recently, the biographies by Fernier (1969), Boudaille (1969), Fermigier (1971), and Lindsay (1973). In addition, important source materials have been published by Courthion and Borel.

As far as the interpretative literature of the post-war period is concerned, there is a general attempt to view Courbet's works in a new perspective, unhampered by the old preconceptions about the artist. Authors like Meyer Schapiro and Linda Nochlin have demonstrated how the artist's works were not merely the products of an unimaginative, narrowly realistic vision, but that, in fact, they were deeply rooted in popular art and, to a lesser extent, in the art of the old masters, particularly those of the Dutch and Spanish schools. At the same time, Timothy Clark brought out the connecting link between Courbet's art and the social history of his time. Together, Schapiro, Nochlin, Clark, and others like Klaus Berger, Benedict Nicolson, and Alan Bowness, have defeated some of the old subjective and prejudicial notions about Courbet and have provided an insight into the artist's true intentions.

Considered in its entirety, the Courbet literature—whether early or late, whether favorable or unfavorable towards the artist—is dominated by three major themes. The first of these themes concerns Courbet's personality: his character, his intelligence, his erudition.

Who was Courbet? Was he the blunt, boasting, big-mouthed rebel he pretended to be or was he, essentially, a sensitive person who hid his vulnerability behind a pot-belly, loud laughter, and swagger? Was he an unpolished boor, a savage who had learned to paint while watching the cows,[2] or was he, in fact, quite cultured and knowledgable?

Contemporary caricatures depict the painter as a peasant, complete with open blouse and sabots;[3] but everyone knew that he had daily intercourse with writers, critics, and philosophers—including no less than Baudelaire and Pierre-Joseph Proudhon. To the world at large he played the naif, the ignorant; but he wanted his friends and acquaintances to think of him as an intellectual, even a philosopher.[4]

Courbet has been called anti-literary, and it is true that he never learned how to spell correctly. Yet he wrote an enormous body of letters,[5] and even a number of short essays on various subjects.[6] His friends claimed that he never read a book,[7] but when he once described his friend, the philosopher Marc Trapadoux, in a letter to the Comte d'Ideville, he casually compared Trapadoux with Gérard de Nerval, Privat d'Anglemont, and Poterel.[8]

"Making verses is dishonest; talking differently from everybody else is posing as an aristocrat," Courbet is supposed to have said;[9] and Castagnary noted that "poets irritated him."[10] Nevertheless, he was closely befriended by several poets. In his youth he illustrated a volume of poems by his friend, Max Buchon,[11] and he remained close to Buchon until the latter's death in 1869. During a period of his life, Courbet was also on intimate terms with Baudelaire, whom he accommodated in his

[2] See Champfleury, *Grandes figures d'hier et d'aujourd'hui* (Paris: Poulet-Malassis et de Broise, 1861).

[3] See Charles Léger, *Courbet selon les caricatures et les images* (Paris: Rosenberg, 1920), *passim*.

[4] See Théophile Silvestre, *L'Histoire des artistes vivants, études d'après nature* (Paris: Blanchard, 1856), p. 246.

[5] Courbet's letters, although extremely interesting and valuable for the understanding of the artist, have been published only fragmentarily. The editor of this volume is presently preparing an edition of Courbet's complete correspondence.

[6] See Pierre Courthion, ed. *Courbet raconté par lui-même et par ses amis* (Genève: Pierre Cailler, 1948), Vol. 2, pp. 44–65.

[7] See, for example, *ibid.*, Vol. 1, p. 156.

[8] *Ibid.*, Vol. 1, p. 90.

[9] *Ibid.*, Vol. 1, p. 79.

[10] *Ibid.*, Vol. 1, p. 149.

[11] Max Buchon, *Essais poétiques* (Besançon: Imprimerie et lithographie de Sainte-Agathe, 1839).

studio when the poet was hard-put, and whom he included among his friends in his painting of the *Studio*.

A second theme that resounds continuously in the Courbet literature is that of Courbet's political orientation and involvement. He has been called a socialist; and certainly his brief involvement in the Commune points to a leftist political orientation. But to what extent was Courbet really interested and involved in politics? We cannot escape the feeling that he was gradually and imperceptably pushed into politics, both by various friends—such as Buchon, Pierre Dupont, and Proudhon—and by his enemies and critics, who saw in his work only a political tenor. Although in 1871 Courbet claimed that he had opened a Socialist club as early as 1848,[12] the fact of the matter is that he was little interested in politics at that time. Writing to his parents in 1848, he stated that he gave little time to politics, "as was his habit," because he felt that there was "nothing more futile than that." [13] In subsequent years, Courbet found out that in the era in which he lived, there was no way, even to an artist, to escape politics, and he decided that he might as well take a positive approach towards the inevitable; so he took to politics in the same uninhibited manner in which he took to food and beer, and with the same disastrous results.

The third theme that recurs over and over again in the writings of Courbet relates to the nature of his Realism. Courbet himself presented his works as faithful and objective recordings of subjects and scenes he had seen in reality, yet frequently his compositions were clearly not derived from reality but from popular art or from the old masters.

Even before Monet, Courbet was called "an eye," [14] referring to the accuracy of his vision; but at the same time he was decried as a caricaturist who wilfully distorted his subjects in order to make them look ugly, coarse, and clumsy.[15]

Courbet's contemporaries equated his paintings at once with photographs (which would seem to refer to their extreme realism) [16] and to popular prints, shop signs, or circus paintings (which would seem to point to their simplification and stylization).[17] A single work, the *Funeral*

12 Courthion, *Courbet raconté par lui-même*, Vol. 2, p. 47.
13 See Georges Riat, *Gustave Courbet* (Paris: H. Floury, 1906), p. 47.
14 See Aaron Scharf, *Art and Photography* (London: Allen Lane, 1969), p. 95.
15 The opinion of Courbet as an artist who wilfully accentuated and exaggerated the ugly can be found in many nineteenth-century reviews of the artist's work.
16 See Scharf, *Art and Photography*, p. 95.
17 See Meyer Schapiro, "Courbet and Popular Imagery: an Essay on Realism and Naiveté," *Journal of the Warburg and Courtauld Institutes*, 4 (1941), pp. 164–165.

at Ornans, has been likened simultaneously to a Greek relief; [18] to Dutch,[19] French,[20] and Spanish seventeenth-century paintings; [21] to popular prints; [22] to the caricatures of Daumier; [23] and to "a faulty daguerrotype." [24]

Even Courbet himself apparently had an ambiguous attitude toward the nature of his Realism. Did he not subtitle his famous picture of the *Studio*—which can be considered as a kind of painted manifesto—a "Real Allegory?" His friends, Champfleury and Proudhon, pointed to the contradictoriness of this title: Proudhon called it an "unintelligible expression," and Champfleury remarked rightly that "an *allegory* cannot be *real,* any more than *reality* can become *allegorical.*" [25]

The title of the *Studio* seems to sum up the paradox of Courbet—of his personality, his intentions, and his artistic achievements. How some of the critics and students of Courbet have come to grips with this paradox can be seen in the present volume.

18 See Théodore Duret, *Courbet* (Paris: Bernheim Jeune et Cie, 1918), p. 32.
19 See Champfleury, *Grandes figures,* pp. 238–239.
20 Ibid., p. 244.
21 *Ibid.,* p. 251.
22 *Ibid.,* p. 244.
23 *Ibid.,* p. 231.
24 See Scharf, *Art and Photography,* p. 95.
25 Quoted in Benedict Nicolson, *Courbet: The Studio of the Painter* (London: Allen Lane, 1973), p. 66.

A BIOGRAPHY OF COURBET

Jules-Antoine Castagnary

Gustave Courbet was born on June 10, 1819, in Ornans, a small town in the Franche-Comté region, in the valley of the Loue river. . . . His father, Régis Courbet, had a house in the little village of Flagey, near Ornans. He was a landowner of comfortable means, one might even call him rich. . . . His mother, Silvie Oudot, was from Ornans, which explains why she gave birth in that town, where her father and mother were still living. . . .

[After Courbet] came four daughters: Clarisse, Zoé, Zélie, and Juliette respectively. Clarisse died at the age of fifteen, when her brother was still in the Little Seminary; [1] the three others are the "young ladies from the village" of the famous painting [fig. 12]. . . .

[The Courbet household was one] of rural bourgeois who, in spite of the worries and the austerities of country life, had not lost every kind of intellectual preoccupation. It was marked by a certain rustic flavor that was utterly charming. They all loved one another a great deal. "Gustave" was always a good son and a devoted brother. The affection that his family held for him reflected on his comrades in Ornans and on the friends he sometimes brought home from Paris. The taste of the family was in no way vulgar. A longstanding prosperity had made it possible to refine and broaden the children's education. And so, in the evening, it was not unusual to see the large room that served both as salon and

"A Biography of Courbet." Excerpt of Jules-Antoine Castagnary, "Fragments d'un livre sur Courbet," *Gazette des Beaux-Arts,* 5 (1911), pp. 5–20; 6 (1911), pp. 488–497; 7 (1912), pp. 19–29. Translated by the editor. Footnotes by the editor; the few original footnotes by the author have been deleted.

[1] Secondary school.

dining room transformed into a reading room or a concert hall. And when one had talked enough, or when father Régis Courbet had won a brilliant victory in his game of checkers, one would make music. The sisters of Gustave sang with much feeling, accompanying themselves on the piano. One listened to Gustave's nice falsetto. Sometimes Promaguet,[2] the son of the organist, who was the teacher of those young ladies, took up his violin. When Max Buchon was there, literature entered the scene; Max Buchon recited poems. But it was remarkable that what "Gustave" and his sisters sang were not the fashionable romances or the great arias of the latest opera, but rather some folksong, badly rhymed, though of an exquisite sentiment; and that the poem Max Buchon recited was not a lyrical or dramatic work of some grand poet, but a humble scene of daily life that he had very carefully made into a poem, giving special attention to exact detail. It seemed that this was the character of the house; those who lived there had an equal bent for the simple and the natural. That, in particular, struck me very much and I realized then that the *Afterdinner at Ornans* [fig. 3], in which, around a partly cleaned-up table, some friends, smoking, listen to a young man playing the violin, was nothing but an episode of the intimate life I saw before me. And today, while I write these lines, I cannot help but feel that this warm environment of tender feelings, of primitive art and folk poetry, in which Courbet passed his youth, has contributed a great deal to the development of his thought. The egg of "Realism" came out of this nest.

The newborn child became, of course, the object of admiration of his relatives, both young and old. The men in the family saw him as an extension of themselves, as a continuator who would realize the dreams that they had hardly outlined during their lifetime. The women adored him. When sisters came after him, they could only join in the cult that was devoted to that elder son, future chief of the family, who was the object of all the ambitions of the men and of all the tenderness of the women.

Raised in Ornans by a grandfather who was mad about him and by a grandmother who always put off punishment to the next day, "Gustave" did not know what discipline was. His youth passed, according to one of his biographers, with the games of the village and the liberty of the fields. That means, I think, that his main occupation consisted of running through the woods, going bird's-nesting, climbing the rocks, rolling in the grass, plunging into the Loue river in the summer, and skating on the ice in winter; in his spare moments he went to school.

At about twelve years of age, he was placed as an extern in the

2 Printing error; should be **Promayet**.

Little Seminary at Ornans. Max Buchon, who was his classmate, on my request wrote down his memories: "We were in the same class, both stammerers; I was intern, he extern; I was calm, quiet, and not very adventurous; he was active and boisterous. I had prizes at the end of the year; he could not even think about that." . . . All the time that he stayed in the Little Seminary, Gustave was a perfect model of non-discipline. Alert and vigorous, he was the first in all physical games. . He did not perform in the same way in Latin and Greek. This was not because he lacked discipline; on the contrary, he had a very bright and logical mind; but he was not attracted by anything that one wanted to teach him. Only French narration interested him. There he could give free play to his imagination, and he wholeheartedly applied himself to it. "His compositions," says Max Buchon, "were strange in conception and so full of amusing details that the teacher put off their reading until the end of the class period, so that he could let his pupils laugh freely."

Uninterested in the study of the classical languages, Courbet had a passion for everything that had to do with form and color. I will not mention the drawings and caricatures with which he filled his notebooks. Those youthful scribbles are not always the sign of a determined vocation. More significant is the following episode. In the chapel of the Seminary was a large religious painting. One day, although he had never seen anybody paint, he managed to copy it at the first go. He took a porcelain palette that belonged to one of his sisters, got colors from a house painter, and went to work.

That shows a kind of self-confidence that is promising.

In the meantime, the Little Seminary was transferred to the village of Maisonnettes, in the small valley of the Consolation River. . . . In the vacant building in Ornans, Abbots Oudot and Lemondey established a boarding school, at which Courbet remained an extern student.

A little later, the pension Oudot secured a drawing teacher. This teacher, who was generally called "Father" Beau, was a poor devil who had been forced out of Besançon through money difficulties. He had been a pupil of Gros, and he had brought back from Paris a certain number of copies that he had executed in the studio of his master. His intention was to exhibit them. That exhibit caused so much admiration, and "Father" Beau so charmed his visitors by relating his memories of the artist, that the pupils of the boarding school flocked to his lessons, Courbet among them. . . . [Thus], in a little village back in the provinces, indirectly, by the mere sight of inferior copies, [Courbet] became aware of the brilliant genius of Gros. He would always have a strong admiration for that great artist, who has not yet received the public acclaim that he deserves; and when Courbet later reviewed his own achieve-

ments and tried to determine his historical role in our school, he said that in painting reality "he continued the tendencies of Gros and Géricault."

Thus Courbet at an early age learned the first basics of drawing; he also began to paint. His first studies were not very ambitious. But, to the student, they were loaded with fond memories of his old teacher; and when later he began to work out ideas of his own, father Beau was one of the first to whom he wanted his endeavors shown.

When Gustave Courbet had finished high school, his family had to think about his future.

His father wanted him to become a lawyer. Cousin Oudot, professor at the School of Law in Paris, who was in regular correspondence with his relatives in Ornans and who often spent his vacations with them, strongly approved of that choice.

As a result, the Courbet heir, after having finished high school, was sent as an intern to the Royal College of Besançon to complete his studies (November 1837). He was not only separated from his grandfather and his grandmother, he was deprived of his freedom.

As could have been expected, the young man could not stand a regime where one "marched always in line from morning to night," where everything—getting up, going to bed, recreation, and work—was regulated "as in barracks." After three days, he asked whether he could go back to Ornans to see his folks. After three months, he wrote pitiful letters in which he begged someone to come to deliver him or at least to let him finish his studies as extern. . . . His parents ignored him. . . .

He fell really ill. The horrible "cold lamb served every evening" gave him nausea. . . . Finally, when he could not bear it any longer, he wrote to his parents: "I warn you that for one week my suitcase has been packed in expectation of you. But since you have not come and since you still believe that it is all a laugh that I want to quit college, I warn you that on New Year's day I am leaving with all my things."

They succeeded in calming him down. Another sad trimester began. An old friend of the family, Mademoiselle Belfort, . . . spoke in his favor. The entreaties of the old lady, who was supported by Courbet's grandfather, finally had success. It was decided that the student would finish the trimester and that afterwards he would be given freedom. . . .

The promise was kept. Courbet went to live outside the college, took up lodgings in the city, and began to prepare himself on his own for his bachelor's degree, taking courses from the professors of the Academy. To relax from this hard work he took up drawing again.

Drawing! Not being able to go on with it had been one of his misgivings about the college. He did follow there a drawing course taught

by Professor Flageoulot,[3] but the students did not do anything in the course. There were no good models and the room did not lend itself to making studies. "We are there," Courbet wrote, "with a hundred people in a large hall where one cannot hold a pencil because of the cold. Moreover, everyone shouts, everyone talks, and everyone makes so much noise that it is impossible to hear each other." [Now, having left the college], he took up drawing again under the [private] tutelage of Mr. Flageoulot, professor at the college.

It was at that time that Courbet made his debut, if one may call some simple book illustrations a debut. His friend, Max Buchon, had his first volume of poems printed in Besançon,[4] and he asked Courbet to draw some vignettes for him. Courbet made four small lithographs that were included in the book. He very much liked this technique that was new to him. He sent several proof sheets to his parents specifying: "Send some to Father Beau, to grandfather, to uncle; I'll send you more in a few days."

Mr. Flageoulot, professor of drawing at the college of Besançon, had at his home a studio where he received his pupils. It was there that Courbet seriously began to paint. . . . The new student worked very hard. His love for painting grew as he learned to paint better. This art astounded and amused him. Working after the model in the Flageoulot studio, he also made studies after nature and he practiced composing small pictures. The studies that he accumulated in these youthful years are countless. Although many of them have disappeared, some have been kept by people who knew the artist at that time of his life. . . . They are generally done on paper. Some represent scenes of daily life or landscapes of the Loue river against a backdrop of grey rocks; but the largest number belong to the world of fantasy: One sees in them a pageantry of gentlemen with pourpoints, fencing musketeers, bandits lying in wait, ruinous towers, skulls—all products of an imagination overstimulated by Romanticism.

Indeed, when he left college, Courbet was a Romantic, just as, for that matter, was his friend Max Buchon and all young people of that time. . . .

Meanwhile, Courbet had reached, even passed, his twentieth birthday. . . . What to do with that beautiful boy, loving, loved, very much alive, skilled in all physical exercise, a charming companion, a good eater, one who knew how to laugh, drink, and sing, one who was full of spirit and good humor, the joy of his friends, the pride of his parents?

[3] Also spelled Flajoulot. Painter at Besançon (1774–1840).
[4] *Essais Poétiques* (Besançon: Imprimerie et lithographie de Sainte-Agathe, 1839).

One had to let him develop freely in a freely chosen career. The internment in the college of Besançon had been a mistake regretted by everybody. No one thought about repeating it, and Gustave Courbet retained his freedom. He left.

On a nice day in November 1840, Jean-Désiré-Gustave Courbet climbed on the top of the coach that operated between Ornans and Paris, showered with the blessings and best wishes of a whole family in tears.

On his arrival in Paris, Courbet showed right away that he was not an ordinary man. To the horror of Mr. Oudot, who, in his role as professor, believed that one cannot learn anything without a teacher, Courbet refused to enter an atelier. Some have wanted to consider this as a sign of presumptuousness but it was simply a proof of clear-sightedness. It meant that, instead of the lessons of a Picot, a Drolling, a Paul Delaroche, a Léon Cogniet, and other celebrities of the time, Courbet preferred the lessons of Veronese, Rembrandt, Velazquez, Rubens—of the great painters of all nations. For somebody who had just arrived from the provinces, it was not so badly reasoned; and since the provincial was a man of determination, he did as he said: "He took the masters as his master."

And so he studied in the museums, in his own way, that is to say, without restraint. After having seen all the paintings in the Louvre and in the Luxembourg,[5] after having visited the historic galleries of Versailles, and after having compared the art of different peoples, he more and more focused his search and his thoughts on the Louvre. The great Venetian, Flemish, Dutch, and Spanish colorists monopolized almost all of his attention. He passed whole days in front of their works, looking, comparing, thinking, trying, "by reasoning," to understand their technique. When he did not understand it, he copied the part that puzzled him, and he copied it over and over again until he had penetrated the secret of the execution.

The diligent study of the masters alone does not in itself form an artist's education. Courbet combined it with the direct study of nature. He worked almost constantly after the live model, in the morning in his studio making paintings inspired by his imagination or by his reading, in the evening at the Académie Suisse,[6] where he had registered because

[5] The Palais de Luxembourg, built in the early seventeenth century on the instigation of Maria de Medici, in the nineteenth century served as a museum of contemporary art.
[6] The Académie Suisse was a studio, run by a former model by the name of Suisse, who provided young art students, at a small fee, with live models and a place to work.

he did not have a teacher. In his vacations in Ornans, he asked his sisters and his friends to pose for him, or he went to the countryside in the Loue valley.

This laborious apprenticeship lasted for six years. The *Prisoner of the Dey of Algiers, Lovers in the Country, Bather Sleeping near a Brook,* the *Man with the Pipe* [cover illustration], the *Cellist,* and the *Painter* marked its most important stages.

From one painting to another, one can follow the progress of the artist, both in his technique, which gains everyday in force and suppleness, and in his artistic conception, which gradually becomes more independent and formed.

In the course of his studies, Courbet did not ignore the annual Salon. Since he was a worker, and since at that time there was no limitation, the number of works he submitted was almost always considerable: two paintings in 1844, five in 1845, eight in 1846, three in 1847, ten in 1848.

But the jury of that time, the members of which belonged to no less than the Académie des Beaux-Arts, did not play games with the artists. When one knows that it refused, in the name of the "holy traditions," some of the works of men like Eugène Delacroix, Théodore Rousseau, Decamps, and Diaz—men whose reputation was established— one can imagine what reception was given to young unknown artists. All that did not conform to the teachings of the Academy was mercilessly rejected. Courbet was nevertheless accepted a first time in 1844, with a small painting in which he represented himself seated in the country with a black dog. In the two following Salons, another one of his paintings was admitted—the smallest and least significant—and it was placed so high that it was out of sight. It was a painting with nudes that was still too much for the times, and in 1847 all of the paintings he submitted were rejected.

Courbet did not feel he had made it, when, in 1844, his small portrait "with black dog" was honored with a place in the Salon Carré; nor did he despair when, in 1847, his *Cellist* was rejected by the jury. His Franche-Comté character bounced back under the strokes of bad luck. Without transition, without compromise, he began to paint again, doggedly persisting in the way he had chosen and accepting none but the advice of the old masters in the Louvre.

Such was the nature of that extraordinary education; it was a product merely of the will. This was called in question by the enemies of the painter but it strictly conforms to the facts. . . .

The time came when Courbet felt that he could not learn anything more from the classics. That was the time when he finished the portrait now become popular under the name of *The Man in the Leather Belt*

(presently in the Louvre) [fig. 1]. Look at that admirable work: Not mentioning the portfolio of yellow leather and certain parts of the execution, there is in the painting as a whole a nobility, a harmony, and a distinction that marks the master.

At the same time that Courbet, in such a superb way, became master of his trade, there came the outbreak of the February Revolution,[7] which wiped out, together with the bourgeois monarchy, the omnipotence of the Académie des Beaux-Arts, and which gave freedom to everyone, including the painters.

The new master now could paint freely and according to his own ideas, if he had any.

And Courbet had an idea, more than an idea, a doctrine: he was a Realist.

Realist? What does that name mean? . . .

In those days painters did not paint what they saw in front of them; they painted the dreams of their minds, in addition to the dreams of others. Mythology, religion, history—those were the only sources of inspiration permitted to them. Beyond those sources, it was agreed, one could find neither poetry nor grand art. . . .

The present was always tainted by vulgarity; actuality had no access to grand art. Paintings depicting the present could be of [only] tiny dimensions. One referred to them with the derogatory term of "genre," and "genre" did not count. . . .

Courbet did not think that way. He found the Middle Ages as distant from us as Antiquity, the loves of Marguérite as outmoded as the love of Paris and Helen. He wanted to leave behind that fabulous world, accessible only to humanists; and he wanted to return, to descend, so to speak, to the real world, to living society—the matter of all history, the source of all poetry. . . .

"To translate the customs, the ideas, and the whole aspect of my time: In one word—to make a living art—that is my goal."

Realism is completely contained in that formula.

Later, making an allusion to his extraordinary education, he wrote: "I have studied, outside of any kind of system and without prejudice, the art of the ancients and the art of the moderns. I have no more wanted to imitate the first than to copy the latter. I have simply wanted to draw forth, from a complete acquaintance with tradition, the reasoned and independent awareness of my own individuality." [8]

[7] The Revolution of 1848, by which Louis-Philippe was forced to abdicate his throne.
[8] Quoted from the introduction to the catalogue of Courbet's private exhibition of 1855, *Exhibition et vente de 40 tableaux et 4 designs de l'oeuvre de M. Gustave Courbet.*

Those who witness today the triumph of Realism under its various names, such as naturalism, modernism, and so forth, and those who find it under one name or another a little overwhelming, may think perhaps that the new doctrine, or rather the painting to which it refers (because the doctrine was not formulated until later), was received with a sympathetic curiosity by the public for which it was destined. Nothing could be more contrary to the history of innovative ideas in France. Realist painting and the Realist doctrine caused the most frightful storm of protest against their creator that has ever descended upon an artist.

Through what error or what misunderstanding? The explanation is very easy. It can be formulated in one sentence: Realism came at the wrong time. Although Courbet was not politically oriented, at least at that time, his art was accused of being so; exposed to the same hate, it fell under the same blows as the February Republic.

In 1849, Courbet sent to the Salon, among other paintings, the *Afterdinner at Ornans* [fig. 3], today in the museum in Lille: It is a genre scene taken from ordinary life and painted on a life-size scale, as if it concerned mythological figures. In a room with a large fireplace, which serves at once as salon and dining room, some table companions who have long finished eating and who are seated around a table that is partly cleaned up, are listening to a young man playing the violin. The interior resembles that of the Courbet family in Ornans. The young man is no one else than Promeyet,[9] the excellent performer and friend of the painter.

Broadly painted in a brown harmony with transparent shades, the painting did not cause any hostile feelings; on the contrary, the artist was congratulated. The jury, elected by the exhibitors, gave him a second medal and the state bought the *Afterdinner*, without knowing that it bought the painting which announced the appearance of Realism on the scene.

The next year prospects were dark. The Salon did not open its doors until December 30th.[10] It was an exceptionally difficult period: The reactionary party raged with furor; the right wing of the Assembly and the President, sometimes together, at other times separately, pursued the destruction of the Republic; everybody had a presentiment of an approaching catastrophe. Courbet, completely preoccupied by his paintings and unaware that the political storms could change the artistic sky and darken its peaceful blue, was resolved to make a big impression. He

[9] Printing error; should be Promayet.
[10] Because the opening date of the Salon was so much delayed, it was decided to combine the Salons of 1850 and 1851 into one single exhibition.

submitted a considerable number of paintings, which, by the way, evidenced a working power that is rarely seen. Among the paintings submitted were three big compositions: *The Peasants of Flagey Returning from the Fair* [fig. 5], the *Stonebreakers* [fig. 4], and *A Funeral at Ornans* [fig. 6]; in addition, there were two landscapes, representing the banks of the Loue river; four portraits, including one of Francis Wey; and a self-portrait that since has become very famous under the name of *The Man with the Pipe* [cover illustration]. One could say that a fragment of the Franche-Comté had been cut out of that sturdy province and transported to Paris.

The new subject matter, the true vision, the forceful rendering— everything was there to seize and capture public attention.

Everyone was shocked with indignation and anger. What! They had dissolved the national workshops; [11] they had conquered the proletariat in the streets of Paris; [12] they had overcome the republican bourgeoisie of the *Conservatoire des Arts et Métiers;* [13] they had confirmed the alliance of the old parties [14] in secret meetings in the Rue de Poitiers; they had purged the general election, eliminating by the law of May 31 three million voters— [15] and yet there were the "vile masses," who had been chased out of politics, reappearing in painting! What was the meaning of such impudence? Where did they come from, those farmers, those stonebreakers, those hungry and tattered people seen, for the first time, mingling silently with the nude divinities of Greece and the plumed gentlemen of the Middle Ages? Were they not already the ominous vanguard of those "Jacques" [16] who, in the frightened public imagination —nurtured on the one hand by malice, on the other hand by stupidity— mounted to the assault of the elections of 1852, torch in hand and sack on the back?

[11] The national workshops, created in order to provide unemployed laborers with an opportunity to earn their living, were closed within five months. This event and the others mentioned in the sentence all took place in the years 1848–1850, when the bourgeois "right" tried to gradually outdo the workingclass "left."

[12] After the proletarian insurrection of 1848, the famous "June Days."

[13] On June 13, 1849, Ledru-Rollin, leader of the leftist party of republican solidarity, organized a rebellion against the new, conservative government of Louis Napoleon at the *Conservatoire des Arts et Métiers.* The uprising was quickly suppressed by the government troups.

[14] The so-called committee of the Rue de Poitiers played a leading role in the party of "Moral Order," which consisted of all the conservative "old parties": Bourbon legitimists, Orléanists, Catholics, and Bonapartists.

[15] The law of May, 1850 required that each voter had three years' residence. Since the proof of residence was the evidence of the tax collector, the non-taxpaying poor were automatically disenfranchised.

[16] Nickname for the peasantry.

Oh, when will the beautiful come?
For thousands and hundreds of years already
Jean-in-Gaiters is calling you,
O Farmers' Republic! [17]

There was an immense, continuous, irresistible outcry. It was impossible to discuss, reason, or present esthetic or historical arguments. No one wanted to listen or to understand. There was a shower of indignant articles: Courbet was a charlatan, a pistol-shooter, a barbarian unfamiliar with any refinement, an ignorant and gross being, not capable of sentiments and poetry, a drunken Helot to be shown to the young as an example of how not to paint. The comedians made fun of him as they had of Proudhon and Socrates, and they presented him on the scene to be laughed at by the people. In the annals of art there have not been worse affronts. Fortunately for him, Courbet was made of that hard limestone of the Jura that withstands rainstorms and thunderbolts without giving in. Nature had even made him immune to a storm. When the Salon was finished, he took his paintings and exhibited them in Besançon, where, for that matter, they had the same success as in Paris.[18]

December 2nd came,[19] and in one blow liberty and fear were suppressed. The tremblers did not tremble any longer, but France was strangled. Farmers and workers were deported in order to "reassure the good and make the bad tremble." Execution, a state of siege, deportation —those are arguments that cannot be refuted. Courbet said to himself: "Since the peasants of Flagey frighten the conservatives, I will show them our peasant and bourgeois women. The country woman has nothing to do with subversive passions; perhaps mine, in their rustic grace, will please the new dictators of public opinion." And indeed, he took up his palette knife again and, in one of those beautiful Franche-Comté landscapes, in which the mountain peaks are surrounded by a high battlemented wall of rocks, he placed, under the plain and brilliant daylight, the *Young Ladies from the Village Giving Alms to a Cowherdess* [fig. 12]. On a sandbank of the Loue river, in the semi-darkness of luxuriant woods that are penetrated by a beam of sunlight gliding from branch to branch, he exhibited the carnal splendors of his *Bathers* [fig. 13]. In the silence of a humble little room, next to a vase of flowers and an idle spinning wheel, his *Spinner* sleeps a moist and light sleep; in the interior of a bolting room, in front of piles of sacks, he placed his pretty *Grain-Sifters* against a harmonious gray background in which flour mixes with dust.

[17] Pierre Dupont, *Chant des paysans* (1850).

[18] Here Castagnary errs. The paintings in question had been exhibited in Besançon in May, 1850, and in Dijon in July, 1850—i.e., before they were exhibited in Paris.

[19] The day of the coup d'état of Louis Napoleon.

They were all episodes of rustic life, some dynamic, others quiet; simple, touching episodes treated with a masterly vigor matching the subject.

The peasant women of Courbet caused the same repulsion as his peasants. Nobody was willing to see the poetic charm of the *Grain-Sifters;* they mockingly called the *Spinner* "Marguérite of the Inn." The *Bathers,* especially, excited the minds and brought the pens into motion. They were used to mythological nymphs, to conventional personages; but to suddenly see a sturdy matron on the thickset grass—that caused loud screams. They accused the artist of willingly seeking out triviality. Or, since the term socialism had disappeared and since they no longer saw the red phantom on the horizon, and since all in all the pastorals of the painter were quite inoffensive, they had some sympathy with his foolishness and they substituted laughter for offense.

In those stormy times, only one man dared to give a protecting hand to the painter who was hooted at by everybody. It was Alfred Bruyas, a rich art lover in Montpellier. He returned from Rome, where he had begun comparative studies of painting. Walking through the exhibition of 1853, he stopped, surprised, before the painting of the *Bathers:* "There is free art," he exclaimed, "that painting is mine." He not only bought the *Bathers,* the *Sleeping Spinner,* and the *Man with the Pipe;* but he signed a friendship treaty with the artist that was equally honorable for both parties. It was symbolized by Courbet, during a stay in Montpellier, in the charming painting, the *Meeting* [fig. 14], that is done in such a witty and confident manner.

The Franche-Comté is not all of France; the customs of the people are not all the customs. Without in the least abandoning his principles, Courbet felt the need to broaden his subject matter. Are not the classes who need not work, in reality, as good as the working classes? After having given all his time to the *Young Ladies from the Village* [fig. 12] he felt it was time for the *Young Ladies on the Banks of the Seine.*

Before he began this new series of paintings, he wanted to sum up, in a memorable work, the seven years that had just passed. He painted the *Studio* [1855; fig. 15], which, of all the paintings he made, is the most unique in philosophy and the most astonishing in technique. In this painting, he represents himself in the center of the canvas, painting a landscape of the Franche-Comté; he is surrounded by friends, visitors, and models. It is his artistic life, abstracted in one page, with an excursion on the personalities, the customs, and the dress of the time. Of what importance this painting will be for this century! If one had equally explicit images of the studios of the masters of past times—Velazquez, Titian, Raphael—how much respect and admiration would not be given to them!

At this time he profited by the occasion offered to him by the

Worldfair to take the public opinion to task. At his own expense he constructed, in the Avenue Montaigne, a sort of barrack in which he installed his collected oeuvre: forty paintings and four drawings. These were all his great paintings: the *Funeral* [fig. 6], the *Studio* [fig. 15], the *Return from the Fair* [fig. 5], the *Bathers* [fig. 13], and the *Wrestlers*, in addition to fifteen landscapes and twenty portraits. It was a bold experiment. The two exhibits, one of the state, the other of Courbet, were standing face to face: two opposite camps, two opposite banners. The public did not come, not even to laugh; the painter hardly covered his expenses.

When this chapter of his life was thus closed, he began to paint —now here, then there, and without preconceived plan—landscapes, seascapes, flowers, animals, portraits, hunting pieces—all the subjects that came in front of his eyes, which seemed to see more clearly and more precisely than ever. Without exactly abandoning mankind, he had more of an eye for the sky and the sea, for verdure and snow, for animals and flowers. He loved them with particularly tender feelings. Eager to see and to penetrate the world that was wide open to his observation, he met in his search with the kind of happy surprises old seafarers meet: He discovered virgin lands where nobody had set foot, aspects and forms of landscape that, one might say, were unknown before him. He climbed to liberating heights, where the lungs expand; he went deep down into mysterious caves; he was attracted to unnamed places, to unknown retreats. . . . He went down into the cragged depths where the source is born out of the sweating rocks; he saw the drops of water collect; he let the silver of the small cascades run through his fingers; and he looked at how the clear brook disappeared along a sandy path between the pebbles and the moss. Nobody had ever painted this vibrating and lovely humidity in such a bold and accurate manner. One cannot look at the *Source of the Loue* and the *Brook*—all those fresh and brilliant landscapes in which the gray rocks, the green leaves, and the running water are combined in such a beautiful manner—without feeling as if a gust of fresh air touches the face.

The immense forest, with its tree trunks like columns, its green dome penetrated by the golden arrows of the sun, its thickets and its glades, its sounds and its silence, particularly attracted him.

Hunter as well as painter, he interrupted a half-finished sketch more than once in order to grab his rifle and and shoot some passing animal. These exploits are commemorated in a series of masterpieces that by themselves would suffice to bring fame to many painters: *Doe Run Down in the Snow, Stag Taking to the Water*, the *Poachers*, the *Quarry* (for which the Americans paid $10,000 to place in the rotunda of [the Museum of Fine Arts in] Boston), and *Mort of the Stag* [fig. 18],

in the museum of Besançon, a panoramic snow landscape in which a howling pack of dogs is quieted down by an enormous lash that commands the whole scene. Those were the joys of winter; in the fall one would see the rutting stags attack each other, heads down, while the hind, object and prize of this deadly duel, runs away bewildered. The *Battle of Stags*, which had such a great success at the Salon of 1861, conveys this feeling. He followed the trail of the deer, and, holding his breath, he saw through the foliage the unknown shelter where those charming animals take refuge and hide the fruit of their loves: This was the subject of the *Covert of the Roe Deer*, which aroused such unanimous admiration when it appeared at the Salon of 1866.

The sea was also the occasion of many triumphs. A swimmer even more than a hunter, Courbet loved the sea in its own right; but he never forgot that empty space occupies more place than full space, and without fail he found and established the right proportions between the three elements of the painting: land, water, and sky. Except in some special seascapes, such as that admirable *Stormy Sea*, exhibited at the Salon of 1870 and now in the Louvre, it is almost always the sky that dominates the painting. In the fog, in the rain, in beams of light, in all those movements of the atmosphere, his palette knife plays with surprising agility: one summer, in Trouville, he made thirty seascapes in thirty days, working hardly more than one or two hours every afternoon.

Courbet would not be the great painter we admire if he had not also struggled with the difficulties of the flesh. Because, as Diderot affirmed:

> It is the flesh that is very difficult to render, that creamy white, even tone that is neither pale nor mat; it is that mixture of red and blue that imperceptibly transpires; it is blood and life, that are the despair of the colorist. He who has acquired a feeling for the flesh has made a big step; the rest is nothing in comparison. A thousand painters have died without having acquired a feeling for flesh; a thousand others will die without ever acquiring it.

The problem is even more difficult than Diderot makes it appear, since Diderot did not take reflection into account. Courbet attacked the problem of flesh, first with vigor—a vigor that caused an outcry—then with a softened grace that finally delighted art lovers. From the *Bathers* of 1853 [fig. 13], who were accused of being gross and sordid, he proceeded to the elegant nudity of the Parisienne. His palette, which was a little rough in the beginning, gradually became softer; his shadows became finer and lighter. The flesh—the true flesh—emerged from under his palette knife. He acquired a passion for that kind of work, which is one of the most beautiful triumphs of painting. Without abandoning reality,

without ever giving in to convention, he painted women of all complexions: redheads, blondes, brunettes; in all positions: standing, seated, lying down; under all names: bathers, sleepers, indolents; in all lights: the sunlight of the beach, the filtered light of the woods, and the semi-dark of the boudoirs. It suffices to mention the *Awakening*, *Woman with Parrot* [fig. 17], the famous painting of Khalil Bey, *Indolence and Luxury*, and the *Redhaired Bather* of Brussels, which are the most important ones. One is here at the culmination point of art. The modeling of those beautiful breasts, of those arms, of those torsos, the freshness and brilliance of those skins—one does not tire of looking at them. Name, if you want, the greatest names in painting, I believe that one has never come so near to life.

While Courbet accomplished his work of unceasing and ever new production, the political and moral situation of our country changed. Everybody had forgotten the red phantom and the imaginary Jacques of 1852. The vanquished of December [20] resumed talking; the dead themselves rose from their graves to protest against an abhorred regime. The empire fell to pieces; liberal democracy rose like a great flood. At the same time, a revolution was born in artistic thought. The Classical and Romantic schools, which long since had lost force, saw their last followers disappear. On the other hand, Realism expanded everyday. The time came when Realism seemed to be the salvation of art in distress. A certain number of young people came to Courbet to request the formation of an atelier under his guidance. The painter of Ornans, who had gotten his education by himself and who called himself a "student of nature," did not believe in teachers and he could not pretend to educate students. At the same time he felt that he could not refuse a service that was asked from him. He accepted, although he made all kind of reservations. The atelier opened in the Rue Notre-Dame-des-Champs. Here, the students tackled art through the direct study after nature. A cow, brought in for this purpose from the fields of Normandy, had the honor of serving as the first model for the students. Unfortunately, difficulties with the landlord put an end to this experiment, which deserved to have lasted longer. This adventure amused the Parisiens, who began to find Realism funny and out of the ordinary. That was the sign for an enormous swing of public opinion in favor of Courbet. The beautiful success of the *Covert of the Roe Deer* and the *Woman with Parrot* [fig. 17] completed the reconciliation.

In 1867 Courbet held an exhibition of his works on the Rond-Point de l'Alma, an exhibition that comprised, in addition to his important compositions, nearly one hundred paintings of all genres—portraits, snow

[20] Those who had opposed the coup d'état of Louis Napoleon.

landscapes, seascapes, and flowers. The *Siesta at Haymaking Time* [fig. 19] and the *Mort of the Stag* [fig. 18] appeared there for the first time. That exhibition had a real success. Art lovers of all kinds came there; so did important personages. One morning when I walked there, and was almost alone in the place, I saw Mr. Thiers enter.[21] Unable to find the catalogue, the printing of which had not been finished, it seemed that he was puzzled in front of certain pictures. I offered myself as a substitute for the catalogue. Together we made the tour. Mr. Thiers, who had expected, so he told me, to find some kind of country fair paintings, could not get over his surprise. All the time that clear vision of things bothered him: "He loves truth too much," he said in his fluty voice, "one should not love truth to such an extent."

All of a sudden, on July 15, 1870, war was declared and in its wake came defeat, invasion, the siege of Paris, all those frightening catastrophes of that terrible year. Courbet in his role as president of the Artists' Commission, looked after the riches of the Louvre; in his role of patriot, he gave a cannon to the National Defense. Named member of the Commune [22] at the complimentary elections of April 10, he was not wise enough to decline that nomination, given to him after hostilities had started. After Paris was taken by the troops of Marshal Mac-Mahon,[23] he was arrested and taken to Versailles as a prisoner and he became the victim of the general accusation that applied to all the members of the Commune: He was accused in particular of having thrown over the Vendôme Column.[24]

The Vendôme Column! He knew as little about it as you and me. He had perhaps tried to protect it; but certainly he had nothing to do with its downfall, which took place on May 11. Nevertheless, Courbet was condemned to six months in prison and to a fine of 500 francs for being an accomplice in the demolition of the Column. Jailed at Sainte-Pélagie, where he was to serve his term, he was at first refused the right to paint. Paris has beautiful skies: He dreamed of painting them. "I got an idea," he wrote to me from prison, "to make a birdseye view of Paris with skies, as in my seascapes. The opportunity is unique; on the coping of the building there is a gallery that goes all around; it was built by Mr. Ouvrard, it is splendid. That would be as interesting as my seascapes of Etretat. But, is it not unprecedented and of unsurpassed brutality,

21 Adolphe Thiers (1797–1877), French politician, who was to become president of the Third Republic in 1871.
22 Revolutionary party that ruled after the siege of Paris and the subsequent revolution of March 18, 1871.
23 Representing the elected government of Thiers.
24 Bronze column on the Place Vendôme, erected by Napoleon, to commemorate the battle of Austerlitz. Thrown over by the Communards on May 16, 1871.

I am not allowed to have my working tools. . . ." He added in a post-script: "Hurry, because the weather is beautiful." The administration became less rigorous. But it was too late: The weather had changed. Nevertheless, he made some pictures; at the posthumous exhibition in the Ecole des Beaux-Arts the visitor could see a dining room panel, *The Trout* [fig. 21]. At the bottom it reads: "71, G. Courbet, *In cumulis facie-bat.*" [25] He also made some fruit still lifes and he represented himself behind prison bars: *"in vinculis."*

When he had finished his term in prison, Courbet went back to his studio (May 2, 1872). He stayed there quietly for 15 months. This might have continued all his life, had not Mr. Thiers reversed the situation. Unfortunately, once May 24th [26] and the Government of Moral Order [27] came, the enemies of the painter grabbed power. The idea of punishing the unhappy artist, of making him pay for the reconstruction of the column, was circulated about. A Bonapartist minister, Mr. Magne, con-fiscated all of Courbet's goods, and prosecution began. As a result of that prosecution, Courbet was suddenly threatened with arrest for debt; he crossed the border in July of 1873, accompanied by Dr. Ordinaire, and he went to the Vaud region. He took refuge at La Tour-de-Peilz in a little house that bore the name Bon port [good haven]; he resumed his brush and made some remarkable works: views of the Chateau de Chillon,[28] other landscapes, a very beautiful portrait of his father, fish still lifes—but his heart was no longer in it. He lacked peace of mind and he missed the two elements without which an artist cannot go on for very long: models and people who appreciate his art. He gradually withered away. One day, those beautiful eyes that had been so wide open in front of nature and that had analyzed color harmonies with such accuracy, closed; that powerful hand which, with brush and palette knife, had reproduced the aspect of things more exactly than ever before and that had transmitted the sensation of real life, fell still. Gustave Courbet was no more (December 31, 1877). . . .

[25] Here Castagnary errs. In reality the inscription reads: *"in vinculis faciebat."*

[26] On May 24, the troups representing the legal government of Thiers broke the resistance of the communards in Paris.

[27] Refers to the government of Thiers.

[28] Famous castle on the shore of Lake Geneva, near the town of Vevey.

COURBET DRAWN FROM LIFE

Théophile Silvestre

Here is an original who, for ten years, makes more noise in the city on his own than twenty celebrities and their cliques could make together. Some regard him as the personification of a new art, as a Caravaggio, as one who fights the imagination in behalf of reality and who undermines, in its very foundations, the authority of our illegally imported Raphaels. Others take him for a kind of ragpicker of art, who picks the truth in the mud of the streets, and who throws the rags of the Romantic school and the wigs of the Academy in his basket; fanatics have placed him at once above all artists of our time, and he himself swears in resolute faith that he has no rival. The men of the world pretend to look down upon him; the critics cut his throat; the artists accuse him; the Vaudeville writers caricaturize him under the applause of the good-for-nothings.

Like his famous friend and compatriot, Proudhon, one of our greatest authors, Courbet has become the enraged *bête noire* of the public.

He has been loaded with blame and praise. He deserves "neither that excess of honor, neither that indignity."

Courbet is not an eagle; but do not take him either for one of those cunning and bragging mountaineers from the Franche-Comté, who, for twenty years, have got the better of people from Gascogne and the Provence through their boasting and their intrigues. Let us recognize in him a painter full of force, originality, and extravagance, who, by virtue of his temperament, his ambition to react against the past and its trivial taste, often makes an outright fool of himself and impairs his solid qualities that nobody can contest.

"Courbet Drawn from Life." From Théophile Silvestre, *Histoire des artistes vivants. Les artistes français, études d'après nature* (Paris: Blanchard, 1856), pp. 241–248. Translated by the editor.

To let the reader know this singular personality well, I must, for a moment, forget my personal sympathies and present him as I see him, as he has posed for me. If the artist does not find here his own traits as in a mirror, his friends will recognize him completely: There are no two Courbets in this world.

My free procedure is the only one that fits that easy-going character, who preaches from the housetops all that passes through his head, and who has recommended that I present him as he is, as he believes to be. Let us admire that self-confidence and that frankness, so rare in our days. I obey him wholeheartedly, for I am eager to proclaim myself, like him, the friend of reality and the pupil of nature.

Courbet is a handsome and tall young man. His appearance resembles the Assyrian type. His eyes—black, brilliant, gently shaped, and surrounded by long, silky lashes—have the quiet luster of the eyes of an antelope. The moustache, hardly visible under the imperceptibly curved nose, slightly touches the beard, which unfolds in a fan shape, and shows thick, sensual lips, of an undefined and uneven design. The skin is fine as satin and has a vigorous brown color; the conical form of the head and the protruding cheekbones are symptomatic of stubbornness; the moving nostrils seem to be indicative of passion. Courbet, however, is soft-natured, and his incredulity places him outside the torments of the imagination. He has nothing violent about him except his love for himself; the soul of Narcissus has descended into him in its latest reincarnation. In his paintings he always paints himself with voluptuousness; and he is overcome with admiration for his work. Nobody is capable of making him one tenth of the compliments he naïvely makes himself, from morning to evening; and if you ask his opinion, he will answer you:

> I am Courbetist, that is all; my painting is the only true one; I am the first and the only artist of this century; the others are students or drivellers. *Everyone* may think the way he wants, *I do not care about it.* I am not only a *painter,* but also a *man;* I can make my judgment in morality, politics, and poetry, as well as in painting. I am *objectif* and *subjectif,* I have made my synthesis. I do not care about anybody and I worry as little about opinions as about the water that passes underneath the Pont-Neuf. Before everything else, I do what I have to do. They accuse me of vanity! I am indeed the most arrogant man in the world.

His vanity, which one has wanted to charge to him as a crime, is naïve and courageous; that of many others is dissimulated and full of venom.

Courbet would be quite pleasant if the development of his intelligence were in rapport with his pretension that he knows and can judge everything. He thinks that his instinct can replace knowledge; and

without knowing about a subject he attacks it full force, hoping that his common sense will guide him in the darkness; and he is convinced, moreover, that the orators of the café will not be able to debate with him. He is stubborn and finishes the discussion by roars of laughter when he does not know what to say anymore. He has long tried to prove to me that he had made profound studies in literature, history, and philosophy. I have found out, vexing him, that he does not know anything. But, like a woman, he is endowed with a certain instinct that sometimes is better than learning. In his egotism, he also reminds me of that comedy character who said: "I have talked about myself, I have talked about myself again, and after that about myself and more about myself." One cannot pass two minutes with Courbet in which he does not talk about himself and his paintings. Aside from the hours of sleep, during which he only dreams of them, he does not stop entertaining you with them.

He is sometimes witty, always bizarre. Inclined to mime everybody, he likes to imitate the voices of mannered women, the squeaking of pedantics, the solemnity of grand personages, or the behavior of his confreres; he roars with laughter before speaking and doing anything; he laughs even louder and is the first to laugh about what he has just finished saying or doing; and he makes whoever listens to him laugh. Returning from a visit, he tells you how he has astounded and confused the people. He always has the last word. He is the victor of victors. He is not without cunning; but he sees men and things without losing himself. As a result [in his paintings], he transforms rather than translates his types; and he succeeds in rendering them unrecognizable.

His pace drags like his voice, which sharpens the accents like needles and leans heavily on certain syllables. . . . His bearing is low-class; his body bends over an oaken stick or a vine-stock with a curved handle—a prop which, like his cheesemonger's pipe that is always lit, never leaves him. His hands are long, elegant, and of a rare beauty. His dress bespeaks a simple man, well-to-do, and not without affectation.

Courbet is all integrity and good nature. His love for the café and his noctambulant habits damage his talent. He is never inclined to get up, or to go to sleep. He is of a friendly disposition; he lies often, but he ends up by persuading himself that he speaks the truth. In order to give more local color to his story, one day he told me, in all seriousness, about the conversation he had in England with Hogarth, who died in 1764! He adores originality of opinions and the fanciful use of words, which leads him to attribute valor to certain eccentric people, such as the "apostle" Jean Journet. But those passing infatuations have no danger for the artist, who rests content with the joy of being himself.

I have found, he said, perfect happiness; I do not know what anxiety is (too bad! no genius without torment!); I love things for what they are, and I make them turn to my gain. Why should I try to see in this world what is not there, and deform, by straining my imagination, all that is there? I do not despise anything; if today I meet a woman gifted with some quality, I enjoy it; tomorrow I pass to another for a different quality. I have suffered from my passions. I do not suffer from them anymore. I have spent one or several years, if needed, to get rid of an attachment or a prejudice; now I am free. Every night I go over my ideas, my doings of the day, and this teaches me to live logically, rationally. If I feel I am on the wrong way, I change.

He believes that he has arrived at knowledge, at self-possession, and he has "got to the bottom" of his illusions: "By losing them, I have lost nothing; I always have enough left, and, moreover, don't I have the unknown before me, which can mean everything for me?" In this way he is sure to instruct himself, to see his personality grow from one day to another in geometric progression, to think more and more strongly about his genius and our folly.

COURBET'S ENTOURAGE

Alexandre Schanne

I will not have to go far [from the studio of Courbet] to find the Realists in their usual nest. It is in the Brasserie Andler, situated in that same Rue Hautefeuille, that several among them, and not the least considerable, like to get together to take their meals and to drink beer, while they say bad things about the Idealists.

This establishment of very modest appearance, a true village inn, was located on the projected course of the Boulevard Saint-Germain; consequently, it has disappeared. . . .

The owner was of Swiss origin, and the pronunciation of our language had always remained a secret to him. Moreover, his brain worked slowly, and if he understood our jokes at all, it was only after a week of thinking. As a matter of fact, I have seen him sometimes burst out laughing without apparent cause; if someone asked him the reason of the untimely gaiety, he repeated the pun—or something resembling it—of the previous week. One would think that he had written home for the translation. Courbet has made an excellent portrait of Madame Andler [fig. 16]; he has represented her seated at her cashier's desk, half hidden behind a vase of flowers and the box for the tips.

Thursdays were the great days [in the Brasserie Andler]. I would not miss them for anything, even though my "hunting-horn laugh" (Murger's expression) had the effect of irritating the nerves of the owner, who said in his Swiss jargon: "One sees vell that "Moncié" Schanne he be there; it is noisy!"

Nevertheless, the Realists (who were not very numerous after all), as they began to be talked about, attracted to their table curious people from all the corners of Paris.

"Courbet's Entourage." From Alexandre Schanne, *Les souvenirs de Schaunard* (Paris: Charpentier, 1887), pp. 295–298. Translated by the editor.

It is understood that I count as friends, and not as intruders, several students in medicine, who, in their own way, have become Realists by becoming surgeons. The majority of them today have made a name in science. . . .

Among the artists and literati were, of course, the great leaders Courbet and Champfleury; close, but not immediately next to them were Duranty (editor of the magazine *Réalisme*), Fernand Desnoyers, author of the pantomime *Le Bras Noir*, Emile Montégut, Jules Vallès, Lorédan Larchey, Gustave Planche, Jules de la Madelène, Théophile Silvestre, Max Buchon, Proudhon . . . and the painters Decamps, Daumier, Français, Hanoteau, Corot, Amand Gautier, and Bonvin; the sculptors Barye and Préault . . . and finally, the musician Debillemont, the ceramist Parvillée, and the art critic turned member of the Council of State, Castagnary.

One can see, through this listing, that our noisy agapae have not prevented a good number of us from occupying the most envied posts that knowledge and talent could give. Let this be said in response to the remarks of a certain bourgeoisie which can never reconcile itself with art and science.

METHOD AND DOCTRINE

Emile Bouvier

"Courbet was a landscapist of humanity." [1] This sentence sums up completely the novelty of his endeavours: We have seen that, before him, the landscape school had disengaged itself from the traditions, that it had substituted the faithful reproduction of nature for conventional pictures. The landscapes of Courbet are a continuation of what Troyon and Corot had started. The mere titles of his works are significant: *Rocks at Ornans, Scenery on the Island of Bougival, Banks of the Loire River, Deerhunt in the Jura Forests.* D'Ideville, who saw him work at Trouville, gives us an idea of how he painted his seascapes: He planted his easel on the cliff, looked, and noted down on his canvas the nuances of the sky, the colors of the waves, or some particular aspect of the coast; the next day, he started again and reproduced another facet of his eternally changing model. His biographer, Gros-Kost, gives a description of him at Ornans, in front of a sunset, fixing in his memory the subtle gradation of the tones, the slow disappearance of the nuances, and the descent of the dark. [2] The sharpness of his vision made him find the true tone of the painting directly, and also made it possible for him to separate the particular values of each detail. Only then did he mix his colors, compose his tones, and begin to paint without casting a glance at his portfolio, without bothering to use this or that sketch. After having outlined the large masses in charcoal, he noted down every particularity on the ground. In this way he could compare his manner to that of the sun,

"Method and Doctrine" from Emile Bouvier, *La bataille réaliste*, 1844–1857 (Paris: Fontemoing, 1913), pp. 225–232. Translated by the editor. Footnotes by the author.

[1] C. Lemonnier, *Courbet, sa vie, son oeuvre*, p, 38.
[2] Gros-Kost, *Courbet, souvenirs intimes*, p. 66.

which first illuminates everything as a whole and then gradually lets the contours of the object come out of the dark, slowly defining them. It is the realist process par excellence, in that it consists of looking attentively, seeing well, and remembering what one sees: [3] "He had only," so someone tells us, "the perception of things under their two esthetic qualities of form and color." [4] Look with how much care he comments, for his friend Francis Wey, on every detail of the *Stags* and the *Whipper-in*: [5] He explains where, when, and how he has seen, with his own eyes, the scenes that he represents. He does not hesitate to venture into numbers and hunting terms to prove that all is real in this landscape, that he has neither invented nor modified anything. Since this set idea and this acuity of vision were served by a hand that possessed all the secrets of the *métier*, he could only end up with true naturalistic masterworks, like those that are exhibited in the Louvre—the *Wave* [fig. 20], the *Covert of the Roe Deer*, and the *Rivulet of the Puits-Noir*.

Apply the same method to the human figure or to the costumes of the peasants of the Franche-Comté, and you have the genre paintings of Courbet. In the *Funeral at Ornans* [fig. 6], he did nothing but unite around him the friends of his father; he let them take the poses that were natural to them; and he reproduced on his canvas the disorder of their group, the vulgar uniqueness of their profiles. A letter to Francis Wey [6] informs us about the genesis of the *Stonebreakers* [fig. 4]: He has met his models on the road to Ornans and he has painted them at their work, without changing anything in their clothes, without cleaning them, and without giving them a sculptural attitude. Courbet is therefore really the "landscapist of humanity": He considers his personages under the two aspects of form and color; and, just as he did not think of knocking off the top of the castle of Ornans in order to make it stand out more, in the same way he did not rob his stonebreaker of his dirty and battered felt hat. If he paints the philosopher Trapadoux, it will be in the usual pose he assumes in his studio—seated on a stool, the legs stretched out, the feet in full view, a book open on his knees, the head inclined, seen in foreshortening, the eyes cast down. [7] And since the models Courbet had in front of him—the ones he picked out of the peasant society of Ornans or the Brasserie Andler—have nothing elegant or affected about

[3] Cf. Champfleury, preface of the *Contes Domestiques:* "What I see enters into my head, descends into my pen, and becomes what I have seen."

[4] Gros-Kost, *op. cit,,* p, 199.

[5] *Archives historiques, artistiques et littéraires,* vol. 1, 1889–90, p. 71.

[6] *Archives historiques, artistiques et littéraires,* vol. 1, p. 35. Cf. Champfleury, *Souvenirs,* pp. 174, 175, 176 (Letters of Courbet).

[7] Reproduction in d'Ideville, *op. cit.*

them, his painting reproduces only common, sometimes vulgar aspects of reality. His *Bather* [fig. 13] is a fat woman, a mass of flesh in which the purity of the line gets lost; his *Young Ladies from the Village* [fig. 12] and his *Grainsifters* are ugly. The *Peasants of Flagey* [fig. 5] are dressed after the fashion of peasants, they are dirty and without expression; the *Young Ladies on the Banks of the Seine* sprawl on the grass in wrinkled dresses and they smile with a smile that is at once silly and voluptuous. All that is only a consequence of this principle—to paint people like objects—and of its two corollaries: not bothering about composition and not beautifying the model.

Courbet was not satisfied with making paintings according to the formulas of the Realist doctrine: He also preached it. He has not exposed it by writing it down; but his biographers have recorded fragments of conversations and anecdotes which suffice to give us an insight into that doctrine. It would be important to know if, as early as 1849, Courbet, who exhibited works that were already Realistic, had a clear idea of the aim he wanted to achieve. Unfortunately, the majority of the remarks attributed to him are not dated; one could suppose that it was precisely Champfleury and his group who taught him to define what was only a tendency in his art. But we possess a precious letter of November 26, 1849,[8] which permits us to deal with this very important question. Referring to the *Stonebreakers*, Courbet, in this letter, gives a veritable Realistic art course; and, in answer to the advice of Peisse, the critic of the *Revue des Deux Mondes* and the *Constitutionel*, he ends with these significant words: "Yes, Mr. Peisse, one must bring art down! For too long, the painters of our time have made ideal art after sketches!" We can, therefore, assume that at that date Courbet had already put himself forward as a theoretician of Realism. Around this phrase, we can group details reported by Théophile Sylvestre, Gros-Kost, and Audebrand; and in this way we can summarize the doctrine of Courbet: One can only paint what one has seen, that is to say, contemporary history. Those who paint something else let themselves be guided by the influence of the tradition and lose their personality. No doubt it is good to know that tradition, but from the old masters one should only learn the technique.

> I have studied, he says in the *Notice* of his exhibition of 1855, outside of any kind of system and without prejudice, the art of the ancients and the art of the moderns. I have no more wanted to imitate the first than to copy the latter; nor did I have in mind to aim for the idle goal of

[8] *Archives historiques, artistiques et littéraries, loc. cit.* Quoted by Troubat, *Une Amitié à la d'Arthez,* p. 167.

art for art's sake. No, I have simply wanted to draw forth, from a complete acquaintance with tradition, the reasoned and independent awareness of my own individuality.[9]

"I am Courbetist, that is all," he said frequently.[10] Linked to this affirmation is a criticism, sometimes exaggerated, of the painters who immediately preceded him.[11]

Obedience to the tradition leads to stereotype: David and Gros have only made stereotypes. Delacroix and Géricault, on the other hand, have departed from nature by the profligacy of their imagination. It is actually the absence of imagination that characterizes the "individuality" of Courbet: "A suspicion of idealism infuriated him. When one showed him photographs that were a little light, he exclaimed, stamping with his foot: "That is not the truth, that is artistry, that is a lie." [12] "They have not one penny worth of idealization," [13] he said to Francis Wey about his *Stags*. "Why should I try to see in the world what is not there and distort by efforts of the imagination what is there?" [14] That "pupil of nature" became incapable of appreciating even the technical qualities of the masters when he detected in their works that shameful idealism. Raphael made him furious.

Painting, sculpture, engraving—everything that had been done before him—did not count. I do not know anymore who talked to him one day of the *Madonna della Sedia* by Raphael. "That is a good joke," he said: "Raphaels, there are in the dirty houses of our suburbs twenty poor chaps who make Raphaels day after day, and neither popes nor Saints dream of giving them crowns or bread."

"Youth!" he said about a statue of Aimé Millet, "does a woman exist who can represent Youth? And then, the young person that one shows us is completely nude. Is that realistic? One should make her a dress; where is the dress?" [15]

Summing up, it seems that for him Realism is synonymous to negation of the imagination, to predominance of truth over poetic fiction. Although he denies being a partisan of art for art's sake, and although he scoffs at kings and priests, and preaches rusticity, he is closer to Flaubert than he thinks. Does he not preach the cult of the form, and

[9] Confession of faith that heads the brochure: *Exposition et vente des tableaux de G. Courbet,* which was probably edited by his friend Castagnary.
[10] Sylvestre, *op. cit.,* p. 113.
[11] About the reaction of Courbet against the painting of his time, see Ph. de Chennevières, *Lettres sur l'Art français,* p. 38 *et seq.*
[12] Audebrand, *La Fin de la Bohème,* p. 109.
[13] Letter of 1861, *op. cit.*
[14] Th. Sylvestre, *op. cit.,* p. 113.
[15] Audebrand, *op. cit.,* p. 109.

does he not substitute technical knowledge for inspiration when he claims: "The powerful painter must be capable of, without hesitation, wiping out and redoing his painting ten times in a row, in order to prove that he is neither a slave of coincidence nor of his nerves." [16] He intended to apply these beautiful formulas not only to the fine arts: His ambition went further; he made himself a literary critic with the same ease. He was drawn to it by his ignorance, which did not let him see the difficulties, and by his vanity, which made him overlook them carelessly.

"Molière!" he exclaimed, "there is another one that I will expose!" Thus armed, he went to war against the windmills of the would-be idealists. Poets irritated him. The only ones to find grace before him were Baudelaire and his compatriot Buchon: "Making verses is dishonest; talking differently from everybody else is aristocracy." [17] He even conceived the idea of a symbolic painting, the *Source of Hippocrène*, which was to translate in Realist painting the hollowness, the emptiness of all poetry. He composed, for the edification of his friends, rustic songs without rhyme, without beat, without metaphors—in a French that smacked of his provincial dialect. Contemporary literature, tragedy—nothing satisfied him. "Mr. Ingres, Mr. Scribe, Mlle. Rachel—put all that in a sack and throw it into the water." [18]

[16] Th. Sylvestre, *op. cit.*
[17] Gros-Kost, *op. cit.*, p. 34.
[18] Audebrand, *op. cit.*, p. 109.

COURBET IN HIS CENTURY

Klaus Berger

The classic revival and even the romantic epoch have sometimes been considered odd in the painting of the XIX century since the period as a whole is so positively *realistic*. Realistic aims are supposed to dominate from the beginnings of Daumier around 1830 until. the end of impressionism (Monet lived until 1926), whereas neo-classicism is taken for an inconvenient inheritance which can gladly be left to the XVIII century and excluded from the new art. Romanticism seems to be much more intelligible in this conception, for the boundaries between romanticism and realism are rather fluid. Actually each new presentation of the problem suggests different gradations, but it seems to be a consistent opinion that both tendencies get on well together. Classicism alone is supposed to preclude any realism, since it is based on a rigorous idealism.

One of the difficulties in coming to an agreement about the complicated structure of XIX century painting seems to be the fact that such principles as realism, classicism and romanticism have not been sufficiently clarified; often the terms have been taken from literary criticism and not precisely enough translated into the realm of the visual.

Therefore it might be useful to approach realism from those paintings of which the realistic features never have been questioned or diminished by any theory or conception. Confining the analysis to the realistic vision involved in them—since all visual art is taken to be a presentation for the eye—one will discover one or several of the every elements of realism, elements of such a nature as to be grasped only from the visual.

"Courbet in his Century." Excerpt from Klaus Berger, "Courbet in his Century," *Gazette des Beaux-Arts*, 24 (1943), pp. 19–40. Footnotes by the author. Reprinted by permission of Klaus Berger and the *Gazette des Beaux Arts*.

This seems to be a good starting point: looking forward and backward one becomes aware of the origin, variations, and final point of these principles within the artistic evolution of a larger period.

A realistic picture appears to be the simplest and most easily recognized of all artistic conceptions; nevertheless its artistic justification leads to a theoretical discussion which often results in the greatest confusion. There is a general understanding about classicism: the strong relation between pattern, subject matter, aesthetic theory, and human background has been clearly pointed out. But what about realism? It seems so simple and plausible to *render* things and men as they are that arguments and explanations appear superfluous, but even here we are confronted with the most heterogeneous opinions. Does realism mean a certain way of rendering, corresponding, for instance, to the photographic lens, does it mean a certain kind of movement, as in a moving picture, or rather the selection of trivial *realistic* subjects emphasizing their material structures and substance of light, color, and volume?

Obviously the movement which in the XIX century pushed itself to the fore against unprecedented opposition was the radical realism related to the name of Gustave Courbet. He himself has explained his opinions about what he calls *l'art vivant* only with regard to the subject matter, and with a purely intellectual approach. He writes: "Savoir pour pouvoir, telle fut ma pensée. Etre à même de traduire les moeurs, les idées, l'esprit de mon époque, selon mon appréciation, en un mot, faire de l'art vivant, tel est mon but." [1] He argues against neo-classicism and romanticism because he cannot see antique gods and goddesses and he has not before his eyes medieval and legendary scenes. For him the truth coincides with every-day reality, and to record it becomes the strongest impetus to his art. Moral, social, political, and other extra-artistic motives are important for him, but there is no point in question concerning a new optical style, a revolutionary manner of representation. Indeed his contemporaries declared many a time, with or without irony, that they saw embodied in his canvases only an "aesthetic of ugliness." One may then wonder what really is the originality of Courbet's style in view of his largely dark palette, the size of his canvases, and his broad brushwork like that of the old masters. Does he not follow in the footsteps of Velasquez and Ribera, Caravaggio and the Dutch?

[1] Quoted from the manifesto Courbet wrote as a preface to the catalogue of an exhibit of his paintings, probably the first one man show ever organized by an artist. Protesting against all kinds of officially sanctioned art which was to be seen at the first *Exposition Universelle* of 1855, the painter had a special cabin built for his production in front of the Exhibition entrance, Avenue Montaigne. Twelve years later, at another exhibition, he did the same thing, and this time he was imitated by another artist refused by the public and the imperial Government: Edouard Manet.

Of course, modern realism has more than one feature in common with the old; Courbet's predelection for the old "models" is by no means accidental. However, as the Renaissance has one face which gives to it the appearance of the rebirth of the classics, and another which is "modern" and autonomous, so modern realism has its own physiognomy, and an original intention. In the XVII century, from the Le Nains' to Frans Hals, we recognize a realistic presentation, realistic motifs and "islands," but they are included in the early-, high- or late-baroque composition with its structure of depth-space, diagonal movement of the curves, counterpoint-calculation and so on. . . . The realistic consideration exists in the detail and is not only subordinated to the swing of the abstract figurations, but its very function is to repeat them in miniature, to vary them, and to determine their significance. Every realistic detail of such a picture reproduces the tension of the total shaping not only in form- and movement-structure but in light and color as well. . . . It is always baroque realism rather than utterly pure realism.

Pure or radical realism is not to be found in painting before the middle of the XIX century, in Courbet. A canvas like *La rencontre,* also called *Bonjour, Monsieur Courbet* [fig. 14] can give an idea of the characteristics of modern realism. There is no formal rule of composition: we are confronted with scenery which in its accidentalness and irregularity is rather like a snapshot. Actually the process of instantaneous photography was invented a few years later so that it seems justified to recognize in both instances the vision of the epoch. . . . You may inspect the Courbet canvas in the reverse sense (the mirror image of the original)[2] . . . , you may cut out the figures and arrange them in another way, you may enlarge or reduce the size, its essence would scarcely be altered. The representation seems made to be examined in small details,

[2] This statement must, of course, be understood not in an absolute but in a comparative way. No painting composition of any epoch is the exact artistic equivalent of its mirror picture. But there are marked differences in degree. The mirror picture of Rafael's *Sistine Madonna* seems to have nothing in common with the original as for the artistic values, whereas in our Courbet canvas original and reverse, though they are discernible, look enough alike so that one hesitates before deciding which is which. Heinrich Woelfflin introduced this device in art criticism. In his article *Concerning Right and Left in pictures* (in: "Festschrift fuer Paul Wolters," 1928, and reprinted in: *Gedanken zur Kunstgeschichte,* Basel, Benno Schwabe & Co., 1941) he demonstrates the artistic meaning which an object has in the canvas depending on its location on the left or on the right side of the composition. All the examples taken from the XVI or XVII centuries, seem to describe an integrating principle of "composition" which naturally disappears with the composition itself, in the XIX century. Speaking about Duerer's *Hieronymus,* Woelfflin says: "One cannot reverse this composition either, without removing its enchantment. . . . The effect is totally altered, the secondary motifs have been brought into the good places." Realism intended to do just that: no longer was any person or object or motif to have a special privilege. "Enchantment" was no longer to be tolerated.

each of which taken by itself is like a little picture with its special structure; nothing is definitely related to the whole context except through the story of the subject matter. The material texture of every detail is emphasized and rendered by the brushwork so that to the baroque realist it would resemble a mosaic composed of a lot of heterogeneous particles. Courbet's manner of presentation differs essentially from that of his realistic "predecessors," for it is no longer a question of starting from a certain general pattern to which the detailed observation is related and even subordinated. The composition having gone to pieces, the variety of the different objects becomes more obvious. This new realistic optical manner consists in making the picture a sum of various "units."

In this canvas [*The Meeting*] one looks in vain for leading principles of composition in the traditional sense. Instead of these, the subject is presented in such an unmistakable and "illustrative" way that there is not the slightest difficulty in entering into the picture: strongly against the horizon stand the three figures; Courbet himself in hiking clothes with knapsack and stick, walking along when he sees his patron, Monsieur Bryas, and Monsieur Bryas' servant coming to meet him. The exact moment of salutation is given: in the next minute they will start to speak to each other. This is the precise and detailed account of a reporter-photographer, we would say nowadays. Nothing has been done to arrange the scene: the important space between Courbet and Bryas is anything but emphasized, it is cut up by such unrelated things as the stick, the dog, and the arm of Bryas, none of which has any artistic function in the picture. The line of the stick is broken by the inside of a hat; the dog, having followed its master, stops and stands lost and unrelated to the scene; the old-fashioned ceremonious gesture of Bryas dropping to his side an arm prolonged shapelessly by the hat, is an isolated and interrupted movement and this is the most striking spot, the focal point of the picture. Of the three men Bryas stands out best, his full silhouette nearly facing the spectator. Courbet himself is visible rather from the back, and the outline of his body is virtually deformed by his shapeless knapsack. Finally, the brightest spot in the picture is— the white vest of the servant, picked out by the light of the late afternoon sun. Looking around one could, by observing the length and the density of the shadows, calculate the position of the sun and the hour of the day. A mail-coach is passing in the background and gives the curious spectator a new clue for locating the time and place on the road to Montpellier.

This is one indication of a fundamental concept of Courbet: to characterize his subjects not only by the three dimensions of space, but by a time dimension indicated by motion. Among his numerous landscapes there is scarcely one in which there is no movement: deer are

leaping or listening to a sudden sound, stags are fighting, hounds are sniffing each other, a little dog is barking at a cow, a brook is bubbling, the trees are being shaken by the wind. No picture of a human figure is without this feeling of the instantaneous. The arm of the spinning woman is just falling to her lap as she dozes off, a stone cutter has his pick poised to strike, two wrestlers are shown as one is losing his balance, a child is absorbed in pouring water from a pitcher into a tiny dish, a bird has just alighted on the extended arm of a reclining woman, a bather is arching her foot as she steps into the water. Even the portraits seem to have been "snapped" in the midst of an animated gesture or a fugitive expression.

In other words, Courbet is waiting for the exact moment of suspended motion to click the shutter of his camera. In the next second the whole scene will be completely and definitely changed. One of the effects of this device is to make the viewer a partner in discovering the subject matter: not only are the subjects shown to him but also the "setting", so that he is brought nearer to the stage and may even feel himself present in the canvas-space to discover by himself the variety of spaces, themes, and colors.

When we are in front of a classical painting, the more we look at the objects, the more their structure becomes simplified and reduced to a few elementary forms. This has always been the basic principle of the classics of all epochs, from antiquity to Cézanne. Realism produces the opposite effect: the visible world is broken up into innumerable irreducible particularities, whence Courbet derived what we shall call the principle of the diversified units. For him the world is a kaleidoscope.

Certain realistic undercurrents hostile to any formalism have always existed, and [are] much stronger, of course, in graphic arts than in painting; nevertheless the given realistic facts can only be the raw material of art, demanding in every period plasticity and a manner of interpretation, a certain kind of vision.

So the principle of the diversified units seems to be an apt characterization of modern realism; this principle, on the visual-artistic level, is for that very reason more important than the motivation in choosing the subject matter and all the other aims claimed by Courbet himself and his contemporaries. It is unnecessary to prove the existence of these elements, that being a metaphysical problem, or to define on the intellectual level their *raisons d'être*, but it is important to demonstrate them, because they result from the inexhaustibility of the visual, the basis of realistic perception. . . .

No one has so well rendered objects by their surfaces and material qualities as Courbet. Observe the skin of the throat of a woman, how different it is from that of the legs. . . . He gives every flower, almost

every leaf, every collar, every belt, every table its own face. He has no thought of consulting his own fantasy, but only the great stock of natural things.

Therefore the reproduction of a realistic canvas is like a good photograph. . . . For the Impressionists the subject matter is cloaked by the structure of the brushwork; for the old styles, on the other hand, this is subordinated to the pattern of the composition. Only for Courbet and the realists the textures of the subject coincide with painting structures in the diversified units.

Thus the lack of true composition is replaced by the fullness of detailed forms. When every object is provided with a face of its own, when this individual variety gives to every detail almost the same emphasis, the effect may be described as a general leveling of the subject matter. All over the canvas the equal intensity of tangible qualities is noticeable, all things are now also of equal visual value. The accents and valuations characteristic of the compositions in the classical manner are indeed not to be found in Courbet.[3]

In a *Portrait of Baudelaire* [fig. 2] not only the face but the collar and cravatte, the book and inkpot, each of these forms an autonomous unit. The same remark is to be made of every representation of persons: everything is done to parcel out the concentration among the most different attributes, away from the face, done mostly by directing the light towards these things. (Portraits of: *Mme. Crocq called La femme au gant, Proudhon, M. Nodler fils.*) It is no accident that the *Self-portrait* from 1849 is known as *L'homme à la ceinture de cuir* [fig. 1].

It should not be a restriction in the appreciation of Courbet's creative power to make clear how much of the substance of the units is due to the tradition of the old schools. The breaking-up of the composition and the loosening of the pictorial structures is entirely characteristic of the XIX century, but the technique of the painting is very often in the footsteps of the XVII. Courbet was an admirer of the technique of the old masters and did some copywork in the museums. Moreover, there was until 1848 in Paris the famous Spanish gallery of Louis-Philippe at the Louvre which must have influenced his study.

So one may find that he borrows not a little from the past by the

[3] The writer of this paper has made a study of Courbet's artistic conception, related to the individualism and democracy of his epoch in a nearly completed book, entitled: *The Expulsion of Man from Art. Cultural and Sociological Aspects of French Art in the 19th Century.* The new philosophy fighting for equality and against the hierarchy of values, bound up with the progressive science, the positivistic attitude, and the social change of the public are to be considered in this perspective. For another treatment of this theme see the symposium on *Courbet and the Naturalistic Movement*, edited by GEORGE BOAS, Baltimore, The Johns Hopkins Press, 1938.

way in which he builds up his picture-space with light and shadow, by the coloristic scale or the spread of volumes; he follows the old Dutch as well as Ribera, Velasquez, Le Nain or Caravaggio and his school. . . . The most heterogeneous influences are often to be seen in the same canvas. In a similar manner his contemporaries built their houses in the style of post-Renaissance and post-Baroque and did not much care whether this portal was to be combined with that dome, according to the conclusions of art history. The decisive difference however, not to mention the quality, lies in the fact that architecture aligned with construction and material develops certain shapes hardly adaptable to the principle of diversified units. Painting, being representative, is better able than architecture, which is abstract, to combine skillfully the most heterogeneous space-units. So in the large canvas *L'atelier* [fig. 15] the picture-space of the painted landscape has been inserted into the very complicated articulation which is the space of the studio. In this case we are able to look, so to speak, over the shoulder of the "constructor" Courbet and to realize how he proceeds in parcelling out the space. The substitution of an arrangement at random for the old strong order is obvious.

Though the historical tradition of the new realism doubtless reaches back to the old realism, there is, in addition, something which may be called its aesthetic tradition; for Courbet, as we shall see, did not invent the parcelling up of the artistic composition into units, he only adopted it, extended it, and combined it with the most effective realistic elements. In uniting these two traditions Courbet achieves his own style and is, in effect, the finisher, not the founder of realism, even with its modern stamp. Perhaps it would be more accurate to say that his work was the peak of realism.

His art, however, has had two lines of successors: on the one hand the line from Manet to Cézanne, on the other the impressionists up to Seurat. Both trends liquidate in different ways those principles described here as realism and lead to a new order, a modern classicism. The pictorial structure and the texture of the subject, which coincided in the work of Courbet, begin then to be detached from one another. The close view and the far view have become quite different; thus the way is paved for the modern anti-realism of our century.[4]

Courbet's predecessors in the dissolution of the old composition are to be found in the movement which is conventionally called "neoclassicism around 1800", Jacques-Louis David being his greatest representative.

[4] There is no opportunity to study this problem within our context. Those interested may consult: ROBERT REY, *La renaissance du sentiment classique dans la Peinture Française à la fin du 19ième siécle*, Paris, Les Beaux-Arts, 1931. Very complete bibliography.

Most of the modern scholars agree that the term classicism is misleading in so far as it recalls the *grand goût* which was based on Greek sculpture, on Raphael as well as on Poussin. David's classicism is of different kind. He refers to antique sculpture, but for him the classics serve largely as an arsenal of isolated forms and subject matter, an effective moral and political inspiration. The *esprit classique* in order to make great pathos visible by noble figures, starts with definite patterns, but David takes a different approach: he picks up various examples, figures and motifs, fragment by fragment, and combines them in a special way. This is a modern idea and puts him at the opening of a new epoch.

The recognition of this feature throws a new light on the criticism that his compositions often "fall apart," [5] because this very thing constitutes his own stylistic intent and places him at the start of these historically oriented styles of the XIX century which assume the rôle of taking over a great tradition and changing it from its organic combinations into modern mechanical coordination. Louis Dimier had already noticed how far David was from any of the old styles when he sums up, rather disapprovingly, the characteristics of his art: "D'abord la rupture de l'ancienne composition, où l'on groupait les personnages: ceux-ci devant figurer désormais isolés, traités à part comme des statues; en second lieu la suppression de l'effet, ou économie du clair-obscure, avec un coloris ramené à des tons brusques et entiers, qui s'opposent les uns aux autres au lieu de s'unir."

This is, *mutatis mutandis,* already the principle of the diversified units with the eclectic taking up of traditional elements. From here not only does a direct way lead to Courbet, but also, for the first time, one of the main tasks of the whole coming century has become obvious: what to do with the heritage of the composition, how to change an obsolete pattern into a new visual order in keeping with the changed attitude of man towards the world, society, towards space, time, movement, and the problems of their presentation in art. It is rather interesting to note how the art world, faced with the same fundamental problems throughout the whole century, interpreted them quite differently from the way we now understand them. Only at the end of this process of clarification which lasted a hundred years, was the veritable goal, the new order, achieved by Seurat, Cézanne, and the younger generation.

The unifying thread through the numerous conflicting movements and experimental tendencies in this century, shifting from an old pattern towards a new one, now becomes more obvious. The XIX is indeed a century between two orders.

[5] Walter Friedlaender, *Von David bis Delacroix*, Bielefeld, 1930, p. 23.

COURBET AND HIS CRITICS

George Boas

If there were such a thing as a work of art *überhaupt,* aesthetic values which any intelligent man could recognize as such, beauty which was really universal and eternal in its agreeableness, the history of taste would be a hopeless enigma. If, however, works of art satisfy a variety of interests, have a multiplicity of values rather than a single value, then it becomes no matter for surprise that different periods have found different things in a given poem or picture or play, and that during any one period different critics have both praised it and blamed it for a variety of reasons which are frequently contradictory. The pictures of Courbet are a perfect illustration of the multivalence of works of art. They aroused floods of criticism both favorable and unfavorable. Their author had no hatred of publicity and no false modesty. He talked a great deal about himself; he encouraged others to talk about him. He was glad to be at the head of a school and was ideally equipped, both physically and mentally, to assume such a position. Consequently the historian of taste has little difficulty in discovering what his admirers said that they liked in his paintings and what his detractors said that they disliked.

The reaction of the general public to Courbet is perhaps best seen in the caricatures and parodies of his art. Léger's indispensable collection of such criticism [1] shows us one hundred and ninety items, all of which, with the exception of three lithographs by Daumier, are anti-naturalistic

"Courbet and his Critics." From George Boas, ed. *Courbet and the Naturalistic Movement. Essays read at the Baltimore Museum of Art, May 16, 17, 18, 1938.* New York, Russell & Russell, 1967, pp. 47–57. Footnotes by the author. Reprinted by permission of George Boas.

[1] Charles Léger, *Courbet selon les Caricatures et les Images,* Paris, 1920.

in tendency. There was no salon at which he exhibited, no private show-ing of his work, which did not infuriate the caricaturists. Their fury expressed itself, so far as their drawings are still intelligible, in the fol-lowing charges.

(1) Courbet was insincere and painted his pictures to shock people.

This charge appeared in the first drawing in Léger's book, a carica-ture by Cham. It shows Courbet standing in an attitude of distress at the Salon behind a placid bourgeois who is looking at one of his pictures. Courbet is saying, "There is a bourgeois stopped before my picture. He is not having a nervous attack. My show is a failure." [2] This caricature appeared before 1851. Fourteen years later Cham repeated the same accusation,[3] one of the easiest to make since it appeals to the sense of our own superiority, in a caricature which combined both Courbet and Manet. In this one, however, he indicated that the public had repaid the realists' mockery of them with mockery of their own. That the public ridiculed the realists was incontestable; that they were ridiculing the public was an assumption.

The insincerity of Courbet was joined to a number of criticisms against his personality. He was conceited, rude, exhibitionistic, and the victim of a persecution-complex.[4] If pictures were nothing but the locus of so-called aesthetic values, what caricaturist would even dream of ridiculing an artist's personality? One might legitimately ask whether modesty and politeness make for greatness in art, and such a question would be indubitably answered in the negative. But the question would, though legitimate, be vain. For the caricaturist wished to project into Courbet's canvases the supposedly unpleasant character of their author. If one could see a conceited, rude, exhibitionistic paranoiac in a land-scape with figures, one would turn away from it in disgust and, presum-ably, turn to other canvases—which habit had made savory—with sharp-ened appetite.

(2) The second accusation against Courbet dealt with his artistic skill. If one could show that this low fellow was also a clumsy and in-competent craftsman, one had succeeded in dealing a severer blow to his reputation. Maxime du Camp, whose friendship and support of Flau-bert showed that he was not temperamentally opposed to artistic novel-ties, maintained that Courbet was incapable of study, composition, and interpretation. "He paints pictures," said du Camp, "as you black your boots." [5] His anatomy, both human and animal, was incorrect; he had neither style, nor color, nor form; his figures were wooden; in short any

[2] Léger, *op. cit.*, p. 12. Cf. pp. 44, 45.
[3] *Ibid.*, p. 58.
[4] See Léger, *ibid.*, pp. 30, 32, 35, 38, 40, among others.
[5] Léger, *ibid.*, p. 37.

child could do as well.[6] Curiously enough, the infantilism of his work seemed particularly noticeable to his critics and his pictures were parodied as childish scrawls as late as 1869. That his work might have seemed revolutionary in subject matter and color would not astonish anyone knowing the history of art, but that the drawing should seem clumsy and childish must, I imagine, strike a benevolent modern reader as almost inexplicable. Yet the *Retour du Marché* [fig. 5], *Les Demoiselles de Village* [fig. 12], and *La Sieste pendant la Saison des Foins* [fig. 19], were all parodied as childish artistry.[7] This is especially interesting for it illustrates the fact that the opponents of realism could oppose it on the ground that it was not realistic enough. This was, in fact, the accusation of the Goncourts, who maintained that even Courbet's *Femme au Perroquet* [fig. 17], was "aussi loin du vrai, du nu, que n'importe quelle académie du XVIII^e siècle." [8] But the subject of what the Anti-realists meant by "realism" can be found more adequately treated in Dr. Cherniss's paper and I shall not enlarge upon it here. The charge, however, that one's opponent is not sufficiently in opposition is always interesting psychologically, for it indicates that one is more occupied in fighting than in the end one is fighting for. Perhaps the German romanticists were right in saying that it is more important to be on one's way than to reach one's goal.

(3) When one passes to the subject matter of Courbet's paintings, one finds that the caricaturists were united in finding it deliberately ugly, coarse, and vulgar. The *Enterrement d'Ornans* [fig. 6] whose Hellenic simplicity reduced Mary Cassatt to tears,[9] was termed an "ignoble and impious caricature" by Chennevières, who was to become the director of the Beaux-Arts.[10] The *Baigneuses* [fig. 13] according to David's pupil, Delécluze, were such that "not even a crocodile would want one to eat." [11] The empress, herself, wondered whether they weren't also *percheronnes*, like the models of Rosa Bonheur.[12] Daumier shows us two art lovers, of typical Daumieresque physiognomy, maintaining that no one in nature

[6] Léger, *ibid.*, pp. 37, 52, 80, 74.

[7] Léger, *ibid.*, pp. 13, 19, 85.

[8] *Journal des Goncourt*, 18 September 1867. Cf. G. Randon's caricature of *La Fileuse* with the legend, "Vous, si scrupuleux esclave de la vérité, vous avez donné à votre fileuse des mains de duchesse"; Léger, *ibid.*, p. 69. The Goncourt's objections to the *Femme au Perroquet* are the more interesting in that it was one of the very few pictures of Courbet which met with general approval. See Léger, *ibid.*, p. 61; Th. Duret, *Courbet*, Paris, 1918, p. 75. The subject itself seems to have appealed to several French painters; at least both Delacroix and Manet did a *Femme au Perroquet*.

[9] See Th. Duret, *Courbet*, p. 32.

[10] Léger, *op. cit.*, p. 15.

[11] *Ibid.*, p. 21.

[12] *Ibid.*, p. 23.

could be so ugly as Courbet's figures.[13] Not only were they ugly; they were also revoltingly dirty.[14] Or they were deformed and monstrous.[15] Perhaps the most violent comment of this type emanated from the author of *La Dame aux Camélias*: "Sous quelle cloche, à l'aide de quel fumier, par suite de quelle mixture de vin, de bière, de mucus corrosif et d'oedème flatulent, a pu pousser cette courge sonore et poilue?" [16] The *courge* was Courbet himself.

Now, I believe that however much one may be restrained by scientific caution, one may justifiably assert such comments to be animated by more than aesthetic dislike. There are several motives which might conceivably stimulate such outbursts. Those of us who are old enough to remember the famous Armory Show will recall that such old masters as Matisse and Picasso were charged with insincerity and a desire to shock the academicians, with having the shrewdness to capitalize their artistic incompetence, and even with insanity. It is not easy now to explain such violence and it may have been that the very strangeness of what came to be called Post-Impressionism was enough to account for it. In the case of Courbet it is hard for us to recapture that feeling of strangeness, for obviously we do not see him against a background of Delaroche, Horace Vernet, and Couture.

But even that shock would have been attenuated if the subject matter of his pictures had been different. *La Femme au Perroquet*, though it displeased the Goncourts, nevertheless was generally admired. The figure was nude; the surroundings were elegant; the model met the contemporary standards of appetizing womanhood. But the subjects of Courbet's other figure pieces were drawn from a social stratum which the Second Empire preferred to forget, though it owed its existence to that stratum's suffrage. Stonecrushers, peasants, beggars, washerwomen, had all been portrayed before, but in the art of nineteenth-century France they had been portrayed with a difference. Léopold Robert had sold a picture of the reapers of the Pontine Marshes to Louis Philippe and to the best of my knowledge no one accused him of artistic incompetence, dirtiness, or insincerity. But Robert's peasants and fishermen with a change of costume could have been taken for gods and goddesses. They were, as the nineteenth century liked to say, "idealized." It was Courbet's refusal to idealize which made his peasants and laborers so revolting.

As early as 1851 the *Stone Crushers* [fig. 4] was seen to be a social and not simply an aesthetic document.[17] This was undoubtedly due to

13 *Ibid.*, p. 27.
14 *Ibid.*, pp. 24, 31.
15 *Ibid.*, p. 46.
16 *Ibid.*, p. 115.
17*Ibid.*, p. 18.

Proudhon's praise of its author, which we shall discuss below. Courbet, himself, we are told,[18] when he painted this picture, saw in his subject matter only an expression of poverty which moved him deeply. "In painting what I saw," he said, "I raised what *they* call the social question." He seemed to think that he could see things as they were, as objective fact, emotionally neutral. What he did not understand was the impossibility of seeing things except through his own eyes and those were the eyes of the passionate and somewhat vulgar humanitarian from Ornans.

(4) The fourth general charge which the caricaturists made against Courbet was his socialism, a charge which he certainly deserved after he came under the influence of Proudhon. From 1851 on—in fact during almost the whole of his professional career—his pictures became symbols of a philosophy which the Government detested and which the Press therefore found it easy to ridicule. For in those days socialism was the dream of Utopians, not a program which would ever have any chance of being carried out, and the proper way to handle it was to make fun of it. By laughter the dominant class saved itself the trouble of thinking.

When we look upon these pictures, it is difficult for us to see them as socialist propaganda. When we compare them to the works of the official artists we are, to be sure, struck with the difference in subject matter, but their difference is not what distinguishes capitalism from socialism. It is, as Daumier saw,[19] actuality as contrasted with exoticism, in the first place. The Idealists, as the official artists were sometimes called, chose their themes from antiquity, the Middle Ages, or the Orient. Courbet, as we know, chose his from contemporary life. But even that was not the radical distinction between his work and theirs. They were idealists not merely in the sense that they "idealized" their subject matter, but also in the sense that their paintings were expected to illustrate some idea. One of the best examples of this is Couture's *Day Dreams* belonging to the Walters Gallery. The casual eye sees this as a simple picture of a boy who has been blowing bubbles. But the whole story comes out only when one reads the edifying motto in the background. Hence when Courbet said, "Un peintre ne doit peindre que ce que ses yeux peuvent voir," [20] he meant that a painter should not occupy himself with the invisible world of ideas. He was thus one of the first men to insist upon the autonomy of painting as painting, to reject the theory that it was an art of exposition or argumentation. It was his opinion, as Castagnary wrote in a manifesto, that "the beautiful is in nature and is found in the most diverse forms in reality. As soon as it is discovered

[18] Ch. Léger, *Courbet,* pp. 43 ff.
[19] Léger, *Courbet selon les Caricatures,* p. 31.
[20] Th. Duret, *Courbet,* p. 126.

there, it belongs to art, or rather to the artist who knows how to see it. As soon as the beautiful is made real and visible, it has its artistic expression in itself. But the artist has no right to amplify this expression. He can touch it only at the risk of changing its nature and consequently of weakening it. The beautiful given by nature is superior to all the conventions of the artist. . . . There is the essence of my ideas about art." [21] The amplification in question is precisely that which Couture and the official artists practised, amplification through the picturesque, the anecdotal, the allegorical. It was the absence of such amplification which made two American critics, Clara Erskine Clement and Laurence Hutton, say in 1879, "His pictures were repugnant to all artistic sentiment." [22]

In spite of Courbet's pretensions of unadorned realism, one of his most enthusiastic admirers, Proudhon, saw nothing but allegory or satire in any of his canvases. Since Proudhon's book, though perhaps well known in France, is not widely read in this country, it may be worthwhile to sketch briefly his general attitude towards painting.

He made a useful, in fact a necessary, distinction between the artistry of a painting and its subject matter, and resolutely disclaimed any intention of dealing with the former.[23] "Art" he defined as "an idealistic representation of nature and of ourselves, with a view to the physical and mental improvement of our species." [24] Each epoch had its own form of idealistic representation and a work of art which does not express the culture of its time is bad. Thus on one eloquent page he tells us of his youthful enthusiasm for David's *Leonidas at Thermopyle,* which later cooled down.

"There is no doubt that the fundamental idea of the picture, patriotic devotion, is excellent and [David's] undertaking was appropriate. But why choose the subject of Leonidas? Such a painting, surely very good as an illustration of the history of Herodotus, fit to edify a student of rhetoric who knows Greek, is none the less irrational, intrinsically false, and that from several points of view. To begin with it means nothing to the people invited to look upon it and who not only do not know Greek, have never read Herodotus, know nothing of the quarrels of the King of Persia with the Greeks, but moreover are absolutely incapable of understanding why these warriors are entirely naked, with the exception of their heads armed with helmets; why the painter has given them such beautiful bodies and beautiful faces that one would take them for angels stripped of their wings; why they all look alike. Greek history, Greek

21 See Victor Champier, in the *Grande Encyclopédie,* art. "Courbet."
22 In *Artists of the Nineteenth Century and their Works,* Boston, 1879, Vol. 1, p. 163.
23 *Du principe de l'art et de sa destination sociale,* 1865, p. 197.
24 *Ibid.,* p. 43.

appearance, Greek nudity, as is fitting for the athletes and gods of Greece, Greek inscription, everything Greek. This might be all very well for a hellenist, an archeologist; but what difference did it make to the Parisians of 1838? . . . As a matter of fact, I was always the only man looking at the *Leonidas*.

"Then letting myself pursue the course of my ideas further and further, I said to myself what a shame it was that the Greek artists, contemporaries of the Persian War, less busied with temples, processions, sacrifices, less devoted to their gods and more grateful to their fellow-citizens, had not left us on marble or canvas a representation of the defence of Thermopyle. I thought that such a picture would interest us to-day in a way quite different from that of David; that at least we should recapture in it the truth of the epoch, the country, the costumes, and the figures; that patriotic feeling would probably have lost nothing and art no more. . . . Shall one say . . . that it is neither Leonidas and his Spartans, nor the Greeks and Persians whom one should see in this great composition; that it is the enthusiasm of '92 which the painter had in view and Republican France saved from the Coalition? But why this allegory? What need to pass through Thermopyle and go backward twenty-three centuries to reach the heart of Frenchmen? Had we no heroes, no victories of our own? . . . All such painting, which pretends to be serious, is based upon conjecture with regard to its subject matter which contains nothing national in it and can interest only a specially educated public. It is illustration, good for books planned as college prizes. And, generalizing all these remarks, we must conclude that every historical picture which represents an act which the artist has not witnessed, which took place when he was not even alive, and which the mass of the people know nothing about, is sheer fancy and, from the point of view of art's high mission, nonsense." [25]

If the David of *Leonidas at Thermopyle* was to be rejected, the David of *Marat Dying* was to be saved. For here was a picture expressive of its age which the public and the artists should have seen as a guide post showing the right road for modern art to follow.[26]

Such pre-occupation with subject matter is not typical of Proudhon, it was characteristic of most of the critics of the past. Proudhon, however, is peculiar in his insisting upon a contemporary subject matter which will have, as we should say to-day, "social significance." His views were shared in this country by no less a popular leader than Henry Ward Beecher [27] and were, after all, similar to, if not identical with, those of

[25] *Ibid.*, p. 108.
[26] *Ibid.*, p. 120.
[27] See an extraordinary speech which he made in Philadelphia on December 21, 1860, reprinted in the *N. Y. Times* of December 22, 1860, on p. 8.

Ruskin in certain of his moods. That an epoch could be expressed had no doubt occurred to many people; but it had been most accurately formulated by Hegel to whom epochs were moments in a history of more interest to God than Man. The history of the idea of epochs—which seems natural enough to us, though in itself a concept very difficult to make precise—from, let us say, Giambattista Vico to our own day, is something which would clarify the modern attitude to humanity and the drama of existence as no other study could. We cannot indulge in such an excursion here, but let us suggest at least that what we call the modern historical sense became acute when the least historical of ideas became a guiding force in our thinking.

What Proudhon demanded of art was, then, that it be the voice of an epoch and thus he bitterly castigated any artist, such as Delacroix, who spoke about his "personal impressions." "It is not by *your* ideas and *your* ideal that you must act upon my mind 'passing through my eyes'; it is by the help of the ideas and the ideal which are in *me*. And that is just the opposite of what you boast of doing. Consequently all your talent, of you the painter as well as of you the poet, is reduced first, even before touching your work, to penetrating into our souls, to discovering the ideal there; then to stimulating it, to stirring it by means of your artistic mirror, and finally to producing in us impressions, acts, and resolutions which lead, not to your glory and your fortune, but to the profit of general happiness and the perfecting of the species." [28] This was, of course, the very opposite of what many nineteenth-century artists were practicing: the cult of the individual, which finally has reached the point at which the artist challenges the observer to understand him instead of inviting him to. Artists, he says, are the regiment's drummers; they must paint for us, not for themselves. It was for that reason that he condemned the neoclassic David, the romantic Léopold Robert, the individualistic Delacroix, the militaristic Horace Vernet. It was also for that reason that he admired Courbet.

What he found in Courbet's paintings was, of course, his own philosophy. Thus the *Retour de la Foire* [fig. 5] showed rural France with its *humeur indécise* and its *esprit positif*, "happy under a temperate authority, in that happy medium so dear to simple folk and which, alas, constantly betrays them." [29] *La Baigneuse* [fig. 13] became for him a satire on the bourgeoisie. "Yes, there she is, that fleshy and substantial Bourgeoisie, deformed by grease and rich living; in whom flabby weight stifles all ideals, predestined to die of weakness of the will, if not of melting fat. There she is, such as her stupidity, her selfishness, her cook-

[28] *Ibid.*, p. 122.
[29] *Ibid.*, p. 287.

ing have made her." Of the *Demoiselles de la Seine* he says, "These two women live in comfort . . . they are true artists. But Pride, Adultery, Divorce, and Suicide, replacing Cupids, swarm about them as their companions; they bring them in their dowry. That is why they finally appear horrible. *Les Casseurs de Pierres* [fig. 4], on the contrary, cry vengeance by their rags on art and society. Basically they are harmless and their souls are sound." "Courbet," he concludes,[30] "a painter who is critical, analytic, synthetic, humanitarian, is an expression of his time. His work coincides with Auguste Comte's *Philosophie positive,* Vacherot's *Métaphysique positive,* my *Droit humain,* or *Justice immanente;* with the right to work and the right of the worker, announcing the end of capitalism and the sovereignty of the producers; the phrenology of Gall and Spurzheim; the physiognomy of Lavater, etc., etc."

These quotations will suffice to show why the friends and admirers of the Second Empire could not be friends and admirers of Courbet. But at the same time as Proudhon found in the painter of Ornans the voice of an epoch and the spokesman for socialism, another critic, Zola, found in him just the opposite and praised him with equal vigor. For Zola a work of art was not the "idealistic representation of nature and ourselves," but "a corner of creation seen through a temperament." [31] Whereas Proudhon wished a work of art to be the product of society, Zola wished it to be the product of an individual. He found therefore in Courbet what Proudhon, it will be recalled, disliked in Delacroix. He describes thus his first visit to Courbet's studio.

"I was astonished and I did not find the slightest cause for laughter in these strong serious canvases which people had spoken of as monsters. I expected to see caricatures, wild and grotesque fancy, and I stood before painting which was compact, broad, with perfect finish and sincerity. The types were true without being vulgar; the flesh, firm and supple, had living power; the backgrounds were full of air and gave an astonishing vigor to the figures. The color, in a rather low key, has an almost gentle harmony, while the accuracy of values and the breadth of workmanship establish the relative planes and give to each detail a strange relief. As I close my eyes, I see these powerful canvases again, a single mass, built strongly and solidly, as real as life and as beautiful as truth. Courbet is the sole painter of our age; he belongs to the family of flesh-makers; he has for brothers, whether he wish it or not, Veronese, Rembrandt, Titian." [32]

[30] *Ibid.*

[31] *Mes Haines,* art., "Proudhon et Courbet," p. 24. I use the edition of the *Oeuvres Complètes* by Bernouard.

[32] *Mes Haines,* p. 30.

That the truth was beautiful, was a standard for beauty, could only be maintained in an age in which science was beginning to get the upper hand. The phrase, "as beautiful as truth," is the most telling conjunction of words in this whole paragraph. But aside from certain technical observations, the rest is pure impressionism. What Zola wanted from a picture was the impression of a strong personality and he found it in Courbet. He cared nothing for the artist's supposed social message. As he said himself, addressing his words to Proudhon, "Our ideal is our love and our emotions, our tears and our laughter. We no more want you than you want us. Your community and your equality disgust us. We produce a style and an art with our bodies and souls; we are lovers of life, we give daily a portion of our being. We are in no one's service, and we refuse to enter into yours. We depend only on ourselves; we give obedience to our nature alone. We are good or bad and give you the right to listen to us or to stop your ears. You outlaw us, you say, us and our works. Try, and you will feel so large a void within you that you will weep from shame and misery." [33]

But perhaps the most eloquent statement of what Zola sought in looking at a picture is to be found in his essay on Manet. There he makes it clear that the object of his highest praise is the work of art which reveals a man, a personality, whether the personality be powerful or gentle. In his own words, "I shall defend throughout my life every sincere individuality who will be attacked. I shall also be on the side of the vanquished. There is an obvious war between untameable temperaments and the crowd. I am for the temperaments and against the crowd." [34] And if you were to ask why he admired self-expression so strongly, his answer would be that of Courbet, "Open your eyes, here is Nature. Open your hearts, there is life." [35]

We could continue this inventory of opinions *pro* and *con,* but enough has been said to prove what needed proof, namely, that just as there are a variety of reasons for disliking and disapproving of a painting, so there are a variety of reasons for liking and approving of one. And just as the former can be, and often are, contradictory, so are the latter. Yet if the professors of aesthetics are right, there must be one proper aesthetic object which alone should command our respect and awaken our sense of beauty. But if the words, "the aesthetic object," be equivalent to the words, "that which has stimulated the admiration or disgust of observers," one must conclude that every work of art is multi-

[33] *Ibid.,* p. 24.
[34] *Mon Salon,* in *Mes Haines,* p. 240.
[35] *Ibid.*

valent and that the value selected by critics for praise or blame will vary not only from age to age but from individual to individual. One may of course retort that this is true on the plane of history, but that aesthetic values inhabit a world of eternal and immutable ideas. If that be so, there remains the question of why the eternal is of so brief duration, a question which it would be wiser to leave to metaphysicians.

COURBET AS A PORTRAIT PAINTER

Pierre Courthion

Courbet always had a particular consideration for portrait painting: Almost without exception, he painted heads that meant something to him. His portraits reflect friendship and admiration. The painter was able to avoid the restriction of the commissioned portrait and had the courage to choose his own models. His portraits of men are reveries in black— a grave procession of poets, musicians, and thinkers. All those who passed through his life were captured inside a frame, alive under his solid impasto.

Max Buchon, the poet of Salins, with his disconsolate air à la Nerval, represents his youth, the college of Besançon, the exchange of the first ideas about life. The portrait calls to mind those naive lithographs made by Courbet to illustrate the *Essais poétiques* of Buchon, published in Besançon in 1839, illustrations in which a Crusoe-like feeling of adventure and romantic tenderness are blended in an ingenuous manner (negroes, lovers dreaming in front of the window, a lake surrounded by mountains, an enormous tree in the forest—Courbet is already completely there). Courbet instilled in these pages the sentiment of independence that abounded within him. . . .

His portrait of Berlioz is striking. That delicate, tormented face that looks as if a sculptor made his thumb wander over it; those eyes buried in their sockets, that thin mouth, bitterly expressive, that chin revealing a sickly sensibility; the angular nose, the sad brow—what disenchantment is expressed by that face! A great love for beauty, purity preserved in spite of everything, but with that a certain weakness and

"Courbet as a Portrait Painter." From Pierre Courthion. *Courbet* (Paris: H. Floury, 1931), pp. 39–43. Translated by the editor. Reprinted by permission of Pierre Courthion.

impotence: large holes, cavities, and yet something which is captivating, moving.

Courbet had a second sense for certain hidden things, for certain subtle sentiments.

All this leads up to the portrait of Baudelaire [fig. 2]. Courbet has never been more profound, or shown a greater inner richness, than at that time [1848]. He had the gift to be able to create an intimate light, an atmosphere filled with poetry like dusk heavy with incense. He paints the Baudelaire persecuted by his creditors, who is continuously moving from one "disreputable and obscure" furnished room to another; the Baudelaire of the palavers, the pub loafer, the opium smoker, who, when he had no wood to make a fire or no decent shirt, would go to bed for three days; the Baudelaire who fought with the rebels on the Carrefour de Buci, dreaming of "shooting General Aupick"; the Baudelaire who, together with Champfleury—through whom he probably knew Courbet—founded the "Salut Public."

Courbet represents him smoking his pipe, bent over a book, the left hand leaning on a sofa. On the table is a quill in an inkstand, next to a heavy book. The smoky atmosphere makes for a sober background with very subtle nuances. Through a dormer window the light falls on his forehead, runs over the silk scarf, and highlights the hand of the poet: It is not much but it is enough to give an astonishing relief to that physiognomy. The face is modeled with a fluent impasto, one might say by means of flecks, in order to indicate what is unique in this process that Manet would adopt later on. It is a type of painting that does not make a statement and that consequently is full of memories, tenderness, and emotion. Courbet never after made a man's portrait as complete as that. It is in that way that we think today of Baudelaire, the esthete of modernity, as grand, more grand perhaps in his reflections on art and in his essays than in his violent poems.

Baudelaire admired Delacroix, who did not understand him; he would later on break with Courbet, who had a presentiment of his genius, and it was Courbet who lost out. Easily influenced as he was, the poet could have refined his taste and curbed his political aspirations. Courbet lost out because no other friend could replace Baudelaire. It is likely that during the execution of his portrait, the poet gave suggestions to the painter. That plain background, that garret wall, moving in its grey bareness: It may well be that it was Baudelaire who suggested that Courbet paint him in that manner—without accessories, without unnecessary fancies. . . . In the *Studio* [fig. 15] we find a replica of this portrait that is harsher and more prominent; the Baudelaire in the studio has the value of a voice, an accompaniment.

The fine head of Bruyas, his admirer from Montpellier, and the

portrait of Emile Ollivier are solid works, of a convincing materiality. The portrait of Proudhon, made after a photograph, is harsh and of a dry precision; two years before he painted this portrait (which is dated 1865, the year of Proudhon's death), Courbet collaborated with the philosopher. As the painter wrote to his father:

> We are together writing an important work that connects my art to his philosophy and his work to mine; it is a brochure that will be sold at my exhibition in England. . . . Two men have synthesized society, one in philosophy, the other in art, and both are of the same country.

Courbet sincerely believed that he was an apostle of progress. He had adopted his friend Bisontin's definition as his own: "Art is an ideal representation of nature or of ourselves, with a view to the physical or moral perfection of our species." That was his gospel, but one has to admit that the "Realist" portraits of Courbet—just as, for that matter, almost all his extremely naturalistic paintings—are not the ones that move us. At some point the painter has failed to recognize his possibilities in the psychical domain; the portrait of Baudelaire proves how much Courbet could have gained in emotional depth had he been better advised, better guided. Carried away by his social theories, he never sacrificed his "métier," his ability to represent the exterior world in a forceful manner; but all too often he made an effort to repress a poetry that was within him, in a latent state, and that was sometimes successfully choked by the mentality of a man inclined to admire himself and to consider himself destined to play a role in the battle of the classes. . . .

Courbet's Nudes
Kenneth Clark

Like all revolutionary realists, from Caravaggio onward, Courbet was far more tied to tradition than he admitted, or than his critics, deafened by the cataract of his talk, could recognize. His nudes are often little

"Courbet's Nudes." From Kenneth Clark, *The Nude. A Study in Ideal Form* (New York: Pantheon Books, for Bollingen Foundation, 1956), pp. 162–164. Reprinted by permission of the Trustees of the National Gallery of Art, Washington, D.C.

more than life studies, and when he tried to give them the additional luster of art, as in the *Femme au perroquet* [fig. 17], the result is as artificial in conception as the vulgarest Salon favorite. The obvious way in which he asserted his realism was by indulging his preference for heavily built models. One of these, the *Baigneuse* of 1853 [fig. 13], was intended to provoke and succeeded imperially, for Napoleon III struck at her with his riding crop. She is, in fact, the only one of his nudes whose proportions are far outside the contemporary canons of comeliness, as we know them from the still life studies of other artists and from early photographs; and even she is in a pose that reeks of the art school. How natural, compared to her, is the *Baigneuse* of Ingres! When all this is conceded, however, Coubert remains a heroic figure in the history of the nude. His doctrine of realism, poor stuff when put into words but magnificent when expressed in paint, was the overflow of a colossal appetite for the substantial. In so far as the popular test of reality is that which you can touch, Courbet is the archrealist whose own impulse to grasp, to thump, to squeeze, or to eat was so strong that it communicates itself in every stroke of his palette knife. His eye embraced the female body with the same enthusiasm that it stroked a deer, grasped an apple, or slapped the side of an enormous trout. Such thoroughgoing sensuality has about it a kind of animal grandeur, and there are paintings in which Courbet achieves comfortably and with hardly a trace of defiance that conquest of shame which D. H. Lawrence attempted in prose. A solid weight of flesh does in fact seem more real and enduring than elegance, and the woman who stands beside him . . . at the center of his realized dream, that vast canvas known as *L'Atelier du peintre* [fig. 15], although she has the patient carnality of the life class, is, after all, more representative of humanity than the *Diana* of Boucher. . . .

To justify the epithet heroic, which I have just applied to him, one must look for those representations of the subject which during Courbet's lifetime and for another forty years won official favor in the Salon. They are not easily found, for the paintings of Ary Scheffer, Cabanel, Bouguereau, and Henner are no longer exhibited in public galleries, and must be sought in provincial *mairies* or the saloons of Midwestern hotels. Each of these artists had his own recipe for success, ranging from the lubricity of Bouguereau to the high-minded sexlessness of Lord Leighton; but all had one characteristic in common: they glossed over the facts. They employed the same convention of smoothed-out form and waxen surface; and they represented the body as existing solely in twilit groves or marble swimming baths. . . .

Courbet As a Landscapist
Bernard Dorival

Courbet, like Millet, did not make landscape his sole preoccupation. Like Millet he uses it as a background (as in the *Enterrement à Ornans* [fig. 6] and the famous *Bonjour, M. Courbet* [fig. 14]) and also as the chief subject of a picture. His pure landscapes are more varied than Millet's; he did not shut himself up as Millet did at Barbizon, but wandered far afield, driven by his own whim or the forces of political history. Though he is most a landscape painter in his native Jura, among pine woods and shadowed springs and desolate escarpments, he painted with no less success the rocks of the Ardennes, Languedoc and the banks of the lake of Geneva on which he ended his life in exile. He is, too, one of France's best sea-painters; no one has better understood waves and breakers than this man from the inland mountains. He saw them, indeed, as mountains: mountains of green granite, black basalt and sapphire. Everything he portrays becomes more compact, more solid, more dense, more powerful than it is in reality. His stones fear neither wind, nor rain, nor frost; his streams are adamant, his leafage, emerald. His massive world knows no movement; even his waves and his waterfalls never break. Courbet is the painter of the everlasting; and he paints it magnificently in a thick impasto, which adds to the impression of solidity and grandeur.

Courbet, indeed, often shows himself indifferent to the changing play of light and weather. He rendered the dry transparent air of Southern France in *Bonjour, M. Courbet* and excellent in painting the damp atmosphere of the coombes of the Jura and the muffled air of woods under snow. Yet the ephemeral, the unstable, the impalpable are not really in his range. Thus, though the Impressionists may be indebted to him, especially in courageously setting down what they see without recomposing it for decorative effect, and in banishing the human figure from their *tranches de nature,* they are less indebted to Courbet (or to Millet) than to Neo-Classical academism as interpreted by Corot. . . .

"Courbet as a Landscapist." From Bernard Dorival, Introduction to Catalogue Exhibition, *Landscape Painting in French Art, 1550–1900* (London: Arts Council of Great Britain, 1949), pp. xxii–xxiii. Reprinted by permission of Bernard Dorival.

Courbet's Still Lifes
Charles Sterling

Undertones of Romanticism were only to be expected in Corot. But a careful scrutiny of the still lifes of Courbet, who passes for an imperturbable realist, reveals that few of them elude the sentimental impress of Romanticism. Courbet painted two kinds of still lifes; they reflect the indecision of his art, which oscillated between objective realism and realism. Some of his flower pictures, powerfully built up in bright colors that flash out in cold light, are simply virile descriptions of the abundant vitality of plant life. Most of the others—nearly all painted in 1871 in the prison of Sainte-Pélagie—show the same enthusiastic insight into the pulsing life of nature; but they rely heavily on dusky effects of twilight, showy contrasts of red and yellow, combinations of smooth volumes and rugged impasto, and all the resourcefulness of a particularly admirable interpreter of sensual sentimentality. . . . Despite the firmness of his chiaroscuro, Courget's rhetoric is much nearer to that of the Neapolitans than to Caravaggio's noble austerity. In prison his only models were fruit, flowers and fish. . . . In working out his compositions he had no alternative but to fall back on his imagination and memory. The latter, we discover, was steeped in reminiscences of 17th-century Baroque painting. The addition of a landscape background to a still life (as in Delacroix's *Trophies of Hunting and Fishing*) or of a woman's figure to a flower piece (as in Courbet's magnificent *Treille*) recalls the stock devices of the Neapolitan School. Such pictures as these go to confirm the impression that Courbet was the last of the great independent painters to follow the masters of the past, this in spite of Manet's more obvious borrowings from Velazquez, Goya and Frans Hals. The reason is that Courbet restored the authentic atmosphere of Baroque art; Manet did no more than avail himself of procedures which helped him to break free of tradiitonal ways of seeing. Courbet's finest pictures, moreover, are those in which he draws freely on his imagination—but

"Courbet's Still Lifes." From Charles Sterling, *Still Life Painting from Antiquity to the Present Time* (Paris: Editions Pierre Tisné/New York: Universe Books, 1959), p. 95. Reprinted by permission of Charles Sterling.

he seldom does so. When he does, however, as in the *Trout* (fig. 21) an imaginative reinterpretation made in 1873 of a smaller picture on the same theme painted in prison two years before, he attains an almost visionary grandeur of expression. This formidable creature, with its flinty scales, is like a remnant of prehistoric times, lying at the bottom of virgin waters. . . .

AN INTRODUCTION
TO THE *STONEBREAKERS*
AND THE *FUNERAL AT ORNANS*

Max Buchon

In the meantime, notice how one of our friends, Mr. Gustave Courbet, makes an artistic tour with the paintings that he plans to give the honor of the next Salon. I hope that the art-lovers of Dijon will give our dear pilgrim the reception that he deserves, not only because of the vigorous simplicity of his talent, but also because of his new way of going to Paris, invented by him with the sole aim of being agreeable to them.

Already last year Mr. Courbet achieved, at the Salon of painting, one of the first successes of the year with his *Afterdinner at Ornans* [fig. 3], which was praised so explicitly in the *Presse* and the *National,* and which was recently given by the government to the city of Lille— a natural place, indeed, for a painting that has a much-noted Flemish flavor.

The picture gallery started by Mr. Courbet last year will most certainly continue this year with the two canvases to be discussed below.

The painting of the *Stonebreakers* [fig. 4] represents two life-size figures, a child and an old man, the alpha and the omega, the sunrise and the sunset of that life of drudgery. A poor young lad, between twelve and fifteen years old, his head shaven, scurvy, and stupid in the way misery too often shapes the heads of the children of the poor; a lad of fifteen years old lifts with great effort an enormous basket of stones,

"An Introduction to the *Stonebreakers* and the *Funeral at Ornans.*" Unabridged translation of Max Buchon, "Annonce," *Le Peuple, Journal de la Révolution Sociale* 18 (June 7, 1850). Buchon's "Annonce" was written as an advertisement for the exhibition of the *Stonebreakers* and the *Funeral at Ornans* in Dijon in July 1850. The text was a revised version of an article that Buchon had published earlier in *Le Démocrate Franc-Comtois* of April 25, 1850 to publicize the exhibition of the same works in Besançon. Translated by the editor.

For a modern interpretation of this article, see the essay by T. J. Clark on pp. 88–107.

ready to be measured or to be interspersed in the road. A ragged shirt; pants held in place by a breech made of a rope, patched on the knees, torn at the bottom, and tattered all over; lamentable, down-at-heel shoes, turned red by too much wear, like the shoes of that poor worker you know: That sums up the child.

To the right is the poor stonebreaker in old sabots fixed up with leather, with an old straw hat, worn by the weather, the rain, the sun, and the dirt. His shaking knees are resting on a straw mat, and he is lifting a stonebreaker's hammer with all the automatic precision that comes with long practice, but at the same time with all the weakened force that comes with old age. In spite of so much misery, his face has remained calm, sympathetic, and resigned. Does not he, the poor old man, have, in his waistcoat pocket, his old tobacco box of horn bound with copper, out of which he offers, at will, a friendship pinch to those who come and go and whose paths cross on his domain, the road?

The soup pot is nearby, with the spoon, the basket, and the crust of black bread.

And that man is always there, lifting his obedient hammer, always, from New Year's Day to St. Sylvester's; always he is paving the road for mankind passing by, so as to earn enough to stay alive. Yet this man, who in no way is the product of the artist's imagination, this man of flesh and bones who is really living in Ornans, just as you see him there, this man, with his years, with his hard labor, with his misery, with his softened features of old age, this man is not yet the last word in human distress. Just think what would happen if he would take it into his head to side with the Reds: He could be resented, accused, exiled, and dismissed. Ask the prefect.

From this scene, which, in spite of its fascination, is merely imperturbably sincere and faithful [to reality], from this scene, in front of which one feels so far removed from whimpering tendencies and from all melodramatic tricks, let us turn to Mr. Courbet's principal work of this year, *A Funeral at Ornans* [fig. 6].

Twenty-odd feet wide and twelve feet high, with fifty-two life-size figures . . . such a crowd, so much material, so much work!

For those who, like us, have the honor of knowing those good people of Ornans to some extent, it is at first an encounter with a rather naïve effect to see that painting in which are grouped, in several rows, all those persons whom you have just greeted on the road and who are assembled there by the master's brush in such a natural, intelligent, and simple manner. The priest, the mayor, the deputy—nobody is missing. They are there, as I said, fifty altogether—all with their individual characters, their traditional outfits, and their own personal worries.

And yet, when, after a glance at that large composition in its

entirety, the eye is drawn to the gravedigger who sits there on his knees on the edge of the grave into which he is to let down the corpse, some indefinable austere thought is suddenly aroused by that yawning hole. It is a thought that seems to suddenly illuminate these faces as by lightning, and that makes the painting into a veritable synthesis of human life, especially because of the wide landscape background, that somber and grey sky, and the atmosphere of contemplation that envelops everything.

Formerly, in the old dances of death, Death in person forced kings, popes, emperors—all the great of the world and all the oppressors of the poor—to dance around, whether they liked it or not.

It seems to us that Mr. Courbet, with his gravedigger, has obtained an equally powerful and significant effect, and has done so without departing from that absolute realism which, from now on, is indispensable in painting as well as in politics; a realism appreciated in advance by the good women of Ornans, in the same way as the *Presse* and the *National* will be able to appreciate it at the forthcoming exhibition.

In fact, that man, that gravedigger, shows no meanness in his robust posture. He is even the only one in that immense reunion who kneels, and yet, look! he alone carries his head high, he alone commands.

Tomorrow that man, who is in his prime, will return quietly to his vinegrower's cottage which he left yesterday; today only he feels as if he is the last link with earthly matters, the gatekeeper of the hereafter.

And yet, must it be said? through the vague oppression caused by his contemplation, one returns unconsciously—no doubt through the idea of compensation—to our poor stonebreaker. In the mind of the painter he might well be nothing but the psychological antithesis, the counterpoise—I would almost say the revenger.

In fine, before going to Paris, two paintings will be exhibited in the coming days in Dijon, as they have been in Besançon. I hope that the artists, the loafers, and, above all, the ordinary folks will go to judge the paintings for themselves. Their colossal dimensions are unusual, no doubt, for these so-called genre paintings that are the specialty of Mr. Courbet. Yet who would dare to complain of the big size of the bottle, if the wine inside is of good quality?

Mr. Courbet paints as he feels, and does not imitate this master or that school, nor is he out for applause. The painting that he wants is neither Italian nor Flemish: It is the painting of Ornans, the painting à la Courbet.

From his free and frank demeanor, which he will justify more and more every year, it is easy to recognize the true son of the Franche-Comté, the veritable child of that rugged country, where those three

impetuous rebels of the philosophical and literary world were born: Fourier, Proudhon, and Victor Hugo. That method, though, appears to us the only true, the only rational, and the only acceptable one; therefore, we don't hesitate to wish him all sorts of appreciation.

IN DEFENSE
OF THE *FUNERAL AT ORNANS*

Champfleury

I heard the comments of the crowd in front of the painting of the *Funeral at Ornans* [fig. 6]; I had the courage to read the nonsense that has been printed regarding this picture, and I wrote this article. Just as in politics, one sees strange alliances of opposed parties reunite to combat a common enemy, the most audacious among the well-known critics have entered the ranks of fools and have fired against reality.

Mr. Courbet has wanted to represent a small-town funeral as it occurs in the region of the Franche-Comté and he has painted fifty people, life-size, going to the cemetery. That is the painting.

Some find it too big and they refer the painter to the scribblers' school of Mr. Meissonnier.

Others complain that the bourgeois of Ornans lack elegance and resemble the caricatures of Daumier.

Some chilled Romantics protest against the ugly as simple ignoramuses.

The lovers of faded ribbons and rancid make-up, who sing about the exploits of eighteenth-century girls, tremble when they see black suits, and exclaim: "The world is lost, there are no more pompons, no beauty spots, no pink silk ribbons."

One likes to think of Courbet as a savage who studied painting while watching the cows.

Some are certain that the painter is a leader of a socialist ring.

"In Defense of the *Funeral at Ornans*." From Champfleury [Jules Husson], "L'Enterrement d'Ornans." This article appeared first in the *Messager de l'Assemblée* of February 25–26, 1851. It was reprinted with slight changes in Champfleury's collection of essays, *Grandes Figures d'hier et d'aujourd'hui* (Paris: Poulet-Malassis et de Broise, 1861), pp. 231–244. The later text is followed here. Translated by the editor. Footnotes by the editor; the two original footnotes by the author have been deleted.

Finally, the opinion of the good-for-nothings can be epitomized in this well-known sentence which flourished during the Empire:

> All one sees in these paintings is of such bad taste that one recognizes nature only in its degradation. The men are ugly and badly done, their suits are gross, their houses shabby. One finds in them nothing but a base truth.[1]

The academician who talked this way in 1810 meant to designate Teniers, Ostade, and Brawer [sic]. The critics of 1850 have not changed the arguments of the academician in any way.

Good grief!

A painting does not cause so much noise if it does not have serious qualities. As it happens, more often the critic who denies is more valuable than the critic who affirms. The *contra* is more useful than the *pro*. It is through similar unintentional means that one makes a work a success. "I love my enemies more than my friends," are the words of a great man who knew how detractors are dying to talk, and he was right. *The country is in danger!* exclaims the *Constitutionnel*,[2] with reference to the painting of Mr. Courbet. Immediately all the curious people of Paris run to the danger, which consists of the *Funeral at Ornans;* they come back from the Salon and tell about the scandal to all who want to hear about it. "The Barbarians have entered the exhibition." They cry out that Mr. Courbet is the son of the democratic Republic of 1848; they want to hang a crepe over the Apollo Belvedere; they propose to close the room of the classical antiquities. If one listened to them, the members of the Institute would have to sit down on their chairs, as the senators did once on their curule chairs, and die proudly, beaten by the muddy sabots of the savage realists.

The inhabitants of Ornans tremble when they read in the newspapers that they may later be suspected of complicity with the monster, since they have lent, for a moment, their bodies and their clothes to his brushes. I understand the terror of Mr. Proudhon, cousin of the revolutionary economist, substitute justice of the peace, who did not see any crime in entering the studio of the painter, with his mourning clothes well brushed, in black frock coat and patent leather shoes, his hat in his hand. Marlet junior, the deputy mayor, who has studied law in Paris, tries in vain to calm him down.

[1] I have been unable to find the author of this quote, but it is very characteristic of the period in which it was written. For similar opinions about the Dutch and Flemish masters, see H. van der Tuin, *Les vieux peintres des Pays-Bas et la critique en France de la première moitié du XIXe siecle* (Paris: Librairie Nizet, 1953), *passim*.

[2] Reference to an article of Louis Peisse in the *Constitutionnel* of January 8, 1851.

Tête, the mayor of Ornans, a big, cheerful man, goes to the café to listen to what his subordinates say. Father Cardet, who was at the funeral in a brown suit with short pants and blue stockings, runs around to find his colleague Secrètan, who lives in the Rue de la Peteuse, and these two honest vinegrowers, who have lost interest in the affairs of this world, and who do not read the papers, are amazed that people make so much noise about the cocked hat of one and the grey suit of the other. Unfortunately, the son of vinegrower Sage is presently in Africa, else he would warmly defend his painter friend. Max Buchon, the poet, is not present either, but he will support Courbet in the newspaper of Salins. Why did Jean-Antoine Oudot, the grandfather of the painter, pass away? He was a man who would have made everybody listen to reason.

The only one left in the village is Alphonse Bon, who meets Célestine Garmont, the crippled wife of hunchback Alexandre. She says: "In the market place they talk about nothing else but the painting of the son of vinegrower Courbet. . . . He has not flattered us, it seems; people say that he has made caricatures out of us; but wait until he comes back! The son of mother Beurey will get even with him. . . . One does not make fun of people like that. He is a mischievous dog."

Indeed, what offends the city of Ornans is that the year before they had received the artist in state, complete with music. Promayet, the director of the band of the Garde Nationale, had arranged that surprise for the Parisian; and how has the painter rewarded his compatriots for this triumphal reception? By amusing the whole of Paris at the cost of the verger of Ornans, of vinegrower Jean-Baptiste Muselier, and of Pierre-Clément, the shoemaker.

The priest of the parish, M. Bonnet, is displeased that one should make fun of his vergers like that, because they belong a little bit to the Church, and one should never ridicule that which relates to the clergy. Why have the newspapers not mentioned Cauchi, the sexton, or vinegrower Colart, the crossbearer? Because they show nothing that is ridiculous, whereas the red nose of Pierre Clément indicates prolonged conversations with the bottle. His Reverence feels that it is because of the big hats that are rented for funerals from Cuenot, the hatter, that no one refers to Etienne Nodier, who carries the corpse with father Crevot.

The sisters of Courbet do not know what to think of the newspapers that their brother sends them from Paris; they are so certain of his intentions that they try to prove by all means that "Gustave" has not dreamed of making fun of the people in the town. They go to see Fili Caillot, who has posed in the portrait, and Joséphine Bocquin, the one who cries and has a hood on her head, and show them a paper in which they are called pretty. The women, happy to see a compliment in print, are almost

convinced when the big Marlet enters; he receives the *Presse* and reads an article in which the critic confirms that the painter has purposely caricatured his compatriots so that he would seem more beautiful himself.[3]

"The newspaper is right," big Marlet says. "Since Courbet knows how to make himself beautiful, he could well have made us like himself."

"He is not beautiful at all, with his pipe!" Mother Promayer [sic!] exclaims.

Only gravedigger Cassart says nothing. The custom of burying people has taught him to think, and he does not blurt out his words like a chattering fool. Caressing his dog, he listens to the reproaches of the big Tony Marlet, and he disappears whistling in the direction of the valley of Manbouc.

I have tried to give a picture of the small town babble caused by the figures in the *Funeral of Ornans.* It was more important than one would think, in order to establish the position of the types in the painting of Mr. Courbet, whom everyone absolutely wants to baptize "socialist." These days it is customary to find out whether the pen of a novelist is dipped in communism, whether the melody is Saint-Simonian, or whether the brush is egalitarian. There is not a shade of socialism in the *Funeral at Ornans;* and for me it is not enough to paint the *Stonebreakers* [fig. 4] in order to show a strong desire to improve the condition of the working classes.

These dangerous fantasies could lead to a classification of artists in parties, whereby they could be claimed now by one, then by the other. One will never persuade me that "Rembrandt was the pupil of Luther." [4] Impure mixtures of hazy pantheism, of symbolic antitheses, and of realities, when will you stop browning in the same casserole in order to poison youth?

Nevertheless, I want to draw again from that well, out of which no truth will come, to show that Mr. Courbet is not as socialist as one would have it. Not that I want to attach him to another party, because that would be as fatal for the painter as for his future works.

Woe to those artists who want to teach through their works, or who want to associate themselves with the acts of some governments. They can stir up the passions of the masses for five minutes, but they only present *passing events.*

If socialism were fundamentally but a new form of liberalism, or a sort of *opposition* in different garb, what chances would a socialist

[3] Reference to an article by Théophile Gautier in the *Presse* of November 15, 1851.
[4] The parallel between Luther and Rembrandt was frequently drawn in the nineteenth century. See S. Heiland and H. Lüdecke, *Rembrandt und die Nachwelt* (Leipzig: Seemann Verlag, 1960), *passim.*

painter have? His work would become outdated as quickly as the very name of the doctrine, which is already much less resounding than in the two first years of the Revolution.

Painting no more has as its mission the exposure of social systems than does music; when painting is turned into teaching it is not painting anymore. It becomes a pulpit that is sad and painful to look at, because there is no preacher on it.

Fortunately, Mr. Courbet has not wanted to prove anything by his *Funeral*. It is the death of a bourgeois, who is followed to his last resting place by other bourgeois. One knows that the painting is not a family portrait; where is the vinegrower who is rich enough to order such an important canvas? It is simply, as I have seen it printed on posters when Mr. Courbet exhibited his paintings in Besançon and Dijon, the HISTORY PAINTING of a funeral at Ornans. It has pleased the painter to show us the small-town domestic life. He has said to himself that printed cotton dresses and black suits are as good as Spanish costumes, the laces and feathers of the time of Louis XIII, medieval armors, and the paillettes of the Regency; and, with the courage of an ox, he plunged into that immense canvas, unprecedented so far.

But it is not the size of the painting that interests me. If Mr. Meissonnier did not paint with a pin, if he knew what "effect" was, if his laborious brush did not place dirty tones on his microscopic canvases, I would respect that Tom Thumb painting as much as the large constructions of Veronese. But, in my imagination, I see Mr. Meissonnier with a clockmaker's magnifying glass, in front of that tedious work, painting after castoffs of Babin.[5]

Among other recriminations, the fools have exclaimed in chorus: "We understand Ostade, Teniers, and Brawer [sic!]; we admire their drinkers and their smokers, but at least they knew how to limit themselves to small canvases; their drinking bouts, their low-class actions, and their feeds took place in small frames."

The Spanish, guided by Murillo and Velazquez, have painted beggars, wretched people, and cripples of the same size as the great men and the infantas of Spain. The *Family Holidays*, where one cries out: "The King drinks!" or where one sings or plays the bagpipe or turns away from the table when there are problems with the digestion, are painted life-size.[6]

[5] Babin, burlesque society formed in Poland in the sixteenth century by Psonska on his estate, Babin.

[6] Reference to the paintings of the Flemish seventeenth-century painter, Jacob Jordaens.

We have in the Louvre a masterpiece, the *Archer's Prize* of van
der Helst: it is the portrait of three magistrates who are holding golden
vases to be distributed among the most adroit archers. This little easel
painting is only a reduction of a canvas by van der Helst that has the
size of last year's painting by Mr. Courbet, the *Afterdinner at Ornans*
[fig. 3]. In the museum of Amsterdam, opposite the *Nightwatch* of Rem-
brandt, one can see an immense painting by van der Helst that repre-
sents the burgomasters of the city talking to each other.[7] Why don't the
fools know the painting by van der Helst? Because thus is their knowl-
edge equal to their sentiment. They are ignorant, silly, and argumenta-
tive.

One will argue that the burgomasters and the magistrates of
Amsterdam are important people, but what about the mayor of Ornans,
the deputy mayor of Ornans, the substitute justice of the peace of Ornans,
the priest of Ornans, and the dog of a retired gentleman of Ornans? Do
they not have the same historical importance as the Flemish burgo-
masters and magistrates? Fifty years from now one will no longer re-
member the names of the bourgeois of Ornans, just as the artist who
travels through Holland does not know the names of the personages in
van der Helst's painting.

As for the alleged ugliness of the bourgeois of Ornans, he has not
exaggerated anything; it is the ugliness of the province as opposed to
the ugliness of Paris. Everybody exclaims that the vergers are disgraceful.
Because there is a little wine in their bloated heads . . . Is that all?
The wine gives a diploma to those who love her and she colors the noses
of drinkers with a powerful red; it is the emblem of the drunkards. A
red nose has never been the object of sadness. Those who have a red
nose do not incline their head to indicate shame; usually they hold
their heads high, convinced that they give joy to their fellow citizens.
The vergers of Ornans are dressed in red robes and caps, like the presi-
dents of the Supreme Court; this has caused the indignation of some
serious people, who, in their error, were indignant to see *magistrates*
with red noses like that. One does not make such errors. The judges,
though rarely pleasant outside the courts, do not have these winy ap-
pearances, in which eyes and ears, indifferent to exterior things, seem to
pay much attention to interior dreams. Each profession has its nose; and
one must have little insight into physiognomy to give the nose of a
verger to a magistrate.

Those vergers amuse me particularly, they make me happy, there-
fore they are not ugly. No, you are not ugly, Pierre Clément, with your

[7] Bartholomeus van der Helst, *Banquet of the Civic Guard* (1648).

nose that is redder than your robe. Do not worry, Jean-Baptiste Muselier, about what is said by the hack writers; enter the café and drink another bottle; It is funny that while so many bad things have been said about those happy-looking vergers, nobody has thought of broaching the subject of the ugliness of the businessman, so well represented by a deathly-pale-looking person, with thin lips, who has a dry and cold neatness that points to the pettiness of life. There is an ugly man, parsimonious and prudent, steady and virtuous. That is ugliness.

The two old men, who, in front of the open grave, are thinking about things of the past while taking a pinch of snuff, are full of character; they are not ugly. The pallbearers are young men with beards and moustaches, like all young men. Should Mr. Courbet have dressed them up in Cossack pants and Hussar vests? The gravedigger is an admirable figure, kneeling on the earth, full of pride. His job half-done, he waits for the prayers of the priest to end. He is neither sad nor gay; the funeral hardly touches him; he does not know death. His gaze wanders to the far end of the cemetery and is focused on nature; that gravedigger is always working for death, yet he has never thought about death. He is the prototype of the man of the people, in his robust beauty. The choirboy who holds the vase with holy water is charming, and even more lovely is the little girl who pulls her crying mother's arm and bends over as if to pick a daisy.

The group of women consists of very young and old ones; in a wicked "realist" impulse, it has pleased Mr. Courbet to make the old women full of wrinkles. Their gray hair is hidden under coifs of white linen and large caps. But the young girls are really young and robust as are all the women of those small towns that are part market towns, part villages, lost in the mountains. There are exceptions, however, and the painter has rendered those exceptions. In the middle of the group of women, a young girl stands out; her head is covered with a bonnet of black taffeta, her figure is slender and delicate; strings of blond hair contrast with the black of her dress. Her physiognomy is delicate and charming and has nothing in common with the conventional types that one encounters in the works of all young painters with a refined palette who have just finished their training period with Mr. Couture.

The critics have turned Balzac over the grill until they have burnt and hurt him; they said that he only liked to depict villains, that only the depiction of vicious people pleased him. In the study preceding this volume, one has been able to read Balzac's defense. He answered that if the vicious people outnumber the virtuous, it must be the fault of society; and that, since he claimed to depict real society, he was not permitted to change businessmen into elegant shepherds.

Like the great masters whom we have lost, Mr. Courbet could say to his pen-pushing judges: "I admit that my vergers are no Antinous,[8] I am even convinced that Winckelmann would not discuss my painting because of the *low-class aspect* of some figures: [9] but beauty is not common in France. . . . You critics, who say you understand the *beautiful,* look at yourselves in the mirror and dare say in print that your appearance conforms to the *Expressions of the Noble Passions* of the famous Mr. Le Brun.[10]

Mr. Courbet can boldly state that three women's heads, the children, the gravedigger, and several other figures, are characteristic of modern beauty; and that the vergers make up the balance and will cause everyone to proclaim the *Funeral at Ornans* the masterpiece of the *ugly.* Is it the painter's fault that material interests, small-town life, sordid egoism, and provincial pettiness have marked the faces with their claws, have made the eyes dim, have wrinkled the foreheads and stupefied the mouths? Many bourgeois are like that; Mr. Courbet has painted bourgeois.

Following a well-known procedure, some have opposed the exhibition of 1850 to the exhibition of 1851.[11] The painting of the *Afterdinner at Ornans* was much superior to the painting of the *Funeral at Ornans,* so they say. And I have seen it printed twenty times, with reference to that admirable painting, that it was regrettable that the painter did not use his powerful qualities for history painting.

There are in France still many feeble-minded people. The courtesans of the Regency, rouge, beauty spots, and lambs have greatly troubled the minds of those poor people, who find neither glory nor happiness in their own time and who can see in their imagination only little poems, suppers, and small dogs, marchionesses [and] actresses. . . . Collé and Piron would bring some calm to their minds,[12] where long, dry weeds are growing. They ignore the fact that the modern costume is in harmony with modern physiognomy, and that the fancy frills of the costumes of Watteau would make us look more ridiculous than Cassan-

8 Antinous, favorite slave of the Roman emperor, Hadrian, was supposed to have been the prototype of classical beauty.

9 Johann Joachim Winckelmann (1717–1768); German archaeologist, who wrote the first scholarly work on classical art.

10 Charles Le Brun (1619–1690), leading painter in France in the seventeenth century, wrote and lectured on the representation of human passions in painting.

11 Here Champfleury errs. The Salon of 1850 was so much delayed that eventually it was combined with the Salon of 1851. The *Afterdinner at Ornans* was exhibited at the Salon of 1849, the *Funeral* at the combined Salons of 1850–1851.

12 Charles Collé (1709–1783) and Alexis Piron (1689–1773) were two French comedy writers.

dre.[13] Our black and serious costume has its grounds [14] and it requires the tender dreams of a *précieux* [15] to exclaim how happy he was that the next Longchamp [16] would bring leaves to the trees and feathers to men's hats.

Fortunately, the time has come for these pantheists, who made nature play such silly comedies. A new art appears, serious and full of conviction, ironic and brute, sincere and full of poetry. Those who expose all that conceited bric-à-brac will soon appear; feelings are running high everywhere. The intelligent young wait for the first audacious one who will blow up all those hunters for words, that school of pleasantness, those beautiful spirits, those sheep of Panurge [17] who jump over the same ditch, those makers of proverbs, those cliché writers, those pastrycooks, with their poems all made in the same mold.

And there will be no temple large enough to contain all the yellow-jacketed books that one will be obliged to tear up before discarding them; because one will have to demonstrate how badly they were stitched, with what bad material they were filled, and what a sad lining was underneath. A difficult job that requires more than one day.

One understands the scandal that was produced by the *Funeral*, which was flanked on the left by the *Call of the Victims* by Mr. Müller, on the right by the *Departure of the Volunteers* by Mr. Vinchon, while on the opposite wall the *Battle of Konlikovo* by Mr. Yvon had its place.[18] One might say that anecdotic-sentimental painting, academic painting, and fake energy were surrounding a virile, powerful, and sincere painting.

From a distance, when one enters the room, the *Funeral* looks as if it is framed by a doorway; everybody is surprised by that simple painting, as one is surprised at seeing those naïve woodcuts, carved by a clumsy hand, that head the broadsides describing murder cases, printed in the Rue Gît-le-Coeur.[19] The effect is the same because the execution is equally simple. Cultured art finds the same accent as primitive art. The result is as captivating as the painting of a great master. The simplicity of the black costumes is akin to the grandeur of parliaments in

13 Cassandre, a character in the Italian Comedy.
14 We find here an echo of the ideas of Baudelaire, who, as early as 1846, had proclaimed the "beauty and the indigenous charm" of the black suit in his essay on "The Heroism of Modern Life."
15 An overrefined person. *Préciosité*, overrefinedness, was a fashionable attitude among cultured people in France during the early seventeenth century.
16 Parisian racetrack.
17 Panurge, a character in Rabelais's *Pantagruel*.
18 The first two paintings are in the museum of Versailles, the third one is in the Kremlin in Moscow.
19 Street in Paris where popular prints are produced.

red robes by Largillière.[20] It is the modern bourgeoisie, full-length, in all its ridiculousness, its ugliness and its beauty.

The scandal aroused by the *Funeral* of Mr. Courbet is due in part to a strong, robust, and powerful individuality that crushes the neighboring paintings. The critics are excited about a painting of the head of a smoker, a self-portrait of the artist. There is genius in the *Funeral at Ornans;* the portrait of the *Man with the Pipe* [cover illustration], which is so much admired, is painted ten times better in ten heads of the *Funeral.* I am not going to give any advice to the painter; let him go where his brush takes him. He has produced a masterpiece in this time of mediocrity; let us hope that by working, he will forget the misery inflicted on him by mediocrities.

[20] Nicolas de Largillière (1656–1746), French portrait painter, who specialized in portraits of the Parisian bourgeoisie.

THE MORAL
OF THE *FUNERAL AT ORNANS*

Pierre-Joseph Proudhon

It is particularly in the *Funeral* [fig. 6] that Courbet's thought reveals itself most audaciously: I do not even except the *Return from the Conference,* about which I will speak later. Everyone has generally done justice to this work as far as the talent of the artist and the energy of his brushwork are concerned. This talent must be quite real for the critics to go that far in their avowal, for no one has understood anything at all of the subject itself and of the way in which it is treated. The author of *Artistes francais étudiés d'après nature,* Mr. Th. Sylvestre, made a description of the *Funeral* that is a caricature. And, I'll admit, the contrast between the figures and the pious motif that unites them is so violent that I think—as far as we, the heralds and popularizers of the new idea, can tell—it will take a long time before the public can understand and support such a lesson and before the artist can count on the approval of the masses for such experiments.

Of all the acts of life, the most serious and the one that least lends itself to irony is the one that ends it, death. If anything must remain sacred, for the unbeliever as well as for the believer, it is the last moments, the will, the solemn goodbyes, the funeral and the grave. All peoples have felt the majesty of these scenes; all have surrounded them with religion. The same sentiment has, at all times, inspired the artists who, in this case and perhaps only in this case, have known both to obey the ideal of their time and to remain within the eternal truth of their mission. In fact, it seems that not one aberration of art is possible in that heartrending ritual where a family, surrounded by friends and relatives and assisted by a priest, goes about putting the seal on the

"The Moral of the *Funeral at Ornans.*" From Pierre-Joseph Proudhon, *Du principe de l'art et de sa destination sociale* (Paris: Garnier Frères, 1865), pp. 207–212. Translated by Dr. H. Henket. Footnotes by the editor.

great separation by surrendering to the earth the corpse of a husband, a father.

How then has Courbet taken pleasure in enveloping such a scene with ridicule and in making its actors grotesque? Note that the scene takes place in Ornans, a small town in the Franche-Comté, amidst simple peasants, in an environment where religion still lives and faith is not altogether dead—all of which make the artist's idea even more inconceivable and almost sacrilegious. Look at the gravedigger with the dumbfound face and the countenance of a brute; at the impious and smutty choirboys; at the pimple-nosed beadles, who, for a couple of dimes, have left their vineyards to come and figure in the funeral drama; at the priests, jaded with funerals as much as with baptisms, galloping with a distracted air the indispensable *De Profundis*: What a sad and sorrowful spectacle! How shameful to display such a scene!

For whom did Mr. Courbet intend this painting, anyway? Where could it find a place. Not in a church, that is for certain. There, it would be an insult. Nor in a school, a townhall, or a theatre. The only remaining possibility is that a gentleman of leisure, avid for curiosities, might think of putting it up in his attic; he'll take care not to hang it in his parlor. No doubt there are, on the far side of the grave, female figures that are quite touching and would almost make one want to weep; but those cold spectators, and that bored gentleman, old family acquaintances who could not think of an excuse not to attend the funeral of a friend, of a deceased dependent: Does not all that point to a sacrilegious premeditation? Where does one find in that the purpose, the moral thought of art? . . .

Well, this criticism, which can be so easily made, is precisely Courbet's justification. In what century are we living? I'm asking the hypocrites who accuse him. Did you never attend a funeral and have you never observed what happens there? We have lost the religion of the dead; we do not understand any longer that sublime poetry with which Christianity, in accord with itself, surrounded it; we do not have faith in prayers and we make fun of life hereafter. The death of man is nowadays, in universal thought, the same as the death of the animal: *Unus est finis hominis et jumenti;* and despite the *Requiem*, despite the catafalque, despite the churchbells, despite the church and all its decorum, we treat the remains of the one like we treat the remains of the other. Why funerals? Why graves? What is the significance of that marble, of those crosses, of those inscriptions, of those crowns of immortality? Would it not suffice to have a dumptruck pick up the corpse by order of the police and take it . . . to Montfaucon? [1]

[1] City dump of Paris.

It is this hideous sore of modern immortality that Courbet dared to show naked; and the picture he made of it is as eloquent as a sermon on the same subject by Bridaine or Bossuet might be.[2] There I see, he tells us, only one thing that is still respectable: the tears of the mothers, the sisters and the wives, and the ignorance of the children. All the rest is comedy and, as you say, sacrilege. And this sacrilege—you would not even notice it—rotting, smelly souls that you are, if the painting did not forcefully impress it on your conscience by the sheer horror of its representation. Let it be understood that this is the reason why Lamennais wanted to be thrown into the pauper's grave, without ceremony and procession.[3] Since our police-laws do not permit a friend to dispose of the corpse of his friend in secrecy, the author of *Indifférence* thought, let us at least shy away from indiscrete curiosity, and to hell with the funeral attendant! . . .

Thus Courbet proves to be, in the painting of the *Funeral*, just as profound a moralist as he is a profound artist; he has given us the cruel truth unmercifully. By revolting the ideal in us, he calls us back to our dignity; and if he did not make a flawless work of art, he made one indisputably healthy and original; and we would call it prodigious if we had the least bit of feeling left for art, if our soul, our reason, our conscience were not, so to speak, struck with numbness.

Of what importance here are all the reservations of the most malevolent criticism? "The composition of the *Funeral* violates all the rules . . . the figures form some sort of disorderly bas-relief . . . the heads, too prominent in the background, force themselves to the foreground? . . . " I agree with everything you say. But is it, therefore, less true that Courbet has opened a new and immense perspective in art; that an idea like the one of the *Funeral* is a revelation in itself; and that the idealistic incitement that results from it is so powerful, that one ends up finding that the artist has not gone far enough—like the Greeks who thought that the figures of their gods were never beautiful enough—and that one would like to make its subject, which is so new, so incriminating and so moving, twenty times the compulsory subject of the competion?[4]

[2] Jacques Bridaine (1701–1767) and Jacques-Bénigne Bossuet (1627–1704) were two famous French preachers.

[3] Félicité de Lamennais (1782–1854), French philosopher, author of the *Essai sur l'indifférence en matière de religion* and *Paroles d'un croyant.*

[4] Probably refers to the annual competition for the so-called *Prix de Rome,* a prize in the form of a grant to enable young artists to study in Rome.

INNOVATION AND TRADITION
IN COURBET'S BURIAL AT ORNANS

Linda Nochlin

While Gustave Courbet's *Burial at Ornans* [fig. 6] is generally held to constitute a landmark in the art of the nineteenth century, its revolutionary quality is usually considered a function of the artist's choice of subject rather than a result of pictorial innovation. Yet a careful examination of the painting both reveals the extent to which it is formally as well as thematically advanced, and brings out the connection of Courbet's innovations with the whole climate of progressive thought surrounding the 1848 Revolution.

From the vantage point of the present, it is perhaps difficult to see exactly why the *Burial at Ornans* created such a furor among Parisian critics and public when it first appeared in the 1850–1851 Salon.[1] It is only when one examines the work in the context of the accepted standards for a major Salon piece at the time that the reasons for the scandal created by Courbet's painting became clear.[2] If, for example, one con-

"Innovation and Tradition in Courbet's *Burial at Ornans.*" Unabridged reprint of Linda Nochlin, "Innovation and Tradition in Courbet's *Burial at Ornans,*" *Essays in Honor of Walter Friedlaender, Marsyas,* suppl. 2 (New York Institute of Fine Arts of New York University, 1965), pp. 119–126. Footnotes by the author, with the exception of note 39, which is by the editor. Reprinted by permission of Linda Nochlin.

[1] Courbet contributed nine works to this Salon, which opened on December 30, 1850. The *Burial,* which was listed as No. 661 in the Salon Catalogue, was erroneously entitled "Un enterrement à Ornus." See *Explication des ouvrages de peinture, sculpture, architecture, gravure et lithographie des artistes vivants, exposés au Palais National le 30 décembre 1850,* Paris, 1850, p. 73.

[2] For a collection of outraged critical opinion about Courbet's work in this Salon, see Georges Riat, *Gustave Courbet, peintre,* Paris, 1906, pp. 86–88.

fronts the artist's "tableau historique," [3] begun a year after the Revolution of 1848,[4] with the most highly praised history painting of the Salon of the year preceding the uprising, Thomas Couture's *Romans of the Decadence* of 1847 [fig. 7], a work which had in fact found favor in the eyes of such progressives as the left-wing critic, Théophile Thoré, and the anarchist philosopher, P.-J. Proudhon,[5] the gap which separates the traditional painting of the period from Courbet's realism becomes immediately apparent.

Despite Couture's intention to create a timely commentary on the corruption of Louis Philippe's government in the *Romans of the Decadence*,[6] his painting, in comparison with Courbet's is an anachronism, not merely because he has conveyed his message in the outmoded language of the past, but in the very fact that his painting contains any explicit message at all. In clothing a social meaning in classical garb, Couture was of course merely following a time-honored precedent. In a similar way, David had criticized the government of Louis XVI in the *Oath of the Horatii* at the end of the eighteenth century, and Delacroix had found it necessary to elevate the actuality of the 1830 Revolution to the realm of acceptable art by the addition of a classically draped, allegorical figure of Liberty, which in a sense, became the "meaning" of the picture [7] as opposed to the mere representation of a specific event from that revolution. It was thus not the message as such, but the very lack of the customary narrative meaning or implication in a painting of its scale and pretensions which scandalized the public in Courbet's *Burial*, and this meaninglessness was seen as a function of a total lack of ordered composition in the traditional sense of the term.

It is certainly obvious that Couture's dependence on tradition and his essential conservatism as an artist, in opposition to Courbet, goes far deeper than togas and classical columns, and penetrates into the basic formal configuration of his painting. One might even go so far as to say that if the arrangement of the elements in Couture's painting can be

[3] This was the term Courbet himself used for the *Burial at Ornans*. See Meyer Schapiro, Review of *French Painting between the Past and the Present* by Joseph C. Sloane, *The Art Bulletin*, 26, 1954, p. 164.

[4] Courbet began the *Burial* in 1849 and completed it in 1850.

[5] Thoré praised the painting for its social significance in his *Salon* of 1847, although he admitted that Couture lacked the genius to be a great artist and did not claim that he represented a new movement in art. See Francine Lifton Klagsbrun, "Thomas Couture and the *Romans of the Decadence*," unpublished M.A. thesis, New York University, 1958, pp. 23–24. Proudhon wrote in 1847 that Couture's painting was the "seul tableau vraiment remarquable" at the Salon of that year and pointed out its political implications. *Carnets de P. -J. Proudhon*, ed. Pierre Haubtmann, Suzanne Henneguy and Jeanne Fauré-Fremiet, Paris, 1961, 2, p. 63.

[6] Klagsbrun, *op. cit.*, p. 22

[7] *July 28, 1830: Liberty Guiding the People*, now in the Louvre.

characterized as a "composition," then that of Courbet's must be termed an "anti-composition," so devoid is the *Burial at Ornans* of the leading principles characteristic of traditional art.[8]

In Couture's *Romans of the Decadence,* one is immediately made aware of a central psychological focus which is also the formal focus of the composition, to which the other elements lead, as directions of movement, and to which they are in turn subordinated. The figures themselves are arranged in groups, each member of which is related to the other members and to the total formal and narrative structure of the picture. Since each figure is constructed to perform his role adequately in terms of the whole composition, no one figure is individuated and specified as a unique entity, but becomes, in a sense, an actor in the overall pictorial drama. Moreover, the figural groups are manipulated so that they occupy and define a clearly-articulated spatial stage; at the same time, a sense of psychological "depth," of multiple layers of significance and implication which the informed spectator could share with the erudite artist, is created by the misty vista of fading classical grandeur behind the world of the figures, with aerial perspective functioning to suggest the past-within-the-past, a kind of pictorial pluperfect. Furthermore, Couture has given added authority and more universal significance to his message of mid-nineteenth century decadence not merely by placing it in the historical past by means of antique costumes, architecture and statues, but also by composing his vast tableau vivant on the basis of the artistic past as well, introducing motifs and poses from such approved predecessors as Raphael, Michelangelo, Poussin, Veronese and Tiepolo.

To all this, Courbet's *Burial at Ornans* offers the most striking contrast, a contrast which goes far beyond the mere fact that one artist has represented a scene from ancient Rome and the other an event from mid-nineteenth century Ornans. In Courbet's painting, there is no question of being led beyond the concrete, individuated aspect of contemporary reality. There is, in fact, nothing especially significant for the composition to lead one towards as an emotional or intellectual focus of significance. This is, of course, even more apparent in Courbet's first conception of the scene, the charcoal drawing of 1849 now in the Musée de Besançon [fig. 8], where the movement of the procession simply proceeds uninterrupted across the surface of the paper, without even the minor hiatus of the group around the grave provided in the finished painting. Yet even this group is hardly emphasized in any consistent fashion by pose, position, color or amount of detail and density of paint

8 See Klaus Berger, "Courbet in his Century," *Gazette des Beaux-Arts,* 24, 1943, pp. 22–24, for a similar view of this aspect of the artist's style.

from the rest of the figures; or rather, one might say that attention is immediately distracted from this group by the insistent and diverting concreteness of the rest of the cortege. There seems to be no particular reason, in terms of an ulterior meaning or message, for the way the figures are grouped. On the contrary, the arrangement seems casual and fortuitous, without beginning, middle or end. One finds that there is no real reason for the boundaries of the picture being precisely where they are, since they are not implied by closing elements as they are in Couture's painting. Despite the fact that Courbet has turned inward the heads of the three female mourners at the far right, one feels that the procession and the landscape background could have been extended or contracted, the present limits of the painting having been determined simply by the number of individuals portrayed. Nor has Courbet attempted, as did Couture, to make deep spatial recession function as the pictorial equivalent of psychological depth and metaphysical profundity in his painting. The figures in the *Burial at Ornans* are not manipulated so as to occupy a spatial stage, and foreshortening is generally reduced to a minimum, as is aerial perspective. Because of the relatively unmodulated richness of the paint texture and the starkness of the individual color areas, as opposed to the suavely-orchestrated, muted tonality of Couture's painting, Courbet's figures seem flat and restricted to the surface of the canvas, rather than existing within and reinforcing a pictorial space. And whereas Couture has drained his figures of their detailed individuality so as to enable them to play their roles in the compositional drama, Courbet has, on the contrary, emphasized the specific character and idiosyncratic lineaments of each individual at the expense of generalization and universality of meaning. The richness of the pictorial detail tends to give an almost equal emphasis to all areas of the canvas, a pictorial "democracy," which, along with the vast scale of the canvas, seemed most apalling to conservative critics at the same time that it appeared most sympathetic to the more progressive ones.

It was precisely because of this compositional *égalitarisme,* this lack of the customary hierarchy of values, of generalization, of selectivity and hence, of conventional emotional or dramatic significance, that one of the more intelligent conservative critics found fault with Courbet, not for the artist's choice of subject:

> L'*Enterrement à Ornus* [*sic*] constitue en effet l'oeuvre capitale, le tableau d'histoire de M. Courbet. Si M. Courbet avait daigné élaborer sa pensée, ajuster les diverses parties en élaguant où dissimulant celles qui déplaisent au profit des motifs heureux qui pouvaient se recontrer, il eût produit un bon tableau. Le sujet en lui-même s'y prêtait: il n'est pas nécessaire, pour émouvoir, d'aller chercher bien loin; les funerailles d'un paysan ne sont pas pour nous moins touchantes que le convoi de Phocion. Il ne s'agissait d'abord que de ne pas localiser le sujet, et ensuite de

mettre en lumière les portions intéressantes d'une telle scène. . . . Si ce sont des portraits de famille, laissez-les à Ornus [*sic*]. Pour nous, qui ne sommes pas d'Ornus [*sic*] nous avons besoin de quelque chose de plus qui nous attache. Ce qu'il fallait éveiller chez le spectateur, c'était le sentiment naturel qui accompagne une pareille scène. . . .[9]

Louis de Geofroy's demand for the "natural sentiment which accompanies such a scene" would, for example, have been amply fulfilled by a very different painting of precisely the same subject as Courbet's *Burial*, Augustin Roger's *Un Enterrement de village* [fig. 9], which had figured in the Salon of 1822.[10]

In Roger's painting, emphasis on the moral and religious significance of the event, rather than its mere concrete actuality tends to bring this minor artist's representation of contemporary life in the provinces far closer in spirit to Couture's *Romans of the Decadence* than to Courbet's *Burial at Ornans*. This emphasis is clearly indicated by the compositional focus on the open grave, accentuated by the dominating church with its cross and clock above it, the rankly overgrown foliage, and the suitably anguished and pious attitudes of the picturesquely generalized villagers. That de Geofroy had nothing against the representation of the lower classes in art is further indicated by his praise of more conventional works with such subjects, works like Bonvin's *Intérieur d'un orphelinat*, Chaplin's *Intérieur (Basse-Auvergne)*, or Luminais' *Braconniers* and *Pilleurs de mer;*[11] what the critic of the *Revue des Deux Mondes* objected to was the fact that Courbet had, in his view, simply limited himself to the recording of reality at its crudest and hence had failed to produce a work of art: "C'est grande pitié qu'en l'an 1851 on soit réduit à faire démonstration des principes les plus élémentaires, à répéter que l'art n'est pas la réproduction indifférente de l'objet le premier passant, mais le choix délicat d'une intelligence raffinée par l'étude, et que sa mission est, au contraire, de hausser sans cesse au-dessus d'elle-même notre nature infirme et disgraciée."[12]

De Geofroy is quick to point out the connection between Courbet's regrettable lack of spiritual elevation and his formal innovations (or retrogressions, as this critic sees them). "Par suite de ce système de peindre les objets tels qu'on les rencontre, et d'écarter tout ce qui pourrait avoir l'air d'une combinaison, les tableaux de M. Courbet ne présentent

[9] Louis de Geofroy, "Le Salon de 1850," *Revue des Deux Mondes*, 9, 1851, pp. 929–30. For a translation of this paragraph, see Footnote 39 at the end of this article.
[10] E. Bénézit, *Dictionnaire critique et documentaire des peintres, sculpteurs, dessinateurs et graveurs*, Paris, 1952, 7, p. 316. The painting was reproduced by Bellay in J. Vatout and P. Quenot, *Galerie lithographiée de son Altesse Royale Monseigneur le Duc d'Orléans, Paris*, n.d., 2, n.p., and might have been known to Courbet.
[11] De Geofroy, *op. cit.*, pp. 937 and 939.
[12] *Ibid.*, p. 930.

ni jour ni l'ombre, et ont un aspect extrêmement plat. La perspective n'y est pas plus soignée que l'effet; . . ." [13] As the critic implies, Courbet's composition, or lack of it in the traditional sense, is determined by his primary interest in individual elements, objects or figures, and in the creation of their material equivalent on the canvas.

Yet while conservative critics found this method of composition banal and awkward, it was precisely for this daring formal unorthodoxy that Courbet's artistically and politically progressive supporters praised him. Said Courbet's foremost champion and ringleader of the "bataille réaliste," the author and critic Champfleury: "Par la *composition* et *l'arrangement* des groupes, Courbet rompait déjà avec la tradition. Sans connaître les admirables toiles de Velasquez, il se trouve d'accord avec l'illustre maître qui a placé des personnages les uns à côté des autres, et ne s'est pas inquiété des lois posées par des esprits pedants et médiocres." [14] Courbet's democracy of vision, his additive, egalitarian composition, were seen as the concommitants of a democratic social outlook. The relation of the *Burial at Ornans* to the ideas of 1848 went far deeper than any overt socialist message, as Champfleury correctly observed.[15] The connection of the painting with the progressive social thought of the mid-nineteenth century lies not merely in Courbet's momentous decision to paint such a subject life-size, which immediately raised it to the category of history painting,[16] but also in the fact that by giving equal emphasis to all elements, by breaking with traditional methods of constructing a painting, a work such as the *Burial* could be connected in its simplicity, awkwardness and lack of rhetoric both with the art of the people and with the very haphazard, random structure of everyday, down-to-earth reality itself. Truth and democracy were both seen as functions of the same naïve, stalwart confrontation of actuality. For instance, one of Courbet's most sympathetic and intelligent critics, the Fourierist, François Sabatier-Ungher,[17] finds that Courbet has created

[13] *Ibid.*

[14] Champfleury [Jules-François-Félix Husson], *Grandes Figures d'hier et d'aujourd'hui,* Paris, 1861, p. 251.

[15] *Ibid.*, p. 235.

[16] The *Burial at Ornans* measures 3.14 m. × 6.65 m.

[17] Sabatier-Ungher is identical with François Sabatier, one of the leading disciples of Fourier of the period, who conducted an important left-wing salon in his home near Lunel, La Tour-de-Farges, close to Montpellier. Sabatier was almost the only critic capable of appreciating Courbet's merits on both the aesthetic and the social levels in 1850–1851, aside from Champfleury. He was a friend of Courbet's patron, Alfred Bruyas, and it was no doubt through the latter that the artist was invited to Sabatier's home during the summer of 1854 which he spent with Bruyas in Montpellier. (The information about Sabatier was communicated to me in personal conversation with M. Jean Claparède, curator of the Musée Fabre at Montpellier, during the winter of 1963.)

a new style appropriate to the nature of modern life. In the *Burial at Ornans*, far from being trivial, "il est vrai. . . . Voilà la démocratie dans l'art." [18]

In the same way, Courbet's style could be seen as directly related to the simplicity and naïveté of popular art itself. Champfleury likened the *Burial* to the art of the popular image-maker: "De loin, en entrant, l'*Enterrement* apparaît comme encadré par une porte; chacun est surpris par cette peinture simple, comme à la vue de ces naïves images sur bois, taillées par un couteau maladroit, en tête des assassinats imprimés rue Git-le-Coeur. L'effet est le même, parce que l'exécution est aussi simple. L'art savant trouve le même *accent* que l'art naïf." [19] The reminiscence of popular imagery in this painting must have indeed been striking, since the hostile de Geofroy remarked on it as well: "Evidemment, M. Courbet est un homme qui se figure avoir tenté une grande renovation, et ne s'aperçoit pas qu'il ramène l'art tout simplement à son point de départ, à la grossière industrie des maîtres imagiers [*sic*]." [20]

While it is impossible to find a specific source for the *Burial* in popular imagery, or to maintain that Courbet was merely trying to repeat the conventions of the *image d'Epinal*, his painting, nevertheless, in both the iconography and the angular line-up of stiff, awkward figures, may be related to such nineteenth-century *images* as the *Degrés des âges*, [21] or, even more specifically, to the *Convoi funèbre de Napoléon* [*fig.* 10], which was created at the time of the July monarchy, and also represents a funeral procession in a rocky landscape. [22] Courbet, in turning to the revivifying source of popular art is thus at once the first major artist to look toward the primitive in the nineteenth century, [23] and is, at the same time, asserting his own feeling of identification with and sympathy for his own highly publicized "popular" background. By daring to turn to popular imagery as a source and by creating a history painting which reminded contemporary critics of one, Courbet was making a statement which was both politically and aesthetically radical.

Social and artistic factors are again inextricably mingled in the

18 F. Sabatier-Ungher, *Salon de 1851*, Paris, 1851, pp. 62–63.
19 Champfleury, *op. cit.*, p. 244.
20 De Geofroy, *op. cit.*, p. 928.
21 This analogy was originally suggested by Meyer Schapiro in his important study of the artist, "Courbet and Popular Imagery," *Journal of the Warburg and Courtauld Institutes*, 4, 1941, p. 165. . . .
22 This image can be dated some time prior to 1837. See Jean Mistler, François Blaudez and André Jacquemin, *Epinal et l'imagerie populaire*, Paris, 1961, p. 184.
23 Robert J. Goldwater has, of course, pointed out the complexity of the implications of the term "primitive" in relation to European art of the nineteenth and twentieth centuries, and the mixture of aesthetic, social and psychological factors which brought about the appreciation of primitive art in *Primitivism in Modern Painting*, New York and London, 1938.

case of the relationship of Courbet's painting to that of the Le Nains, "ouvriers peintres" [24] and painters of the people, interest in whose work was crystallized into a revival by the political occurrences of 1848 in Courbet's own circle mainly by Courbet's major defender, Champfleury.[25] The elements which Champfleury found admirable in the Le Nains' manner of composition are precisely those which have been remarked on in Courbet's *Burial at Ornans.* Said Champfleury of the Le Nains: "Leur façon de composer est anti-académique; elle échappe aux plus simples lois, ils ne s'inquiètent pas de grouper leurs personnages. . . . Ils ont cherché la réalité jusque dans leur inhabilité à placer des figures isolées au milieu de la toile; par là, ils sont les pères des tentatives actuelles, et leur réputation ne peut que s'accroître." [26] Thus, in the case of the Le Nains', as in the case of Courbet's painting, the representation of reality is equated with a lack of composition and a lack of skill or facility, both of which are considered artificial, academic, and, by implication a kind of imposition of the preconceptions of the Establishment on the raw material of common, everyday experience. The psychological and pictorial disassociation of the figures from each other in Courbets *Burial,* an aspect of Courbet's basically undramatic approach to painting, can finally be perceived as a virtue, as a stalwart refusal to employ the hierarchical schemata of high art to embellish, and hence distort, the brute facts of what exists here and now for the honest observer.

Yet Courbet also drew on more conventional sources from the art of the past in constructing his vast canvas, though it was a sector of that past which had been relatively neglected in paintings of such scale and pretentions: the art of the Dutch and the Spanish masters of the seventeenth century. Sabatier-Ungher points out the relation of Courbet's *Burial* to the work of Rembrandt, Velasquez and Zurbaran, all of whom, he feels, raised everyday life above the level of the commonplace.[27] Certainly, the stark, unmodulated contrasts of black, white and red on which the painting is constructed, the solidity of the shadows and the very subject of a burial itself may owe something to Zurbaran's so-called *Funeral of a Bishop,* then in the Soult Collection in Paris.[28] An even more specific relation exists between Courbet's canvas and a prototype

[24] This term was applied to the Le Nains by Champfleury in his *Essai sur la vie et l'oeuvre des Lenain, peintres laonnois,* Laon, 1850, p. 48.
[25] Stanley Meltzoff, "The Revival of the Le Nains," *The Art Bulletin,* 24, 1942, p. 265 and *passim.*
[26] *Les Peintres de la réalité sous Louis XIII: Les Frères Le Nain,* Paris, 1862, p. 16. According to Meltzoff, *op. cit.,* p. 266, many of the studies contained in this volume were actually written considerably earlier.
[27] Sabatier-Ungher, *op. cit.,* pp. 36 and 62.
[28] The painting is now in the Louvre under its correct title: *St. Bonaventure on his Bier.*

from the art of seventeenth-century Holland; the *Burial* is, in fact, based on a well-known group-portrait by Bartholomeus van der Helst, the *Banquet of Captain Bicker* of 1648 [fig. 11], which Courbet must have seen and admired in Amsterdam in 1847.[29] Van der Helst was often considered the rival of Rembrandt at the time, and an illustrated article on the Dutch artist had appeared in the *Magasin pittoresque* in 1848, in which he was praised for "un sentiment puissant de la vérité."[30] Certainly the scale and format of Van der Helst's work and the poses of some of the figures, especially of the kneeling burgher and of the little boy on the far left have been taken over by Courbet. Yet despite the general similarities, Courbet's painting remains less "composed" and less rhetorical: there is less suggestion of depth and space through movement and foreshortening, and certainly less sense of an arbitrarily-imposed, active relation among the figures in the *Burial at Ornans*. What is important is the fact that Courbet should have turned for inspiration to a painting based on the simple observation of rather ordinary people in the milieu in which they lived when he felt he needed some traditional support for his own large-scale history painting.

For the *Burial at Ornans* is, among other things, a group portrait; or perhaps one should say it is the portrait of a community, Courbet's own community, gathered around the grave of one of its members. The artist himself actually tended to look on the creation of his painting as a communal enterprise. Evidently the whole town of Ornans was anxious to participate. Wrote Courbet to Champfleury: "ici les modèles sont à bon marché, tout le monde voudrait être dans l'*Enterrement;* jamais je ne les satisferai tous, je me ferai bien des ennemis; ont déjà posé le maire qui pèse 400, le curé, le juge de paix, le porte-croix. . . ."[31] Indeed, part of the two-dimensional, additive quality of the work is due to the fact that the *Burial* was created as a series of individual portraits. Courbet worked on his canvas in a studio which was only sixteen inches longer than the canvas itself and about fourteen feet wide, so that while he was painting he was never able to get far enough back to view the work as a whole.[32]

Yet the painting does not owe its originality and power to the fortuitous difficulties attending its creation: its lack of physical depth and conventional metaphysical implication are functions of factors far more profound and significant than the narrowness of Courbet's studio.

29 Robert Fernier, "En marge de *l'Enterrement d'Ornans,*" *Société des Amis de Gustave Courbet: Bulletin*, No. 10, 1951, pp. 8–10.

30 H. van der Tuin, *Les Vieux Peintres des Pays-Bas et la critique artistique en France de la première moitié du XIX^e siècle*, Paris, 1948, pp. 125–126.

31 Undated letter cited in Champfleury's *Souvenirs et portraits de jeunesse*, Paris, 1872, pp. 174–175.

32 *Ibid.*, p. 175.

It is the artist's involvement with the concrete, discrete fact which keeps one riveted to the surface here, in both the physical and the psychological sense. Mary Cassat was wrong when she likened the *Burial at Ornans* to a Greek frieze,[33] although one can of course see what she meant. In actuality, there can be nothing less classical than this painting, just as there can be nothing less Christian than the attitude conveyed by the funeral represented, a fact which conservative critics immediately realized and which they found impious and offensive, a part of the generally "socialist" flavor of the work as a whole.[34] Despite his general obtuseness in the face of a work of art, Courbet's friend, the philosopher P.-J. Proudhon, suggests something of importance when he observes of the *Burial at Ornans*: "Nous avons perdu la religion des morts; nous ne comprenons plus cette poésie sublime dont le christianisme, d'accord avec lui-même, l'entourait." [35] It is not that Courbet is overtly anti-religious in this painting, but simply that for him the transcendent meaning of funerals in general is completely unimportant in comparison to the concrete existence of *this* funeral at Ornans. It is this particular event which has been recorded, not with photographic minuteness and literalism, but with fidelity and a lack of preconception. This lack of preconception is particularly evident in the handling of color in the *Burial at Ornans*: the red of the beadles' robes, like that of their noses, is nothing more than a local phenomenon; the merging of the dresses of the black-clad women to the right and the consequent unity created by the rhythmic succession of their white-framed heads is more the result of a simple statement of fact—they all wore black to the funeral—than of abstract contrivance on Courbet's part; the earth around the grave has been painted with an amazing degree of richness and substantial detail; the brilliant turquoise-striped stockings of the old veteran, Secrétan, and the rich texture of his greenish-grey velveteen breeches stand out as strong, harsh, unharmonized notes rather than tactfully submitting to the demands of a generalized significance.

"La plus profonde faculté picturale de Courbet, le ressort essentiel de son tempérament, c'est un sentiment prononcé de la vitalité de la matière." [36] Here, in the *Burial at Ornans,* this faculty is given free expression in a completely contemporary kind of history painting; history itself, formerly thought to occur in the elevated realm of kings, nobles and heroes was now perceived as dependent upon the concrete actions

[33] Cited in Théodore Duret, *Courbet,* Paris, 1918, p. 32.
[34] See, for example, the criticisms of the *Burial* cited by Champfleury in *Grandes Figures,* pp. 232–233 and Riat, *op. cit.,* p. 86.
[35] P.-J. Proudhon, *Du principe de l'art et de sa destination sociale,* Paris, 1865, p. 210.
[36] Haavard Rostrup, *Trois tableaux de Courbet* (Collections of the Ny Carlsberg Glypothek, 1), Copenhagen, 1931, p. 118.

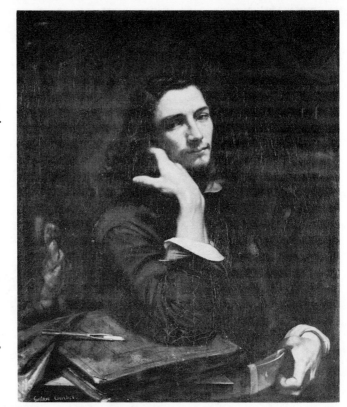

Fig. 1
COURBET:
*The Man in the
Leather Belt,* c. 1845.
Paris, Louvre
(photograph: Réunion
des Musées Nationaux).

Fig. 2
COURBET:
Portrait of Baudelaire,
c. 1847. Montpellier,
Musée Fabre
(photograph:
Claude O'Sughrue).

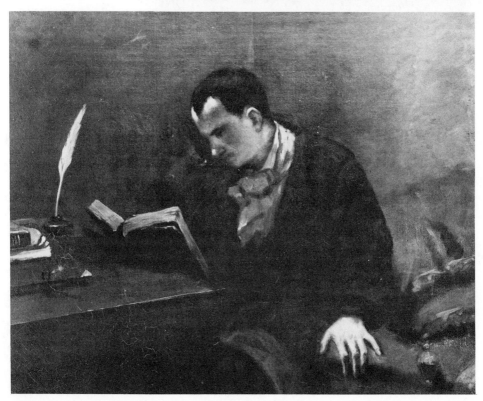

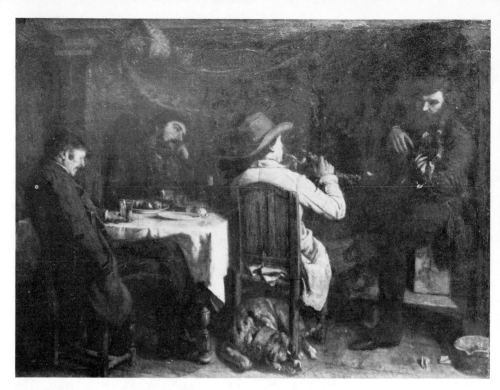

Fig. 3
COURBET:
An Afterdinner at Ornans,
1848-1849. Musée de Lille
(photograph: Giraudon).

Fig. 4
COURBET:
The Stonebreakers, 1849-1850.
Destroyed; formerly in Dresden,
Gemäldegalerie
(photograph: Bulloz).

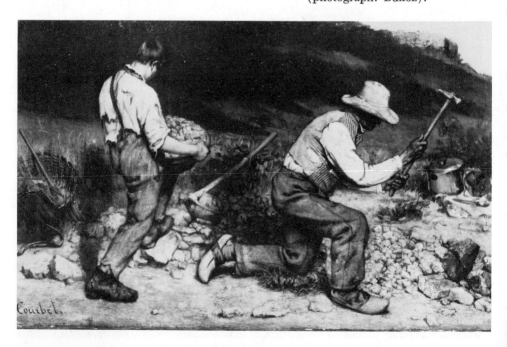

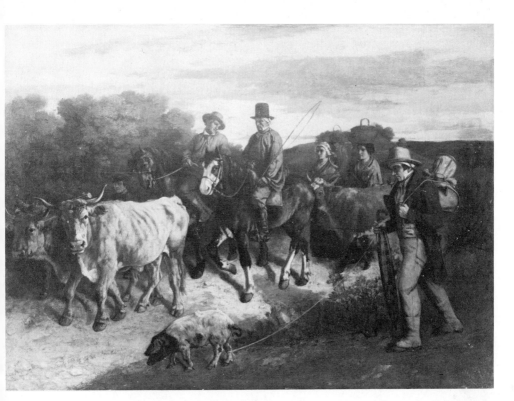

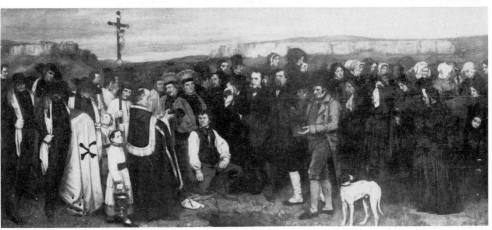

Fig. 5 (above)
COURBET:
The Peasants of Flagey Returning from the Fair, 1850.
Musée de Besançon
(photograph: Meusy).

Fig. 6 (below)
COURBET:
A Funeral at Ornans, 1850.
Paris, Louvre
(photograph: Réunion des Musées Nationaux).

Fig. 7
THOMAS COUTURE:
Romans of the Decadence, 1847.
Paris, Louvre (Photograph: Réunion
des Musées Nationaux).

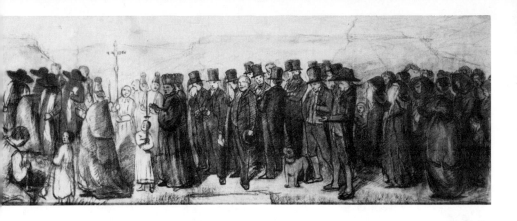

Fig. 8
COURBET:
Preliminary drawing for *A Funeral at Ornans,* 1850.
Musée de Besançon
(photograph: Meusy).

Fig. 9
AUGUSTIN ROGER:
"Un enterrement de village," 1822.
Lithograph after the painting by Bellay
(from J. Vatout and P. J. Quenot, Galérie lithographiée
de son Altesse Royale, Monsieur le Duc d'Orléans).

Fig. 10
"Convoi funèbre de Napoleon."
Popular image from Epinal,
printed and published by Pellerin.

Fig. 11
BARTHOLOMEUS
VAN DER HELST:
*The Company of
Captain Roelof Bicker
and Lieutenant Jan
Michielsz Blaeuw.* Amsterdam, Rijksmuseum
(photograph: copyright
Foto-Commissie Rijksmuseum Amsterdam).

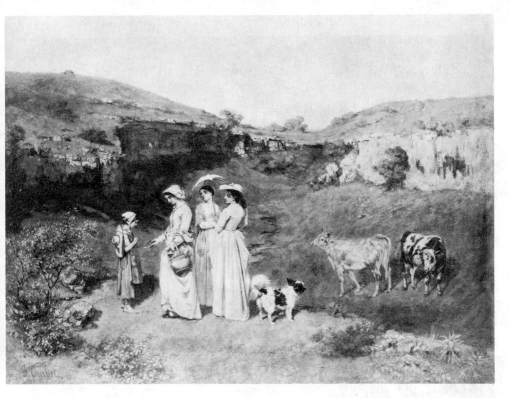

Fig. 12
COURBET:
Young Ladies from the Village, 1851-1852.
New York, Metropolitan Museum of Art
(photograph: museum).

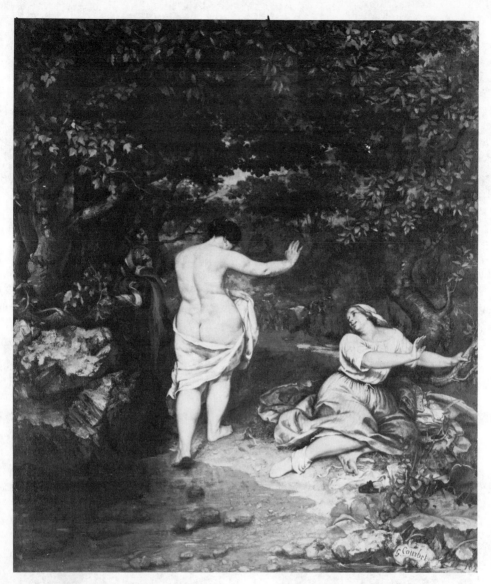

Fig. 13 (above)
COURBET:
The Bathers, 1853.
Montpellier, Musée Fabre
(photograph: Claude O'Sughrue).

Fig. 14 (top right)
COURBET:
The Meeting, 1854.
Montpellier, Musée Fabre
(photograph: Claude O'Sughrue).

Fig. 15 (bottom right)
COURBET:
The Studio, 1855.
Paris, Louvre
(photograph: Réunion des
Musées Nationaux).

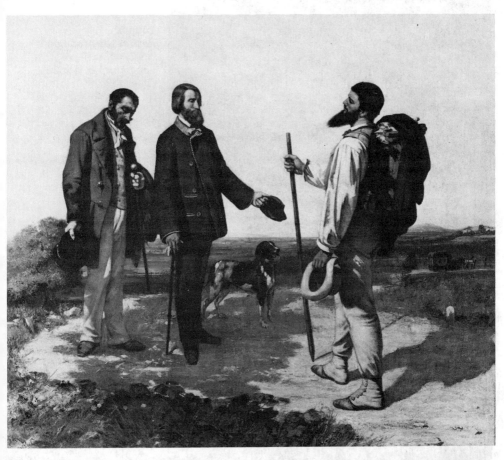

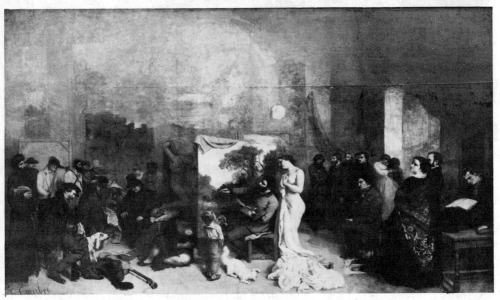

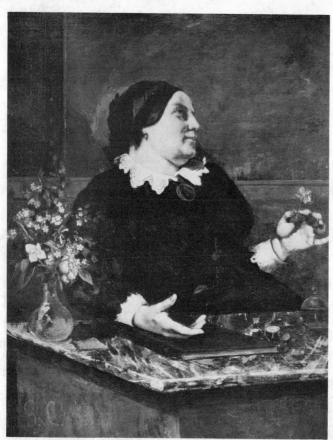

Fig. 16
COURBET:
*Portrait of Madame
Andler (La Mère
Grégoire)*, c. 1855.
Chicago, Art Institute
(photograph: museum).

Fig. 17
COURBET:
*The Woman with a
Parrot*, 1866.
New York, Metropolitan
Museum of Art
(photograph: museum).

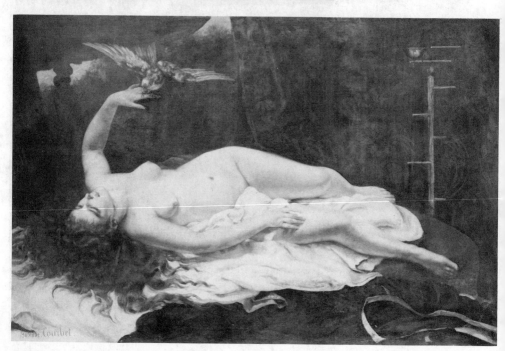

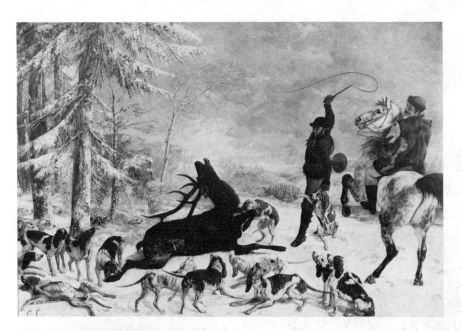

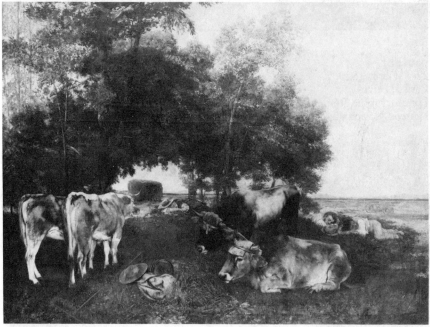

Fig. 18 (above)
COURBET:
Mort of the Stag, 1867.
Musée de Besançon
photograph: Meusy).

Fig. 19 (below)
COURBET:
Siesta at Haymaking Time, 1868.
Paris, Musée du Petit Palais
(photograph: Bulloz).

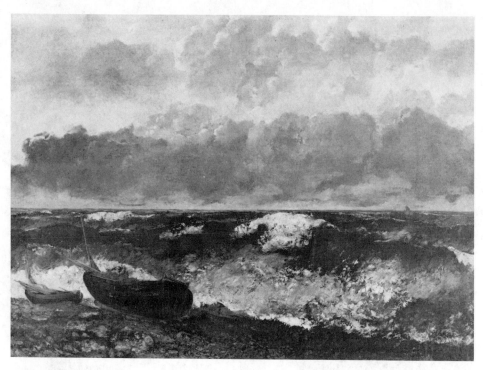

Fig. 20
COURBET:
The Wave, 1870.
Paris, Louvre
(photograph: Réunion des
Musées Nationaux).

Fig. 21
COURBET:
The Trout, 1871.
Zürich, Kunsthaus
(photograph: Walter Dräyer).

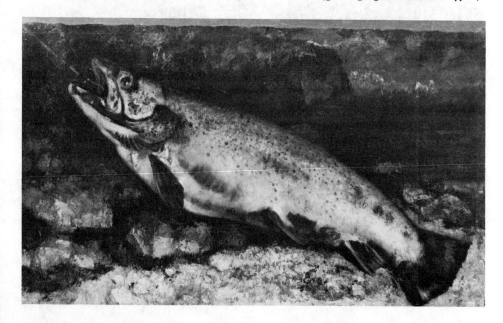

and reactions of ordinary people.[37] And just as the content no longer needed to be elevated and generalized to be significant, so too the formal means by which this content was expressed no longer needed to be embellished and idealized; on the contrary, such tampering with the facts must now be considered to lie in the realm of falsehood. As Ernest Renan had pointed out in *L'Avenir de la science*: ". . . l'humanité cesse de croire à des chimériques beautés pour arriver à découvrir les merveilles de la réalité." [38] Courbet, in the *Burial at Ornans,* has expressed the progressive spirit of his time by representing an event in the lives of "le peuple" in a style which is itself a metaphor of the specificity, the concreteness and the randomness of ordinary life, on a scale hitherto reserved for the representation of elevated or distant events in a suitably idealized style. In this fact lies the revolutionary nature of the painting, and of realism itself.[39]

[37] Meyer Schapiro, Review of *French Painting between the Past and the Present* by Joseph C. Sloane, *The Art Bulletin*, 26, 1954, p. 164.

[38] *L'Avenir de la science: Pensées de 1848* (extraits), ed. Bernard Lalande, Paris, 1954, p. 48. The work was written in 1849 but not published until 1890.

[39] The following is a translation by the editor of the lengthy French quote on pp. 80–81.

"The *Burial at Ornus* is indeed the most important work, the history painting of Mr. Courbet. If Mr. Courbet had bothered to elaborate his thought, to adjust the various parts by cutting out or dissimulating those that are distasteful to the benefit of the interesting motifs that a scene like this could include, he might have produced a good painting. The subject is suitable enough: it is not necessary to go very far in order to produce a moving work; in our opinion, the burial of a peasant is no less touching than the funeral procession of Phocion. But he should first of all not have localized the subject, and secondly he should have emphasized the interesting portions of such a scene. . . . If they are family portraits, leave them at Ornus. To us, who are not from Ornus, we need something more to attract us. What he should have aroused in the spectator is the natural sentiment which accompanies such a scene."

A BOURGEOIS DANCE OF DEATH: MAX BUCHON ON COURBET

Timothy J. Clark

'Nous célébrons tous quelque enterrement.'

Baudelaire, Salon of 1846.

Everyone agrees that Courbet's art, at least at certain moments, was political; but nobody agrees as to the advantage or disadvantage of that fact. Part of the trouble is the abiding imprecision of the very concept of political art, and part is the lack of evidence on Courbet's political views and intentions.[1] The study of his politics has been bedevilled by the controversy over the destruction of the Vendôme Column, and the degree of Courbet's responsibility for that action. Naturally art historians have shrunk from discussing the *quality* of that action, its profound links with parallel gestures of renunciation by Rimbaud or Lautréamont, and its influence on subsequent artistic practice in France ('La magnifique lumière des tableaux de Courbet est pour moi la même que celle de la place Vendôme, à l'heure où la colonne tomba': Breton).[2] But they have given far too much weight to the maudlin letters of the last years, written in the shadow of the Commune, in a demoralization at once political and

"A bourgeois Dance of Death: Max Buchon on Courbet." Excerpt of T. J. Clark, "A bourgeois Dance of Death: Max Buchon on Courbet," *Burlington Magazine*, 111 (1969), pp. 208–212 and 286–290. Footnotes by the author. Reprinted by permission of T. J. Clark and the *Burlington Magazine*.

[1] The best account remains that of MEYER SCHAPIRO; 'Courbet and Popular Imagery: An Essay on Realism and Naïveté,' *Journal of the Warburg and Courtauld Institutes,* 4 [1940–1941], pp. 164–191, especially pp. 169–171 and 188–191. See also LINDA NOCHLIN; *The Development and Nature of Realism in the Work of Gustave Courbet: A Study of the Style and its Social and Artistic Background,* New York University, Ph.D. [1963].

[2] A. BRETON: *Nadja,* Paris [1928], p. 13.

physical. The tone of these letters—incoherent, self-pitying, full of inaccurate revolutionary nostalgia—has been allowed to define our image of Courbet's politics. And the lack of evidence for the years before 1870 [3] has fostered the most persistent of all the myths about Courbet: that he was a naïve and 'natural' painter whose involvement in politics was extrinsic to his art, and finally disastrous for it.

The purpose of this article is to present a piece of evidence on the nature of Courbet's artistic intentions in 1849 and 1850. The evidence is an *annonce* written by Courbet's friend Max Buchon to publicize the exhibition of *Les Casseurs de pierres* [fig. 4] and *Un Enterrement à Ornans* [fig. 6] in Besançon in May, 1850, and in Dijon in July, 1850.[4] The *annonce* is important in its own right, as a brilliant and original piece of criticism, giving some idea of Buchon's strength as a writer (besides translating Hebbel, he was an unpretentious poet of rural life). But it is also important as evidence of the response of one of Courbet's immediate circle to the first great works of his maturity: the response of a man who had been the painter's closest childhood friend and remained his constant companion and mentor. The very circumstances of its publication suggest that if there was any one account of his painting which Courbet accepted as a 'presentation' of his aims and intentions in 1850, it was Max Buchon's.[5]

[3] Courbet first appears in police files on 19th January 1868, *'remarqué au cimetière de Passy le jour anniversaire de la mort de J. P. Proudhon,'* Archives de la Préfecture de Police, Paris. File on Courbet, Ba. 1.020. From then on he is given full coverage. As the file indicates, he was probably by that time a member of the International Working Men's Association, Panthéon section (Marx's 'First International').

[4] The first version appeared in *Le Démocrate Franc-Comtois* [25th April 1850], and the Dijon article in a short-lived Fourierist journal called *Le Peuple, Journal de la Révolution Sociale*, No. 18 [7th June 1850]. Both articles appeared *before* the show's opening in the respective towns, and are specifically designed as introduction and persuasion. The Dijon article is headed *Annonce*. Buchon made important revisions between April and June [reprinted in this volume (ed.)].

[5] In an undated letter, which probably comes from 1851, Courbet wrote to Buchon: *'Je te félicite de ton article, je t'en sais grand gré, il ressemble parfaitement à la nature de mon talent et il est de cet art que j'aime tant,'* quoted in HUGO FREY: *Max Buchon et son oeuvre*, Ph.D. dissertation, Univ. of Besançon [1940], p. 64. Courbet may be referring directly to the *annonce*, or to a review of *Les Paysans de Flagey Revenant de la Foire* by Buchon in *L'Impartial de Besançon* [17th Jan. 1851], which discussed Courbet's art in terms similar to the 1850 *annonce*, though with much less critical force and specific observation. In any case the suggestion made by FREY, *op. cit.* p. 64. n. 2 (and echoed by NOCHLIN, *op. cit.* p. 106, n. 4), that this refers to a Buchon article in *La Démocratie Jurassienne* of 1851 is certainly mistaken. That journal ended its brief life under the Second Republic on 30th July 1850, and even before that date there is no article which corresponds to the terms of Courbet's congratulation.

Both Frey and Nochlin rightly emphasize Courbet's closeness to Buchon, and both are certain that Buchon must have had specific opinions and influence on

In addition the article will discuss the general question of Courbet's politics in this period, and their relevance to the works exhibited in the Salon of 1850–51. It will hope to contribute to an understanding of Courbet's art and its public, and to move towards a general theory of the 1850–51 exhibit and the Parisian reactions to it.

Why do we need a new theory of the genesis and reception of Courbet's 'realism?' Because the available accounts fail to explain many of the mysteries which surround the Salon. Why, for instance, did the *Enterrement à Ornans* become the focus of critical fury, while the *Casseurs de Pierres* remained relatively unscathed—even though its imagery may appear to *us* more radical in style and more explicitly proletarian in content? The public reaction to the *Casseurs de Pierres* changed between 1851 and 1855: by the latter date the piece of advice scribbled in the Complaints Book of the *Exposition Universelle* by 'Un homme propre et délicat' is fairly typical of the reaction at all levels: 'On prie M. Courbet de vouloir bien faire raccommoder la chemise et laver les pieds à ses casseurs de pierres.' [6] In the light of such vulgar certainty, the equivocation of the 1851 reaction to the picture is all the more puzzling. Why was there such a change in the whole tone and temper of criticism between the mildly popular *Un Après-Diner à Ornans* in the Salon of 1849, and the 'disgraceful' *Enterrement* of 1850–51? Why did Millet's *Le Semeur*, which again seems to our eyes an image of the peasant just as violent and brutalized as anything in Courbet, so completely escape critical spleen? [7] Why was there such a geographical difference in the reception of Cour-

Courbet's art. They repeat the opinion of Ch. Léger, who described Buchon as Courbet's *seconde conscience*' (CH. LEGER: *Courbet, ses amis et ses élèves,* Mercure de France [1928]). It would necessarily have been a conscience with a political dimension. By 1849 Buchon was an active political figure of a Fourierist persuasion, a regular contributor to *La Démocratie Jurassienne* and other Leftwing journals in the Franche-Comté, and probably under police surveillance. After the *coup d'état* of December 1851 he escaped to exile in Switzerland. We now have some more concrete evidence as to the operation of the 'second conscience' in artistic matters.

[6] The remark, which is as near as we shall come to the reaction of the 'ordinary' *bourgeois,* is preserved, by accident it appears, in Archives Nationales, series F21 519. Of the thirty complaints which survive, only three are artistic in nature. Two attack Courbet, and the other complains about the quality of the English exhibits.

[7] My account of the critical reaction to the Salon of 1850–51 is based on a reading of all available periodical literature. It uses the material indicated in M. TOURNEUX: *Salons et Expositions d'Art à Paris,* Paris [1919] but includes items beyond the scope of that survey. It significantly differs from the account given in WEINBERG: *French Realism: The Critical Reaction 1830–1870,* New York [1937], pp. 97–116, which is based, explicitly, on the reactions of only seven critics (and it goes beyond the impressionistic collections of outraged opinion common in Courbet biographies, e.g. G. RIAT: *Gustave Courbet, peintre,* Paris [1906], pp. 86–88). I found the reactions of obscure and second-rate writers often far more revealing than the stylish but guarded thrusts of a Delécluze or a Gautier.

bet's work? Courbet himself regarded the show in Besançon as a great success; [8] the Dijon exhibition roused no great feeling one way or the other: [9] it was only in Paris that opinion polarized. Even there it was not a matter of uniform hostility—Courbet's art *did* have its defenders in Paris, and the existence of a Courbet faction with a dangerous and exaggerated enthusiasm for his work forms the background for many of the most violent attacks on him.[10] At certain moments the political aspect of that enthusiasm, and its answering distaste, is sufficiently clear:

> 'Les louanges étranges décernées à M. Courbet ont en premier organe certain populaire aviné qui envahit les banquettes du Salon-Carré. Qu'avait-il là à regarder en effet, si ce ne sont les plus mauvaises croûtes? —Puis des rapins ont fait écho, de proche en proche, il a été question de M. Courbet.'

This was Elisa de Mirbel in *La Révolution Littéraire:* [11] the disruption of the syntax only translates the violence of the emotions. The key word is *populaire,* for what is unforgivable here is not so much Courbet's painting (Mlle. de Mirbel hardly mentions it) as his *audience;* and the image of Courbet's admirers as a horde of wine-besotted scum was to become almost standard in later years. It is a fantasy image, of course, but it indicates at least one truth which we tend to forget: the Salons of the mid-nineteenth century were mass spectacles, attracting huge crowds, and fulfilling for their time something of the function of the cinema in the early twentieth century.[12] In this context it was not necessarily absurd to regard a picture as subversive in the full sense of the word, and to see it as your critical duty to stop the picture's influence at all costs. (Or even, as does Buchon in his *annonce,* to elaborate its subversive content.)

The 'popular' appeal of Courbet's 1851 exhibit is not an *explanation* of the problems we have posed: in one way it is another mystery to be explained. For the question still remains, why was Courbet's art popular in this specific sense? What was the particular appeal of pictures of peasant and small-town provincial life to the Parisian working-class? Why

8 See G. MACK: *Gustave Courbet,* London [1951], p. 72.

9 MACK, *op. cit.,* p. 73. Researches in the periodical literature of Dijon at this time found no reaction to the Courbet exhibition after the Buchon *annonce.*

10 The Courbet faction was part fact, part imaginary. But at a certain level an enthusiasm for Courbet could be thoroughly fashionable. See, for example, the witty and facile defence of Courbet by F. MÉRY in *La Mode* [26th January 1851], pp. 206f. For a discussion of the political implications of some criticisms of Courbet, which reaches conclusions very different from mine, see OLIVER LARKIN: 'Courbet and his Contemporaries: 1848–1867,' *Science and Society,* 3 [Winter, 1939], pp. 42–63.

11 See vol. 1, pp. 26–27. The magazine's revolution was strictly literary.

12 On this topic, see P. GRATE: *Deux Critiques d'art de l'Epoque Romantique: Gustave Planche et Théophile Thoré,* Stockholm [1959], pp. 48–50.

was the *Enterrement* savaged and the *Casseurs de Pierres* spared? Why was a portrayal of rural society such political and artistic dynamite in an *urban* context, while it had been received in Besançon and Dijon—both towns which were still half rural [13]—without incident?

Our explanation will start from one of the most impressive features of Buchon's *annonce:* its willingness to treat the two pictures under review as forming part of the same political narrative. It is not simply that Buchon's account of the pictures is fearlessly and specifically political— for our purposes it is more important that he takes it for granted that the exhibit is a coherent and inter-related whole; one which encourages visual and narrative connections and comparisons of one picture with another. It is this assumption (one would call it an insight, indeed the crucial insight into the nature of Courbet's art at this period, were it not for the suspicion—it can be no more than suspicion—that this view of the pictures emerged naturally, as it were unconsciously, from the process of working and talking with Courbet in 1849 and 1850) which underlies Buchon's whole discussion. On this basis he reaches his most imaginative and unexpected piece of interpretation—the comparison of the old man in the *Casseurs de pierres* with the kneeling grave-digger in the *Enterrement.* I say *reaches* deliberately, for the crucial three paragraphs in which the comparison is pressed home are all additions made for the Dijon *annonce*—it is as if the perception of the visual rhyme between the two figures precipitated a complete new consciousness of the pictures' allegorical dimension:

'Autrefois, dans les vieilles danses macabres, c'était la mort en personne qui faisait pirouetter, bon gré malgré, les rois, les papes, les empereurs, tous les grands de la terre, tous les oppresseurs du pauvre monde.

'M. Courbet nous semble avoir obtenu, avec son fossoyeur, un effet tout aussi énergique et significatif, sans être néanmoins sorti de ce réalisme absolu, aussi indispensable désormais en peinture qu'en politique, et qu'apprécient les bonnes femmes d'Ornans par anticipation, tout aussi bien que la *Presse* et le *National* pourront le faire à l'exposition prochaine. . . .

'Et pourtant, faut-il le dire? à travers l'oppression vague où sa contemplation vous jette, on en revient involontairement, par idée de compensation sans doute, à notre pauvre casseur de pierres, dont ce fossoyeur-ci pourrait bien n'être, dans le pensée du peintre, que l'antithèse psychologique, le contre-poids; je dirais presque le vengeur.'

[For a translation of this passage, see p. 62 in this volume (ed.)].

[13] To take one statistic at random to back this assertion: the inquiry into the social and economic situation instituted by the Republic in 1849 lists the occupation of the majority of the population of *Besançon Nord* as 'agriculteurs.'

The middle paragraph already insists, in anticipation of Courbet's conceptual contortions over *L'Atelier du Peintre* in 1855, that a picture can be real and allegorical at the same time. And it makes the link between realism as an artistic and a political duty which was to become a constant theme of Courbet's aesthetic. One recalls the famous letter to *Le Messager*, dated 19th November 1851,[14] in which Courbet declares himself '*non seulement socialiste, mais bien encore démocrate et républicain, en un mot partisan de toute la Révolution, et, par-dessus tout, réaliste, c'est-à-dire ami sincère de la vraie vérité*'. Even with its typical over-statement, the letter operates in Buchon's conceptual universe.

In his *annonce* Buchon has seen two things. First that Courbet's 1851 exhibit can best be understood as an inter-related series—and one which becomes all the more complex and thematically coherent when the *Paysans de Flagey* [fig. 5] is added for the Paris show. Second, that the narrative links and contrasts between the pictures centre on a linkage and contrast of social class: between, as Buchon elucidates it, the rural proletariat of the *Casseurs de Pierres* and their *oppresseurs*, the respectable bourgeois of Ornans; and between those two classes and the *fossoyeur . . . vengeur*, a man who is identified as a vine-grower and a peasant. To schematize: in Buchon's account the peasant liberates the proletarian from the bourgeois; or such is the possibility.

The details of this structure are Buchon's invention; this is a *pictorial* narrative and we have every right to consider any verbal reworking too explicit. Nevertheless, Buchon has seen, in the process, another crucial feature of the 1851 exhibit: that suggested by the word *bourgeois*.[15] For the Parisian audience, the coherence and the flashpoint of Courbet's exhibit was precisely its bourgeois nature. That insight was in fact *repressed* by most of the critics,[16] but it is superbly explicit in the

14 Quoted in RIAT, *op. cit.*, pp. 93–94.
15 The word bourgeois had already acquired by 1850 a whole complex of connotations. It is used in this article in a traditional, descriptive and specifically French sense, to indicate that class of urban property-owners, with its own distinctive moral and cultural order, which was felt to have usurped social power in the early nineteenth century. It is a concept which finds its definition—its use-value, one could say—in the work of Flaubert, Baudelaire, Daumier, or in Marx's descriptive analyses of nineteenth-century French history, particularly *The Eighteenth Brumaire of Louis Bonaparte* [1852]. See also the most important modern work on the formation and structure of the Parisian bourgeoisie. A. DAUMARD: *La Bourgeoisie Parisienne de 1815 à 1848*, Paris [1963]. It is invaluable for the study of French art at this time.
16 We are able to talk of repression because the act leaves such clear, yet unconscious, verbal traces. Hence the danger of taking at face-value the language of the critics in 1851 (as Weinberg does). What is most curious is the dissociation between the well-worn, aesthetic nature of the surface objections (criticism of Courbet's lack of composition, of lack of chiaroscuro, of insufficient idealization

other review which ranks with the Buchon *annonce:* Champfleury's article in *Le Messager de l'Assemblée.*[17] From first to last, in this review, Champfleury's appreciation of Courbet is as the painter not of the peasantry but of the rural bourgeoisie, the *bourgeois de province* who were about to be celebrated and sacrificed in the novels of Flaubert.

> 'C'est la mort d'un bourgeois qui est suivi à sa dernière demeure par d'autres bourgeois [. . .] Est-ce de la faute du peintre si les intérêts matériels, si la vie de petite ville, si des egoïsmes sordides, si la mesquinerie de provinces douent leurs griffes sur la figure, éteignent les yeux, plissent le front, hébètent la bouche. Les bourgeois sont ainsi; M. Courbet a peint des bourgeois [. . . .] Ce n'est pas l'austérité, c'est la bourgeoisie moderne, avec ses ridicules, ses laideurs et ses beautés. . .'

Sentences like these form a refrain to Champfleury's long defence of Courbet against his attackers. Nor is it an accident if they recall Baudelaire's famous conclusion to the Salon of 1846, *De L'Héroïsme de la Vie Moderne.* For Champfleury's review is, as a whole, profoundly Baudelairian: it is written by someone still totally under Baudelaire's spell. The clearest sign of this is the obsession with modern dress and its peculiar beauties—the very definition of modernity which the article offers is framed in terms of costume and its profound connection with a whole

of the subject—the kind of charges that had been levelled at a succession of progressive painters: one has only to look back as far as the reaction to Couture's *Romains de la Décadence* in the 1847 Salon) and the disproportionate anger generated in the critics' style and imagery. It is what Freud called dissociation of affect from content.

I shall argue in another article that a proper analysis of the structure and vocabulary of the 1851 reviews—a 'practical criticism,' shall we say—reveals quite clearly the presence of a level of distaste, of fear, and at times of panic, which is quite divorced from purely formal concerns. The role of the word *bourgeois* in the Salon reviews is quite distinctive—it regularly crops up at the conclusion of formal diatribes, to indicate, as it were, what kind of displacement is represented by the anger at Courbet's stylistic innovations. Invariably it is the specifically bourgeois images which are the focus of hysterical, disproportionate rage—the male mourners in the *Enterrement,* and the grotesque image of the man with pig and umbrella in the *Paysans de Flagey* (see, on the latter, the reaction of PROSPER HAUSSARD, a 'progressive' critic writing in the republican socialist newspaper, *Le National* [20th February 1851]. It is the very paper whose favourable reaction Buchon anticipates in the *annonce*).

This is not to suggest that Courbet's art is *not* formally original: of course it is. But the difference between the reception of *Un Après-diner à Ornans* (let alone of Millet's *Le Semeur*) and of the *Enterrement* is not explained by any fundamental stylistic innovation.

17 Published on 25th and 26th February, 1851; republished, with some modifications, in CHAMPFLEURY: *Grandes Figures d'Hier et d'Aujourd'hui,* Paris [1861] [reprinted in this volume (ed.)].

new social order.[18] When we add that the review includes a digression in praise of the joys of wine (*à propos* of the red noses of the beadles in the *Enterrement*), and that ten days later, on 8th March, *Le Messager de l'Assemblée* published the first section of Baudelaire's *Du Vin et du Hachish;* or if we point out that the article ends with a panegyric on Delacroix's 'mystery' ('*M. Eugène Delacroix est le seul grand artiste d'aujourd'hui*'), then the relationship with Baudelaire may seem dangerously close to caricature. It is certainly one of unashamed plagiarism,[19] but the article works, as art criticism, precisely because its enthusiasms coincide with one important aspect of Courbet's art.

The relation of Baudelaire to Courbet still remains obscure [20] but it is clear that the association of poet and painter in the 1840's was a far more important experience for both than has often been recognized. The iconography of Courbet's art in the mid-1840's has its source in the myths and attitudes of the Baudelairian *milieu* (more of the *milieu*, with its ostentatious, Bohemian self-consciousness, than of the subtler poses of Baudelaire himself): the early self-portraits, in particular, owe everything to that life-style. But this, perhaps, was one reason for their weakness. What Baudelaire contributed to the *strength* of Courbet's art was a certain kind of ambitious and acute social vision. Champfleury was hardly wrong in seeing the *Enterrement* as almost a direct answer to Baudelaire's prescriptions of 1845 and 1846, his call for a painter who would show 'Combien nous sommes grands et poétiques dans nos cravates et nos bottines vernies' [21] and how 'Nous célébrons tous quelque enterrement.' [22]

And yet, however great was Courbet's debt to Baudelaire, and

18 E.g., 'Il a plu au peintre de nous montrer la vie domestique de petite ville; il s'est dit que des robes d'indienne et des habits noirs valaient les costumes espagnoles, les dentelles et les plumets de Louis XIII [. . .] le costume moderne est en harmonie avec la beauté moderne [. . .] Dans notre temps où l'économie politique joue un grand role, où la science s'agrandit de jour en jour, ou la fantaisie ne sera permise qu'à des esprits savants, le costume doit devenir sérieux . . .''

For a discussion of the relationship of Courbet, Champfleury and Baudelaire, see YOSHIO ABE: 'Un Enterrement à Ornans et l'habit noir Baudelairien' in *Etudes de Langue et Littérature Françaises, bulletin de la Société Japonaise de Langue et Littérature Françaises,* No. 1, Tokyo [1962], pp. 29–41.

19 In an earlier article on Courbet's *Enterrement,* which he had been able to see in the Dijon exhibition, Champfleury quoted directly from Baudelaire's 1846 Salon. See *L'Ordre* [21st September 1850] and ABE's discussion, op. cit., pp. 34–35.

20 See CH. LÉGER: 'Baudelaire et Courbet' in *Mercure de France,* t. CCXC [1939], pp. 721–727, and ABE, *op. cit.,* pp. 36–37. I am indebted to conversations with Dr. Irene van Reitzenstein, of the University of West Berlin, on this subject (though we disagree on many points).

21 BAUDELAIRE: *Curiosités Esthétiques,* Éditions Garnier Paris [1962], p. 85 (Salon of 1845).

22 *Ibid.,* p. 196 (Salon of 1846).

however acute Champfleury's intimation of this fact, perhaps Courbet's greatest achievement in 1849–1850 was to *break* with the Baudelairian influence. Courbet's withdrawal from Paris in October 1849 was the single most decisive step in his artistic life. In artistic and personal terms, the retreat to Ornans was a retreat from abstraction—the abstract imagery of 'individualism' which pervades the postures and fantasies of the early self-portraits, and the 'rebellious pathos'[23] of Bohemia. It was a withdrawal into the concrete texture of Courbet's individual past, a return to what had *determined* his individuality. (The problematic nature of that individuality for the artist is sufficiently clear in the imagery of *L'Homme Blessé* or *Le Désespéré*, or in a title like *L'Homme Délivré de L'Amour par La Mort*.) In a word, what is achieved in the three great pictures of 1850 is an intuitive identification of the quite specific, historical situation of Courbet's own family. The pictures have the force of catharsis; in them Courbet recognizes and represents his class identity. . . .

The 1851 exhibit is not merely a description of *the* bourgeoisie; it is an identification of oneself and one's family as bourgeois; its greatness lies in its recognition both of the ambiguities of that identity, and of its final, unavoidable presence. The *ambiguity* of the Courbet family's situation is a matter of empirical fact. The family was one of that steadily growing class of rich vine-growing peasant proprietors who, in the course of a generation, moved from the countryside into Ornans, and gradually, unconsciously, built a bourgeois identity for themselves.[24] The fact that Courbet's father appears in *L'Enterrement* in the bourgeois top hat and *habit noir,* and in *Les Paysans de Flagey* as the central figure in a peasant smock, goes to the heart of the matter. Yet in spite of the ambiguity, the presence of a bourgeois identity is never in doubt; in the *Enterrement* it is decisively asserted. The difference from *Un Après-diner à Ornans* is quite fundamental here. Where the earlier picture had portrayed an enclosed, protected, domestic, *interior* life— a life in which the family unit is primary, though the actual subject includes Courbet's father with some friends—in the pictures of 1850 the family is, as it were, dispersed and reconstituted as a social fact. In the

[23] See WALTER BENJAMIN: 'Paris, die Hauptstadt des XIX Jahrhunderts' in *Illuminationen*, Frankfurt [1961], translated as 'Paris—Capital of the Nineteenth Century' in *New Left Review*, No. 48 [March–April 1968], p. 85.

[24] George Riat's description is the most succinct: 'Tel fut . . . le milieu familial où Courbet grandit, milieu bourgeois plus que paysan, pas assez bourgeois que le jeune homme fut privé du spectacle de la nature, trop peu paysan pour qu'on ait songé à faire de lui autre chose qu'un adepte des carrières libérales.' G. RIAT: *Gustave Courbet, peintre*, Paris [1906], p. 3.

Enterrement the family is, in a literal sense,[25] separated out into its constituents, which then take their place in a social or class constellation, as units in the dense structure of a privileged [26] social ritual, as parts of a bourgeois whole. It is basic to Courbet's achievement that here society is no longer structured on and around the family—that instead the family is pulled apart by society and forms part of a social continuum.

Class identity is, as always, a hidden identity as long as the family remains our primary point of personal reference: its unity, undeniable and seemingly *undetermined,* is a mask for social reality. To recognize a class, one has to de-constitute the family.[27] Courbet had made a first, abstract and iconoclastic effort to do that in *Loth et ses Filles* in 1840–41 —but to escape from the family one has to do more than make obscene gestures in its direction. In *Un Après-diner à Ornans* the problem of the family is merely evaded: all we have is a change of personnel, not of configuration.[28] But the *Enterrement* is something new in Courbet's art, neither a family group, nor a self-portrait, nor even a 'portrait of my friends.' It is a *placing* of the family—it establishes a distance, a point of view, an irony. The famous subtitle *tableau historique* participates in this: what is given form is precisely Courbet's own history.

Which brings us back to Buchon's *annonce*. If we are talking of self-identification, it is worth remembering that Buchon himself appears in the *Enterrement,* complete, as far as we can tell, with *habit noir.* He is one of the very bourgeois oppressors on whom the grave-digger will have his revenge. And there is a similar irony in the sheer *elegance* of Courbet's later portrait of Buchon: the revolutionary as dandy and

25 The father is in top hat in the rear row at the centre, the daughters in the front row at centre right, and the mother on the extreme right, holding the hand of the mayor's daughter.

26 That a burial of this kind was a social privilege in the 1840's is undoubted: from 1839 to 1847, an average of 78.6 per cent of Parisians were buried in the *fosse commune* (A. DAUMARD: *La Bourgeoisie Parisienne de 1815 à 1848*, Paris [1963], p. 11). Such a deprivation was bitterly felt: the Parisian working-class attached tremendous importance to the religious rites of burial. On several occasions the refusal of the clergy to administer religious rites to men who had not received extreme unction provoked popular uprisings in Paris (*ibid.,* p. 348).

27 I am indebted here to Sartre's analyses of similar—if infinitely more complex— manoeuvres of consciousness in Flaubert. See J. P. SARTRE: 'La conscience de classe chez Flaubert,' *Les Temps Modernes,* Nos. 240–241, especially pp. 1935–1937, and 'Flaubert, du poète à l'Artiste,' *Les Temps Modernes,* Nos. 243–245, especially pp. 209–211 and pp. 246–247.

28 The description which Courbet contributed to the Salon stresses the utterly factual and familial nature of the scene: 'Une (sic) après-diner à Ornans—c'était au mois de novembre, nous étions chez notre ami Cuénot, Marlet revenait de la chasse, et nous avions engagé Promayet à jouer de violon devant mon père.' *Archives du Louvre, Notice des artistes,* 1849 Salon.

flâneur, the last homage to Baudelaire.[29] Nevertheless, Buchon's prime function in 1849–50 was as antidote to Baudelaire and Bohemian Paris: he was the one man who could assert, with utter confidence, the virtue of politics and provincialism (the two qualities which, by 1849, the Baudelaire circle most despised). In so doing he made a crucial contribution to Courbet's art.

We have described the 1851 exhibit as designed as a coherent whole. In it is presented a complex account of the differentiated *structure* of rural society, and the place of Courbet's family within it. Central to that representation is a vision of class differences, hierarchies, ambiguities, even conflicts within rural society. This is not to say that rural socety is volatile in Courbet—but it is certainly, and fundamentally, disunited. And the ways in which Buchon's *annonce* echoes this description are clear.

But why did this image of rural society so profoundly disturb an *urban* audience? In the scope of this article the answer can be only cursory. Any reading of the periodical literature of the Second Republic will show that Paris was obsessed with *le problème de la terre* and the implication of the slogan *La République des Paysans*. The newspapers are filled with *Adresses aux Cultivateurs* and *Solutions à la crise dans les campagnes*.[30] On one level this is a simple matter: the peasantry, after all, had been given the vote and had become the numerical masters. But there is a note of mounting desperation in the Parisian view of the provinces which remains to be explained.

The starting-point of a study of the rural situation in 1848–51, and its relevance to Courbet's art, is still Meyer Schapiro's account of twenty-eight years ago: [31]

'The events of 1848 to 1851 had made clear the sharp differences of opinion among [the people], the stratification of peasants and small proprietors, of factory workers and artisans, the first group attached to its soil, conservative, often religious; the others, without possessions, brought together in work and more apt to independent resistance and struggle.'

[29] It is now in the Musée Jenisch in Vevey. Probably begun in Switzerland in 1854, but retouched later (under the influence of Manet?).

[30] Among a mass of material, the outstanding work is AD. BLANQUI: 'Tableau des populations rurales de la France en 1850,' *Journal des Economistes*, t.28 [January 1851] and t.30 [September 1851]. More typical of the prevailing mood is a work like L. Y. MAILLARD: *Les Villageois; leur misères actuelles; des divers remèdes proposés; leur future bonheur dans la communauté*, Paris [1848], which ends with a *Cabétiste* solution. The government inquiry of 1849 into the agricultural and economic situation in the provinces was the most grandiose product of this general concern.

[31] MEYER SCHAPIRO: 'Courbet and Popular Imagery: An Essay on Realism and Naïveté,' *Journal of the Warburg and Courtauld Institutes*, 4 [1940–1949], p. 185.

In this account the peasantry are essentially a conservative force, 'frightened by the spectres of revolution' [32] and ultimately on the side of the upper classes against the revolutionary proletariat in the towns. And the *Enterrement* is a picture which in a profound sense represents that conservatism—'here the history of man is like natural history and assumes a timeless and anonymous character. . . . The funeral custom replaces the occasion, the cause and effect of an individual death. The community at the grave absorbs the individuals. . . . Thus the consciousness of the community, awakened by the revolution of 1848, appears for the first time in a monumental picture, in all its richness of allusion, already retrospective and inert.' [33]

It is time the emphasis of this brilliant account was reversed. The view of the peasantry as an increasingly reactionary force in the Second Republic has been all but demolished by French historians in recent years.[34] We can now see the countryside as the area in which the crucial social and political struggle was waged between 1849 and 1851. After the abortive Parisian uprising of 1849, the revolutionary initiative passed to the peasantry: radical and reactionary activists moved out of Paris and

[32] *Ibid.*, p. 185.

[33] *Ibid.*, pp. 190–191.

[34] The best work is PHILIPPE VIGIER: *La Seconde République dans la Région Alpine: Étude politique et sociale*, Paris [1963]. C.f. A. SOBOUL: 'La question paysanne en 1848,' *La Pensée* [1948], Nos. 18–20; *Id.*, 'Documents, Les troubles agraires de 1848,' *1848*, t.39 [1948], pp. 1–20 and 39–61; L. CHEVALIER: *Fondements économiques et sociaux de l'histoire politique de la Région parisienne (1848–1870)*, Thèse Lettres, Paris [1951]; A. ARMENGAUD: *Les Populations de l'Est Aquitain au début de l'époque contemporaine. Recherches sur une région moins développée (vers 1845–vers 1871)*, Paris [1961]. See also E. TENOT: *La Province en décembre 1851*, Paris [1865], and AD. BLANQUI, *op. cit.*

Schapiro's account obviously owes much to Marx, but it is worth pointing out that Marx himself was fully aware of the revolutionary development of the peasantry between 1849 and 1851, which culminated in the resistance to the Napoleonic *coup d'état*. See Marx: *The Eighteenth Brumaire of Louis Bonaparte* (in K. MARX and F. ENGELS: *Selected Works*, Moscow [1962], Vol. 1, pp. 243–344) especially pp. 333–338. E.g. 'The three years' rigorous rule of the parliamentary republic had freed a part of the French peasants from the Napoleonic illusion and had revolutionized them, even if only superficially; but the bourgeoisie violently repressed them as often as they set themselves in motion [. . . .] In the risings after the *coup d'état*, a part of the French peasantry protested, arms in hand, against their own vote of December 10, 1848 [when the peasant vote had made Louis Napoleon president of the Republic]. The school they had gone through since 1848 had sharpened their wits [. . .] The interests of the peasants [. . .] are no longer, as under Napoleon I, in accord with, but in opposition to the interests of the bourgeoisie, to capital. Hence the peasants find their natural ally and leader in the urban proletariat, whose task is the overthrow of the bourgeois order,' pp. 335, 336 and 338. Only the last phrase goes beyond historical description—in 1851 the Parisian workingclass had yet to recover from the defeats of the June Days and 1849.

the big cities into the countryside and began a fierce battle for peasant allegiance. The battle was most often secret or suppressed—but for two years the peasantry hung in the balance between conservatism and revolution. By December, 1851, when Louis Napoleon staged his *coup d'état* against a demoralized Parisian working-class, all eyes were on the response in the provinces. And the peasantry was, in fact the only class to mount an organized and coherent resistance to the *coup*—in the Alpine departments 25,000–30,000 peasants took up arms; there was insurrection in the Var, in the Lyons countryside and the Rhone valley, and elsewhere. More important, the resistance to the *coup d'état* had a real political and social programme: in three years the peasantry had moved from the spontaneous *jacqueries* which swept the French countryside in the bad harvests of 1847 and 1848, towards full political consciousness, a determination to forge and this time to *control* the *République des Paysans*, the *République Démocratique et Sociale*.[35]

The process which ended with the resistance of December 1851 is complex, and the story of the Republican secret societies in the countryside is still being written. But two things are clear. First, the idea of the peasantry as immutable supporters of the *parti de l'ordre* was in disarray—and news of its breakdown reached and excited Paris. Attention in the capital—on both Right and Left—was focused on the struggle in the provinces, and on the magical date of 1852, the year, so it was rumoured, of the peasant revolution.[36] Secondly, the focus of that conflict was the

[35] See, e.g., VIGIER's conclusion, *op. cit.*, Vol. 2, pp. 336–7: '*La signification véritable des évènements survenus dans la Région alpine . . . apparait maintenant de façon suffisamment claire. Il ne s'agit pas d'une Jacquerie—ni d'un simple mouvement de résistance spontanée à l'acte fortuit d'un homme. L'ampleur de ces mouvements, le fanatisme manifesté par les combattants de Crest ou des Mées sont le resultat d'une propagande inlassable menée depuis trois ans auprès des paysans et des artisans des bourgs ruraux enregimentés en très grand nombre dans les sociétés secrètes républicaines dont ces évènements révèlent à la fois l'existence et l'extension considérable. [. . .] ce mouvement de résistance n'a eu qu'accessoirement le caractère négatif d'une protestation contre l'acte de Louis Napoléon: ce dernier était beaucoup moins détesté que les notables conservateurs . . . L'insurrection a pris souvent, surtout dans les Basses-Alpes, l'aspect positif d'une véritable Révolution nouvelle, qui doit fonder la République démocratique et sociale. Il s'agit bien . . . d'une nouveau avant tout politique. Mais qui songerait à exposer sa vie pour défendre un régime unanimement décrié? On se bat pour en instaurer un nouveau —celui que l'on voulait jadis mettre sur pied en 1852—un régime qui fasse aux réformes sociales et aux revendications populaires une large place.*' The reaction to the coup was, of course, too localized to be effective—in general the peasantry of the whole of northern France put up no resistance, and the risings were crushed by the army.

[36] '*Attendez 1852, disent les hommes de peine en réclamant leur salaire, ce sera notre tour alors.*' Arch. Nat. BB30 396. General report of the Nîmes *procureur général* in 1852, quoted in CL. LEVY: 'Notes sur les Fondements sociaux de l'insurrection de Décembre 1851 en Provence,' *L'information historique* [1954], No. 4, p. 143.

intensifying hostility between the peasantry and the rural *bourgeoisie*. In the first half of the nineteenth century the small-town, provincial bourgeois had finally become the dominant power in the countryside—buying land for himself and providing capital for the peasant proprietor. Farming was in turmoil—new cash crops; new techniques, often expensive; and painful adaptation to new markets. In such a context, capital from the town moved in unopposed. Then in 1847 came the first of four years of bad harvests, and in the full-scale agricultural crisis which ensued all the writers agreed that the great problem was the crippling burden of peasant debt: and that question was immediately one of the peasant's relation to the bourgeois. In a report of December, 1849, the Préfet of the Drôme elucidated:

'La bourgeoisie ayant vendu ses terres et étant créancière des paysans, les démolisseurs [*i.e. the Republican and socialist propagandists*] ont rendu les bourgeois suspects aux paysans, parce qu'ils ont dit à ceux-ci que les bourgeois s'opposaient à ce que le paysan pût se libérer afin de le tenir en quelque sorte en servage. C'est ainsi qu'on a fait déclarer la guerre par la veste à l'habit.' [37]

[37] Quoted in VIGIER, *op. cit.*, vol. 1, pp. 62–3. It is interesting from our point of view that the Préfet identifies the conflict as one of *costume*—peasant *veste* against bourgeois *habit noir*.

Cf. the Préfet of the Basses-Alpes in 1850, in a report to the *Conseil Général*: '*a lutte s'établit, en ce moment, entre le capitaliste et le proprietaire obéré.*'

Vigier's verdict on the new conflict must be quoted in full: 'Dans cette vaste contrée où le regime féodal, sauf quelques rares exceptions, ne fut jamais très pesant, le riche propriétaire résidant et le gros exploitant, qui procurent aux paysans des alentours les 'journées' leur venant en aide (et qui sont eux-mêmes parmi les plus durement atteints par la crise agricole), suscitent moins d'animosité chez le petit cultivateur que *le bourgeois de la ville ou du bourg, acheteur (au plus bas prix possible)* de ses denrées, ou pourvoyeur des porteurs de contraintes . . . Les habitants de Chavannes marcheront, le 7 décembre 1851, sur le château de leur ancien maire; mais ce n'est pas parce que Gallard est l'héritier de leur seigneur: c'est parce que cet ancien notaire est *le créancier* d'un grand nombre d'entre 'eux.' op. cit., p. 73, (the words in italic type are my emphasis).

Finally it should be noted that peasant-bourgeois hostility, and, of course, its pernicious results, is a *leitmotif* of all writing on the rural community in the 1850's and 60's, even when it coexists with a thoroughly mythological vision of rural society as a one-class community (see below). To take a random example (from a book which is one of the best of its genre), this is ALCEE DURRIEUX in *Monographie du Paysan du Département du Gers*, Paris [1865] (written in 1860–61), p. 25: 'A ces traits principaux [du paysan] se mêle une défiance extrême, *un habit noir est un ennemi pour l'homme des champs.*' (the words in italic type are my emphasis). The same theme had been adumbrated in Balzac's *Les Paysans*, first published 1844. And in the visual arts, Daumier had given the *Bourgeois campagnard* merciless definition in a drawing for *Les Français peints par eux-mêmes*, Paris [1841].

This, then, is the setting of Courbet's 1851 exhibit.[38] By 1850 rural society had become the locus of social and political struggle, and one of the most potent sources of conflict was the antagonism between peasant and bourgeois, 'la guerre par la veste à l'habit' in which 'un habit noir est un ennemi pour l'homme des champs'. In this setting the total, articulated structure of Courbet's three works, and Buchon's account of them, take on a complex of meanings. I would wish also to modify Shapiro's formal account of the Enterrement. What we have is certainly a picture of a community, and a representation of its dense, material existence—but I doubt whether the community 'absorbs the individual'. As the eye moves to the right along the frieze-like structure of the Enterrement, there is certainly a drama played out between the acutely individual, 'realized' portrait faces of the Ornans bourgeois and the layer of thick, almost undifferentiated black pigment which increasingly engulfs the figures.

As Schapiro implies, the revolutionary aspect of Courbet's painting at this time is his use of the dark ground. Monet was later to recall that when he was painting with Courbet in the 1860's, Courbet used to recommend him to start with a dark ground so as to establish his main masses in the shortest possible time. Needless to say, Monet did not follow the advice for long; and I think the attitude of the two painters to this method is somehow significant of a whole difference of aesthetic.

[38] We have reason to believe that the insurrection of 1851 stayed in Courbet's mind, and that at one point he planned a specific work on the subject. In the Archives de la Préfecture de Police, Courbet, file Ba. 1.020, the following extract from Phare de la Loire [19th December 1868], is preserved: 'Le Français parle ainsi d'un tableau dont il a été question naguère dans l'une de nos correspondances parisiennes:

On annonce que M. Courbet enverra cette année au Salon un tableau représentant Martin Bidauré, le paysan du Var, fusillé deux fois.'

Here at least we have, to quote Schapiro, 'the occasion, the cause and effect of an individual death.' The Martin Bidauré referred to is evidently the Martin Bidoure of J. MAITRON: Dictionnaire Biographique du Mouvement Ouvrier Français, Vol. 1, 1789–1864, Paris [1964], p. 225: BIDOURE: 'Surnom du plus célèbre des insurgés du Var de décembre 1851: le peigneur de chanvre Martin de Barjols.' The project never bore fruit, but its existence as late as 1868 is evidence of the continuing importance of the 1851 resistance for Courbet.

The situation in the Franche-Comté from 1848–51 varied according to time and place. There was no insurrection in 1851, and Ornans itself was a conservative borough, voting solidly for the parti de l'ordre in all elections. But the Jura was a hotbed of Republican organization (it was Buchon's main point of reference as a politician) and when Louis Napoleon visited Besançon in 1850 he was given a violent reception by the workers of the north of the city (most of them, as we have seen, 'agriculteurs'). See R. MARLIN: 'L'Election presidentielle de Louis-Napoléon dans le Doubs,' Annales littéraires de l'université de Besançon, Histoire [1955]. On the general situation, the most useful is R. MARLIN: L'epuration politique dans le Doubs à la suite du coup de 1851, Dôle [1958], and E. PRECLIN: 'La Révolution de 1848 en Franche-Comté, 1848–51,' Etudes D'Histoire Moderne et Contemporaine, 2 [1948].

For putting a series of representative marks on a white or neutral canvas, as Monet does, is a process of 'materialization.' An object materializes under the painter's brush; it is an equivalent for something in the real world 'outside,' yet because the painter accepts an initial absence of this real world from his canvas he is still a creator in some magic sense, a conjurer. Courbet is different. When he paints on to a dark ground his action is in some way closer to a sculptor than to this kind of painter. Painting on to a dark ground is *articulation*, the articulation of a matter which is already accepted as present.

One thing is clear—darkness in Courbet is not traditional shadow or chiaroscuro. It is crass to call Courbet a 'traditional' painter (as have several 'modernist' critics) merely because he used a lot of black pigment: the point is that he used black in a new way. Courbet's black is not the old drama of light and shade from which figures emerge, or by which they are swallowed; the black and the descriptive colours of hands and faces exist in an unstable equilibrium, since one is the *matter* of the other. In spite of Courbet's 1847 visit to Holland, and the depth of his enthusiasm for Rembrandt, the drama is not in the ebb or flow of light, or a sudden mimetic leap of space: Courbet's achievement was to assimilate Rembrandt's handling to a totally different attitude to form. The drama in a Courbet of this period is in the interplay between the basic anonymity of matter and the perceived individuality of another person or even another thing.

What is important is that, in the *Burial*, ground and image are in conflict—each is given an equal and opposite pictorial weight. A head in the *Burial* exists clearly against the dense blackness of the bodies, and yet by the very method of painting we feel the way in which the blackness informs and defines it. This blackness is also its terror. At this point materiality is not neutral in Courbet; it is taken as the *essential*, but with a kind of horror. This may be the reason why the handkerchief which masks the face of Courbet's sister Zoé is so disturbing: underneath the kerchief, instead of an imaginable face and features, is blackness, and that is both 'matter of fact' and also terrible.[39] Elsewhere in the picture the conflict of matter and individuality, anonymous community and asserted 'personality' reaches no such conclusion. As a whole, the conflict is unresolved.

The picture's reception in Paris now begins to make more sense. The Paris of early 1851 was peculiarly and rightly sensitive to a portrayal of rural society which indicated its social differences and ambiguities, which hinted at nascent or latent conflict. This was not simply an attack

[39] By grotesque coincidence, it was Zoé who was later to be committed to an asylum, diagnosed as schizophrenic.

of political nerves, of bourgeois fear and excitement at the myth of
'1852.' There were more profound and deep-rooted reasons why these
monumental pictures of rural France had an immediate relevance to
nineteenth-century Paris.

Paris in 1850 was an immigrant city.[40] The railway boom of the
40's had brought a fresh wave of peasants into the capital to swell the
ranks of the working-class. That process was common to all European
cities, but Paris was also a city of temporary, migrant workers—peasants
who came in thousands to settle for the summer in appalling *taudis* on
the Ile de la Cité or in the fast-growing industrial sprawl of the areas
around the new *barrières*. It was a city where the physical presence of
the peasantry was undeniable, where a proletariat in the classic sense
was still in process of formation, where the diverse human material
which went to make industrial society still had its own weight.[41]

These are the *populaires avinés* who celebrated Courbet's pictures.
If we are to identify Courbet's Parisian audience, we should remember
that the older generation of the city's working-class was, by 1840, hope-
lessly enfeebled both physically and politically. In 1848 the most volatile
sections of the working-class were precisely the new peasant immigrants.[42]
When we read of workers from the banlieue blowing up railway lines
in June 1848, in an attempt to stop the arrival of trainloads of peasant
National Guards from the provinces (summoned by the central govern-
ment to crush the June Days uprising), we should remember that the
worker of the banlieue most often still wore his peasant smock.[43] At this
point peasant fought peasant—with only a few years of urban experience
to differentiate them.

Paris was an immigrant city *at every level of the social scale.*[44]
What was true for the working-class was equally true for the bourgeoisie,
even for the aristocracy of finance capital: in every social class there were

[40] See L. CHEVALIER: *Classes Laborieuses et Classes Dangereuses à Paris pendant la
première moitié du XIXe. siècle*, Paris [1958]; CHEVALIER: *La Formation de la
population parisienne au XIXe. siècle*, Paris [1950]; DAUMARD, *op. cit.*

[41] The diversity of Parisian 'types' was a constant theme of the pseudo-sociological
Physiologies of the 1840's e.g. *Physiologie du Provincial à Paris* [1841].
 On the survival of strong local and regional features in the immigrant popu-
lation, see CHEVALIER: *Classes Laborieuses . . .* , pp. 364f. On the nomadic char-
acter of the working class, *ibid.*, p. 459. Chevalier quotes this remark from LE-
COUTURIER: *Paris incompatible avec la République* [1848]: 'Il n'y a pas de société
parisienne, il n'y a pas de Parisiens. Paris n'est qu'un campement des nomades.'
Thiers made a speech on the same theme in May 1850.

[42] On the demoralization of the indigenous Parisian, see CHEVALIER, *op. cit., passim.*

[43] See A. I. MOLOK: 'Les mouvements révolutionnaires dans les banlieues de Paris
pendant l'insurrection de juin 1848,' *Annuaire d'etudes françaises*, Moscow [1964].

[44] See DAUMARD, *op. cit.*, pp. 226f., on the effect of immigration on all social milieux.
See *ibid.*, pp. 249–86, on the recruitment from provincial rural milieux into all
levels of the bourgeoisie.

men who had been recruited, in the course of a generation, from the countryside. If there is one 'typical' figure of bourgeois Paris in the mid-nineteenth century, it is the wealthy merchant or shopkeeper whose father had been a peasant, and who had himself made the journey to Paris, made a good marriage, acquired a little capital, and speculated at the right moment. He is, of course, Daumier's 'hero'.

For such a bourgeois, the nature of rural society was part of his myth of himself. It was where he came from, and *what he had rejected.* His very definition of what it meant to be a bourgeois was framed against the background of his rural past. Thus in the 1840's and 50's there evolved a distinctive bourgeois *myth* of rural society—a myth which was central to the structures of bourgeois self-consciousness. Like all myths, it is inchoate: in a state of constant development and self-contradiction, and shot through with an uneasy sense of those very social realities it tries to mask. Only its barest outline can be sketched here.[45]

For the myth, rural society is a unity, a one-class society in which peasant and master work in harmony. Rural society is, in other words, the antithesis of the community in which the bourgeois actually lived—it is a world in which social conflicts are magically [46] resolved, in which the tensions and class divisions of the city are unknown.[47] For the myth, emergence from rural society is an act of will rather than a social process: one *made oneself* a bourgeois, by a distinctive and conscious effort, an effort in which ambiguities of social status had no place. The peasant, of course, was greedy for land, gradually accumulated possessions, enriched himself—but, for the myth, the line between that gradual differentiation, that *unconscious* history, and the *act* of the bourgeois who made himself and his own history, was absolute.

Only the sheer quantity of material on these themes, and the heady insistence of its tone, will convince the reader that this mythology lies

[45] See, e.g., MME. ROMIEU: *Des Paysans et de l'Agriculture au XIXe. siècle,* Paris [1865]; D. DE THIAIS: *Le Paysan tel Qu'il est,* Paris [1856]; BLANQUI, *op. cit.;* V. MODESTE: *De la Cherté des Grains et des Préjugés populaires qui déterminent des Violences,* Paris [1850]; F. DE LASTYRIE: *Le Paysan, ce qu'il est,* Paris [1869]. In all a consciousness of conflict coexists with an absolutely stereotyped vision of a stable and united society. Cf. the subtler imagery of the novels of Balzac, George Sand, Flaubert and Zola. On the evolution of the image of the peasant in nineteenth-century literature, see G. ROBERT: *'La Terre' d'Emile Zola. Etude historique et critique,* Paris [1952].

[46] 'Magically' is the correct word. One has only to quote Marc Bloch on the actual nature of the French rural community since the seventeenth century for the point to be clear: 'In the eyes of the historian [. . .] agrarian revolt appears as inseparable from a seigneurial régime as, for instance, strikes from large capitalist enterprise.' BLOCH: *Les Caractères originaux de l'histoire rurale française,* Paris [1931], t.1, p. 175.

[47] Cf. *Ibid.,* 1, 194: The rural community has always contained 'with inevitable fluctuations in the lines of cleavage, fairly well-marked class divisions.'

close to the centre of bourgeois concerns and consciousness at this time. But one thing is undeniable—the period from 1849 to 1851 was the moment when the myth was most needed and most threatened. At a time when the political domination and social confidence of the bourgeoisie were in doubt, rural society seemed about to spawn its own conflicts. Worst of all, at the heart of that conflict, the focus of peasant hatred, was an object whose very existence was unthinkable to the Parisian bourgeois, a profound embarrassment to his own identity—the *bourgeois de campagne*. He existed, and he was hated; nor did he exist as a result of an act of will; he had, it seemed, *evolved;* at times he could even be unconscious of his bourgeois status and its demands. One day he could wear the *habit noir;* the next, the peasant *veste.*

In this context, Courbet's exhibit of 1851 was a superbly *appropriate* revolutionary statement. It was a portrayal of rural society designed for an urban audience—it was really subversive only when it arrived in Paris (and there is a hint, in Buchon's cool ironies about the warm reception expected from *La Presse* and *Le National,* that he at least realized the fact). For the Parisian audience, it exposed a whole complex of myths and anxieties: it presented an unavoidable picture of rural society as a complex totality, including and even *producing* a bourgeoisie, and having a whole differentiated social structure of its own. In Courbet's vision, the countryside had its own proletariat, and its own privilege. Becoming a bourgeois was given back its ambiguity: as a process with contradictions and opponents.[48]

Courbet's achievement in 1849 and 1850 is two-fold. We have described his representation of the rural bourgeoisie in two ways—as an act of self-identification; and as an act with public implications for the Parisian audience, which, though he had withdrawn from it in 1849, remained Courbet's prime concern. But clearly the two aspects are interrelated. Finding, and profoundly antagonizing, a public was integral to the discovery of his own history—the inability to find *and* affront a public after 1856 was directly responsible for the mounting desperation of Courbet's artistic effort until the Commune.

In brief, it is because Courbet identified and subverted certain mythological structures which were essential to himself and his class,

[48] Hence the violence, and the particular *structure*, of the critical reaction: its relative unconcern at *Les Casseurs de Pierres;* its obsessive anger at the bourgeois features of Courbet's art. Naturally this reaction transcends the divisions of official politics— the review of PAUL ROCHERY in *La Politique Nouvelle* (which professed a brand of 'scientific' socialism) [2nd March, 1851], follows the classic pattern. The critics of 1851 could not, of course, be aware of the full extent of the exhibit's ambiguities: the dual role of Courbet's father as both peasant and bourgeois is important to our understanding of the genesis of 'realism,' but it was not something the public could see.

that he was able to bury the partial myths and phantasies of his earlier 'Bohemian' painting. In the process of exploding his own myth—of the family as absolute and isolated—Courbet identified a mythical system which was crucial to a specific type of class consciousness, and class dominance, in the city. In doing so he was able to speak directly, as his agitated critics complain, to the dominated class, the raw peasant recruits to the Parisian proletariat, the *populaires avinés,* or the *gens du peuple* to whom Buchon addressed his Dijon *annonce.* He found a way to subvert an ideology, and discovered a public. At this moment his painting could leave behind the abstractions of the private art of the 40's, the self-consciousness displayed to a *coterie.*

In other words, the discovery of a public, and the conversion of painting into a political act, was not incidental to Courbet's achievement. The creation of a dual public—one to address and one to antagonize—was a concomitant of Courbet's elucidation of his own history. It was part of that elucidation. On an empirical level we have plenty of evidence to suggest that the search for an audience and the desire to make his art fully political was a prime concern of the painter at this time. We know the importance he attached to the Besançon and Dijon shows,[49] and his delight at the success in Besançon; we have the political declarations of 1851, and his later plans for a one-man exhibition in a 'circus' booth and for murals in railway stations.[50] And we have the evidence of his close friends—in particular the terms of Buchon's advertisement. But I have suggested that Courbet's art became political in more complex and intrinsic ways—ways, needless to say, which the artist himself could hardly have articulated. Of course he did not need to. They are *there,* in Courbet's art: they help to explain both the form and content of the paintings of 1851, and the peculiar violence of the reaction to them.[51]

[49] See G. MACK: *Gustave Courbet,* London [1951], p. 72.

[50] On the 'circus booth' plan, see SCHAPIRO, *op. cit.,* pp. 170–1. On the murals, see SAINTE-BEUVE: *Correspondance,* Paris [1877], Vol. 1, pp. 289–90.

Political provocation survived into the 1852 Salon, which is usually regarded as representing a failure of nerve on Courbet's part after the *coup d'état.* One of his exhibits was a portrait of his Ornans friend Urban Cuénot, probably that exhibited previously in the salon of 1848. The significance of that repeat lies in the fact that Cuénot was in prison for political crimes at the time of the 1852 Salon—he was arrested in December 1851 in the purge which followed the *coup.* See the list of political offenders in MARLIN: 'L'Epuration Politique dans le Doubs,' *op. cit.* p. 20. He had at one point been the mayor of Ornans, which is sufficient evidence of the danger of treating electoral statistics as final evidence of a town's 'reactionary' politics. Cf. note 15. In any case to exhibit Cuénot's portrait in 1852 was courageous.

[51] I acknowledge help from the Central Research Fund of London University towards this research, and a Research Fellowship from the Centre National de la Recherche Scientifique. Particular thanks go to Dr. John Golding for all his help with this research.

AN ARTIST'S VIEW
OF COURBET'S STUDIO

Eugéne Delacroix

August 3.

I went to the Exposition; I noticed that fountain which spouts gigantic artificial flowers.

The sight of all those machines makes me feel very bad. I don't like that stuff which, all alone and left to itself, seems to be producing things worthy of admiration.

After leaving, I went to see Courbet's exhibition; [1] he has reduced the admission to ten cents. I stay there alone for nearly an hour and discover that the picture of his which they refused is a masterpiece; [2] I simply could not tear myself away from the sight of it. He has made enormous progress, and yet that made me admire his *Burial* [fig. 6]. In the latter work the figures are one on top of the other, the composition is not well understood. But there are superb details: the priests, the choir boys, the vase of holy water, the weeping women, etc. In the latter work (the *Atelier* [fig. 15]) the planes are well understood, there is atmosphere and there are some parts that are important in their execution: the haunches, and the thigh of the nude model and her bosom; the woman in the front plane, with a shawl. The only fault is that the picture he is painting offers an ambiguity: it looks as if it had a *real sky* in the midst of the picture. They have refused one of the most singular works

"An Artist's View of Courbet's *Studio*." From Walter Pach, trans. *The Journal of Delacroix* (New York: Crown Publishers, 1948), pp. 479–480 (entry for August 3, 1855). Footnotes by the translator. Reprinted by permission of Crown Publishers, Inc.

[1] Courbet, whose *Burial at Ornans* and *The Atelier* had been refused by the jury, organized a special exhibition of his works at No. 7 avenue Montaigne, near the Exposition.

[2] The picture referred to is *The Atelier,* which had been refused with the *Burial at Ornans.*

of this period; but a strapping lad like Courbet is not going to be discouraged for so small a thing as that.

I dined at the Exposition, sitting between Mercey and Mérimée; the former thinks as I do about Courbet; the latter does not like Michelangelo!

Detestable modern music by those singing choirs which are in fashion.

THE PAINTER'S STUDIO:
ITS PLACE IN NINETEENTH-CENTURY ART

Werner Hofmann

Courbet's *L'atelier* (*The Studio*) [fig. 15] was misunderstood by his contemporaries. Somewhat alarmed by the catchword of realism, they let their gaze travel uncertainly over the picture's more obvious features, spelled out the mere physical facts and reacted to the challenge of a painter who already had a reputation for political radicalism with a pleasurable shudder.[1]

When the first Paris exhibition was held in 1855, the Salon jury proved true representatives of their time. They rejected Courbet's work which was hung—an offering to a great city's itch for the outrageous—in a wooden pavilion, a pavilion over the entrance to which Courbet set the words 'Le Réalisme', his chosen slogan.

Yet there were some who themselves were adept with the brush and were ready enough to acknowledge the merit of this vast canvas and of its pictorial density. One of these was Delacroix, who expressed his admiration in his diary. Almost without exception, however, people were conscious of something provocative in the picture's vaguely suggestive and even slightly puzzling title. Foremost in complaint were the realists themselves, though the symbolists were not far behind. The realists felt the allegorical implications to be superfluous, the symbolists thought them out of keeping with the very robustness of the style. Nobody could make anything of the concept of an *allégorie réelle*—which the subtitle

"The Painter's Studio: its Place in Nineteenth-Century Art." From Werner Hofmann, *The Earthly Paradise: Art in the Nineteenth Century* (New York: George Braziller, 1961), pp. 11, 12, 17–22. Footnotes by the author. Reprinted by permission of George Braziller, Inc.

[1] See: René Huyghe, Germain Bazin and Hélène Adhémar, *Courbet—L'Atelier du Peintre* (Paris, 1944).

called it—while the painter's explanatory comment that the work was concerned with his own life over a particular period of time, that it was in fact a kind of pictorial autobiography, left the difficulties unresolved. Allegory and reality are mutually exclusive—such was the verdict that Courbet had to endure from Proudhon and Champfleury who were actually his friends. Like their fellows, the two realists could see no need for any hidden message and considered it reactionary to use ordinary popular human types as conveyors of some cryptic meaning. In the opposite camp there was equal incomprehension. For the symbolists art was a sublimation of reality. They could make nothing of the picture, and so naturally proceeded to find fault with it. Huysmans spoke of it as 'terrifying foolery', while Peladan maintained that it possessed neither perspective nor composition.

Yet Courbet's picture, which his age so signally failed to understand, is one of the nineteenth century's strangest and most widely illuminating documents. It is a *tableau clef*. In it the century's artistic development is for an instant arrested and a balance struck; the whole first half of the century is gathered together in it in concentrated form, while the second half is already foreshadowed. The themes which this picture unites within itself are nothing other than the great guiding visions of an epoch which, so our present complacent age supposes, jettisoned the real content of life and art for the sake of *la bonne peinture*. There is no contradiction in the explanatory subtitle; rather it represents the reduction to a formula of the central problem of a whole epoch. . . . Courbet declared, as we have seen, that this picture referred to seven years of his creative life, and this remark brought about a certain narrowing down in the interpretation of the work. Indeed, it encouraged a tendency to do no more than trace out certain biographical connections. Now *L'atelier* is undoubtedly a pictorial account of the painter's life. It brings together the people whom he had encountered, it gives an account of the milieu in which his art had its home. It is both a self-portrait and a portrait of friendship. Yet linked with these layers of content, there are others which may truly be called allegorical but which only disclose themselves on a somewhat closer study.

L'atelier is among other things a picture of the ages of man. His existence begins with the mother—who in the picture sits in the shadow of the easel and is giving suck to her child. Her very poverty bears witness to a kind of basic humanity that knows no distinctions of class or rank. The next stage is that of childhood, which is here represented by the two boys. They are at the beginning of their earthly pilgrimage and their gaze is questioning and thoughtful. As man awakens to full manhood he both expresses and disguises himself by outward show. He presents himself to the world as an individual. Clothes, gestures and

bearing spell the differences between one individual and another. The lovers, marvellously self-forgetful—it had been Courbet's intention to depict free love—are a prelude to the married couple. From the gentle image of young love that is insensible to the conventions, we pass to conventional things, to social smoothness and impeccable correctness of attitude.

The middle years follow, and in the left of the picture we see the descending steps of age; the gravedigger and the skull sound the solemn closing chord. And so the circle of life is rounded off at the point where it began—close to the symbolic figure of motherhood.

L'atelier is a cross-section of human society and in it its creator confesses to being a man of his time. In a letter to Champfleury he declares that his purpose is to bring together representatives of society's lower, middle and upper strata. On the right we see his own friends and the lovers of the arts; on the left is the ordinary world; there we see the common folk, we see poverty and wretchedness, and wealth, and we see the exploiters and the exploited. The dissonances which lie hidden within the structure of this world are made plain by the composition.

This was the element in its content, already deeply revelatory of the painter's mind, on which the critics concentrated and which they discussed in greatest detail. Yet here again we fail to do justice to the work if we place all the emphasis on one aspect of the whole—in this case on the implicit social indictment. That indictment undoubtedly has its place in the picture. Yet the types that enrich themselves out of the poverty of others—the merchant, the prostitute, the gravedigger and the priest— are placed in the midst of other figures who are either the products of the social system, like the unemployed worker, or, like the three hunters and the veteran of 1793, come from a world that is free of these particular conflicts.

What we must do if we are to understand the picture as a whole, a whole which is greater than the sum of its purely social components, is to place the different thematic layers one on top of another. Then we shall see that *L'atelier* is one of the nineteenth century's truly great pictures of humanity. It is much more than a mere social cross-section; it plumbs great depths and poses the whole question of our human destiny. The picture makes visible the powers of growth and decay, the flowering and withering of life. The people in it are both bond and free, they have been banished from society or live in slavish independence upon it, some live at its very edge, others at its shining heart. Courbet shows us the frailty of man and the vanity of our worldly existence. All stand there with empty hands. The artist alone has control over a palpable reality—his canvas. He alone enjoys true possession. In all other parts of the picture

the dominant mood is indifference and resignation (the lovers stand like strangers in the midst of a world that seems unaware of them). Each of these parts has its individual symbolic note. Yet, held together and dominated by the central apotheosis of the artist and his craft, they interpenetrate. That is why the indictment lacks aggressive feeling or any sharp satiric point. Instead we have something that recalls Rembrandt, something that is the expression of a compassionate humanity.

It is idle to pretend that *L'atelier* reveals its various meanings without any effort on the part of the observer. It does not meet his gaze, as does Ingres' *Apotheosis of Homer* . . . , with a simple clarity of arrangement and design that the eye can take in at a glance. It does not force its message on the mind. Instead of continuity and homogeneity one even seems to detect interrupted starts and recurrent uncertainties, and one's first impression is one of disconnected juxtapositions. The great background with its suggestion of incompleteness, and of hangings or backcloths imperfectly arranged, is too unsubstantial to hold anything together. It gives the whole the air of a shadowy stage picture that puts across a variety of meanings and fades away at its edges. There are uncertainties of depth and the eye is left to shift and determine the limits of the scene at will. We are confronted by painted curtains, veils and soiled pieces of stage-scenery. These last seem—particularly in the left half of the picture—to be part of a huge wall-painting which has itself remained a fragment and here and there deepens out into a third dimension. Plane surfaces border on sections that suggest space and depth; the world without and the world within seem somehow to be floating into each other. No realist ever painted in this fashion. Only he who dreams and knows the tired twilight of the eye in which night and day melt into a sad intermediate world, can venture to set that world down upon canvas.

What imparts such coherence as it possesses to the background against which the picture is set—and it is a coherence essentially loose and casual—is really the combination of pieces of stage-scenery. Between grey strips we get a glimpse of something that looks like a landscape. There is a round medallion that looks like the pale face of the moon. Yet nowhere do such islands of landscape become sufficiently defined for us to feel that we are confronting a palpable reality. They remain the visions of a dream which hide and disclose themselves without our bidding. Peladan, who made his criticisms from the symbolist angle, was not entirely wrong. The pictorial space is governed by no law of perspective and has no focal point; here we have a natural scene that floats and flows and has about it a quality of infinity.

It is the very air of unreality about the background of the picture

proper that enhances the reality of the picture on the easel. Compared with the inconclusive hints that mark the depths of the painting, this picture within a picture is much more immediately real. What lurks in the depths of the picture proper is a world of shadows, a world made heavy with the stuff of dreams. Upon the easel this becomes tangible reality. The landscape upon the easel attracts the observer's attention and opens his eyes. It is the window that looks out on the unambiguous world of real things.

What is true of spatial relationships applies with equal force to the relationships between the people in the picture. They are vague and susceptible of varying interpretations. It has been said that the true determining element in the build-up of the picture's spatial content is the picture on the easel, placed as it is diagonally across it. It can be understood in two ways: if we treat this piece of canvas simply as a rectangular plane, it has the effect of pushing back the rest of the picture and dividing the foreground from the background; if we treat it as a painting, then we see in it the depiction of a slice of nature ablaze with daylight, with nothing dim, vague or dreamlike about it at all.

Just as the picture on the easel contrasts with the stage-scenery of the background, so the painter stands out against the other figures that people the world of stage-sets which is his studio. This is due to something more than the fact that the composition places him in the middle of the painting. What really distinguishes him from the others is that he alone stands in an active relationship to reality. The others are, each in his own way, undecided people possessing no clear immediate purpose; he alone pursues a goal; he paints, and, because he is performing an action, he is more immediately real than those who stand or sit around him. Of these only one, the reading Baudelaire, is in comparable measure master of his inward self. Yet the poet has entered into the reflected world of his book, while the painter is mastering the material world by recreating it and giving it form.

It is the same with the people in the picture as with the insubstantial background against which they are set. One has the feeling that unseen partitions have slid between their bodies. These men and women have nothing in common that truly binds them to one another. As with the background so with these juxtaposed groups; there are gaps of which the eye is not immediately aware, there is an element of the haphazard about their organisation, a lack of discernible relationship. In only a few cases does the mere physical act of standing, sitting, or squatting suggest communication, does it suggest an unspoken dialogue with a complementary figure. In the case of the mother that figure is the child at her breast; while with Baudelaire and the prone boy the figure is replaced by

the book in the one case and in the other by the sheet of paper on which the youngster is trying his hand. With the two lovers the relationship has developed into complete equality of give and take between the pair, and there is full reciprocal interchange between one human being and another. Yet all this is most in evidence in the central group—in the painter whose 'dialogue' is with his work, in the little boy who stares at it all with marvelling attention, in the naked woman ('Truth'), whose sympathetic and understanding gaze contrasts with that of the others whose eyes for the most part seem to lack direction, and who appear to be looking at nothing in particular. In comparison with 'Truth' what superficiality do we not discern in the look of that woman in the expensive cloak as she turns her head slightly to the left? As to her escort, his fashionable side-whiskers tell us pretty well all that is worth knowing about him; we do not, and need not, see his face. Our imagination can fill that in—he is clearly the well-groomed type that is much the same all the world over. It is usual to refer to this couple as the fashionable lovers, and indeed they are the very embodiment of the fashionable world and all its flighty curiosity. We see the essential coldness of the human type that is for ever gyrating round the edge of things, that always remains an onlooker, that is always a member of the public. Here indeed is the Vanity Fair of civilization. People like these could at any time be seen wandering aimlessly round museums and 'salons', they pullulated in the grounds of World Exhibitions, those stamping grounds for creatures driven by the great collective desire for novelty.

The figures in the right-hand half of the picture—they are for the most part friends of Courbet—remain in distinguished isolation. The group on the left seems at first sight to be more strongly knit together, yet even here it is clear that every man exists for himself, is concerned with his own affairs, and has sunk into a kind of waiting mood that has no real end and no beginning. Mass-man, frozen into a dull collectivity, contrasts with the other half of the picture, though even here the figures are no less isolated from each other. The painter, however, belongs to both realms. It is therefore no mere chance that he occupies the centre of the picture. The powers that his very isolation sets free he transmutes by his creative act into binding elements.

The picture is a triptych, whose centre of spiritual interest is in the middle section. If we confine ourselves to this section, however, then the picture deals with nothing more than is expressed in the title; it is the picture of a studio which shows the artist at work. Yet it is much more than this; it is a glorification of the creative act through which the world knows its own meaning. *L'atelier* is a pendant to *The Apotheosis of Homer*. . . . In the latter we see a collection of men of genius

in hierarchic grouping, one rank above the other, a pictorial expression of the narrowly exclusive tastes of a painter wholly governed by the ideals of classical antiquity.

To this Courbet prefers the loosely grouped gathering of friends who have little interest in anything outside their circle; hard by he puts the common people, who no longer have the power even to recognize themselves in a work of art. In Ingres we have an eclectic lengthwise view of history that covers a considerable period of time, a view that only takes account of the topmost reaches of human genius. Courbet on the other hand concentrates entirely on the world of his own day which the classicist's far-reaching gaze onto the summits of past history treats as virtually non-existent. In the company that surrounds the antique poet there is unanimity, harmony and the proud self-consciousness of distinguished men. In contrast to this, Courbet's cross-section of the society of his day is ready to accept disparity, high and low being placed alongside one another. Here is a painter whose faith in man is not concentrated on the past as Ingres' is, but fixed upon the future, though when he contemplates the present his gaze is sceptical and without illusion. There is nothing of adoration in this picture. There is devotion of a kind in the middle group. It is a discreet devotion, but it contrasts with what is shown at either side of the picture—mere indifferent physical presence. Depicted reality develops allegorical dimensions in which there is a hint of the relation of the artist to the world around him.

Rembrandt, whom Courbet discovered in Amsterdam in 1847, is not only the pictorial but also the spiritual godfather of this work. Five years before it was painted, a treatise had appeared by Alfred Dumesnil on the subject of Rembrandt's religious faith.[2] In it there was among other things an attempt to interpret the etching commonly known as the 'hundred florin' etching, a hundred florins being the price—an unusually high one to be paid in those days during a painter's lifetime—which Rembrandt actually received for the work. In this picture, as Dumesnil pointed out, the Pharisees and the philanthropists are shown on one side—all busily discussing poverty—while on the other are the people of Christ; and it is possible that Courbet was concerned with a similar contrast. It is possible that his aim was to show on the one side the writers, poets and critics, the men, that is to say, who stand apart from life, separating themselves from it by that very process of reflection through which they endow it with order, and to place over against them the common people who live their lives directly, and whose existence achieves fulfilment by the mere fact of its occurrence. What separates the two groups is much more than a physical distance of a few yards;

[2] *La foi nouvelle cherchée dans l'art de Rembrandt à Beethoven* (Paris, 1850).

there lies between them a no-man's-land which it is impossible to cross. On one side are the masses with their brooding and clumsily moving minds who know no word that can free them from their necessities, sitting and standing as though they were in chains; on the other are those for whom all this provides the very justification of the work they do. They describe that which anonymous humanity lives through before them—the 'heroism of modern life'.

The painter who wields his brush with such a gesture of assurance knows all about the resultant tensions. Does he intervene as a helper, like Christ in the 'hundred florin' etching—binding disparate elements into a unity? He works in isolation. People are all around him, and yet he is strangely cut off from them, from the very source in fact from which his vision of reality is derived. They are for him a background, an image in his memory, out of which, whenever he is in need of this, his artistry can bring profound experiences to the surface of his mind. When we think of the artist as thus cut off from men, we realize his tragic loneliness. Even when as a man he feels himself ready to give active help— and there is much evidence of Courbet's humanitarian inclinations—he only finds that this very trait tends to drive him back to his work, the work which enables him to give visible form to the vision within him. In the last resort it is not political convictions that count but mastery of the canvas. All that he has seen, all that he has willed or experienced, enters the service of this work of his and drives him forward towards its completion. Courbet, the realist, was always being reproached for an inability to free himself from drab reality. Yet what he sets down in paint in this picture is nothing less than a justification of imaginative power and the creative function of memory. He transforms his social environment into a vision of humanity, he shows that what the eye has observed can by the sovereign artist be intensified into a spiritual experience and recalled at will, so that a landscape can be painted even in the studio. Perhaps it is this very landscape that enables us to understand the 'message' of this picture. It is the only place in the picture which is wholly free from anything that can be called oppressive or burdensome. It is intended to be something through which we look outwards. In the picture of nature a man can recognize the affirmation of a purer and wholly durable world, a world with which he can feel a bond of affinity, a world where he can purge his spirit and be master of his soul. In it there is embodied—if something approximating to a religious concept is permissible—one of modern man's certitudes of salvation. Thus the painter's gesture becomes a prophetic intimation, while the two people at his side become endowed with a measure of faith such as can only accompany religious devotion.

The artist, the woman and the child—it is these who still see in the

world the aboriginal freshness of the first day of creation. They stand to that world in a relation that is comprehensive and total.[3] Their capacity for experience is wholly uninhibited and is directed towards life as a whole. With these three figures there is indeed a community in the quality of their experience that sets them quite apart from the groups on each side of the picture. They embody the world of the simple and the true. Their relation with the real world is not severed by the process of reflection nor is it burdened by the weight and weariness of mundane trivialities. In contrast to themselves, their surroundings represent something entirely different—the complex world of civilization with its disguises and masquerades. In these three figures, however, there is real spontaneity and real freshness of vision and feeling. It is there in the child whose feelings are unregulated by any convention. It is there in the woman whose real self is unconcealed by any artifice, who reveals the truth of nature and the essential honesty of all that is truly natural. It is there in the artist himself who sees the processes of nature in terms of an incarnation of female fruitfulness which he is engaged in transforming into a work of art. This female figure must be understood neither as a model, nor as a muse, nor as a mere studio companion—she is the natural measure of things, she is herself the rounded fullness of life. 'The perfect woman of all ages', says Nietzsche in his *Vermischte Meinungen und Sprüche*, 'is the creator's recreation on every seventh day of his civilizing task, the resting of the artist in his work.' There is a similar quality in the artist's relation to the child, though here he is drawn to nature in bud rather than to nature in maturity. The artist of the nineteenth century who was simplifying his means of expression by a reversion to the styles of archaic and primitive epochs, was also finding in the child a source from which he could discover new spontaneous and unconventional forms —a naïveté which was expressed not in some remote domain of history but here in the present and before his very eyes.

In the first of his lectures on *Heroes and Hero-worship* Carlyle speaks of the poet as a kind of survival from the early days of the human race when the world which is now divine only to the gifted, was divine to whosoever would turn his eye upon it. Carlyle's primitive man is of the stuff of which poets and prophets were to be made; this type of mind still accepts the world as a whole; undisturbed by mere criteria of good taste it makes no distinction between beauty and ugliness, or between the commonplace and the sublime. That which moves the men who are possessed of it is simply the intensity of their apprehension, the degree to which they are truly alive; and with such men as these the champion

[3] Cf. Meyer Schapiro, "Courbet and popular imagery," in: *The Journal of the Warburg and Courtauld Inst.*, 4, 1940.

of the realist creed has always enjoyed some measure of affinity. The realist rejects whatever may be the prevailing rules of the aesthetic game, and, in doing so, he also rejects—in theory at least—the discriminatory dissection of reality in obedience to what is in essence a condemnatory moral judgment. Where there is no order of precedence between ideal beauty and forms of beauty that fall short of it, all things are beautiful and worthy of being set down by the artist. All that is alive is right. That was the view of the Romantics. The artist combines all that his eye perceives in the unbroken texture of his experience and his world is therefore wholly coherent. This kind of realism has nothing to do with that later rather precious and circumscribed view that was formulated by Trübner in the words 'Every subject is interesting, even the least important offers enough to interest the artist. Indeed, the simpler the object, the more interesting I can make it by painting, colour and design' (malerisch und koloristisch).[4] Courbet's relation to reality is on a deeper level; it roots, like his art, in an act of faith, and consists of more than a mere exercise in the ingenious use of colour.

L'atelier delves into some of the nineteenth century's most central complexes of motive. It proclaims the spiritual dignity with which in all the different classes of painting it contrived to endow the landscape painter's art. A deep longing for what is open to the skies, unfettered and natural finds its expression here. The landscape is a piece of the world that belongs to everyone. Because men feel they have been cut off from their first original spontaneity, they seek a second one and seek it consciously. In landscape an ageing civilization gains a new lease of youth and, freed from its historico-mythological ballast, turns its gaze towards the timeless and enduring in which history has no place.

Furthermore, Courbet's painting is one of the pictures of friendship in which intellectual élites erect a monument to themselves. It stands halfway between, on the one hand, the studio groups of the Impressionists which aim at little more than suggesting a sort of general atmosphere, and, on the other, those gatherings of men of genius characteristic of the idealist painters who so favoured the theme of human greatness but habitually projected it into the past. In the long series of self-portraitures in which the artistic world of the nineteenth century indulged, *L'atelier* occupies a middle place between the mere factual account of life and the transfiguring apotheosis. In fine, regarded as a portrayal of humanity, this *allégorie réelle* belongs to one of the most remarkable and, from the point of view of the development of ideas, one of the most illuminating categories of painting that the nineteenth century produced.

Here are the great themes whose development demands a sym-

[4] *Personalien und Prinzipien* (Berlin, 1908), pp. 125, 128.

phonic breadth of treatment. Embedded in between them and entrusted with walking-on parts are the symbolic figures of the new vision of humanity: the worker, motherhood, the outlawed and the rejected. Courbet shows us the relation of the individual to society, he shows us the problem of the isolated man and that which arises from his integration in the mass. There is a connection between the group on the left side of the picture and the mad-house scenes of the Romantics, for there is here already a suggestion of something that became more explicit in the second half of the century when wild unreason broke through the barriers of the asylum and became part of the stuff of ordinary life. We see it in Daumier's *Un wagon de troisième classe* . . . , in Degas' *L'absinthe (dans un café)* . . . , and in the metropolitan scenes of Toulouse-Lautrec.

Another of the century's dominant themes—the metamorphosis of womanhood—is distributed over various parts of the picture. We have the mother, and not far from her the harlot still dressed in her plain country clothes (to the right behind the grave-digger's top-hat); and we have the central figure of 'Truth'. In addition to these Courbet had originally painted in the elemental female figure, the animal-like *femme fatale,* giving her the features of Jeanne Duval, the mistress of Baudelaire. Originally she had been discernible next to the poet's head. Later, at the latter's request, Courbet removed the portrait. In the worldly couple and the pair of lovers we can recognize the various problems raised by the sex-relationship, the tension between *eros* bound and *eros* free.

All this would suffice to earn for this picture an exemplary place in the history of nineteenth century art. Yet its essential significance is of a deeper kind than has as yet been suggested. For it touches a conflict which went on throughout the century and caused the polarization of its creative powers, a conflict which men sought again and again to resolve. It was the conflict between allegory and reality, the conflict between the claims of higher truth and fidelity to objective fact, between life as we imagine it and life as we discover it to be. Once we have grasped this, its cardinal problem, we will understand the century in a way that has nothing to do with its isms, trends and the rest, for we will understand it in its artistic totality. . . .

THE PAINTER'S STUDIO:

Alan Bowness

The *Atelier* [fig. 15], or to give it its full title, *L'atelier du peintre, allégorie réelle, déterminant une phase de sept années de ma vie artistique* (*The Painter's Studio, real allegory, resolving a phase of seven years in my artistic life*)—is the third of Courbet's big pictures, each measuring approximately twelve feet high by twenty to twenty-four feet across. They span that seven year period in the middle of his career which, as Courbet realized, was a clearly defined middle phase separating his formative early years from those two decades of maturity and generally relaxed painting that followed the *Atelier* in 1855. In 1848 Courbet began his struggle to establish what he considered to be the final form of modern art: in 1855 with the *Atelier* he retired, satisfied that he had found the solution. Courbet's pretensions in this respect were regarded as ridiculous by his contemporaries, but now, ninety years after his death, looking back over the development of painting in the 19th and 20th centuries, they do not seem so absurd. In a certain sense one can justify the claim that with the *Atelier* Courbet invented modern art. The purpose of this lecture is to try to do precisely that.

To return to the three big pictures for a moment. The interesting thing is that they are each closely associated with a particular friend of Courbet's who played a major part in shaping his career and his personality as an artist.

"The Painter's Studio." Unabridged reprint of Alan Bowness, *Courbet's 'Atelier du peintre,'* Fiftieth Charlton lecture on art (Newcastle upon Tyne, 1972). Footnotes by the author. Reprinted by permission of Alan Bowness.

1 This lecture is printed as delivered in November 1967, with a minimum of alterations and footnotes. A brief bibliography of main sources will be found at the end of the text. *L'Atelier du peintre* is in the Louvre; 359 × 596 cm.

Un enterrement à Ornans (A Burial at Ornans) [2] was Champfleury's picture. A young realist writer, he persuaded Courbet to abandon Romantic subject matter and paint from his own experience of life. The first result was *Une après-dinée à Ornans* [3] —Courbet and his father and friends sitting in the kitchen of Courbet's home. A genre picture of unprecedented size (six feet by eight feet), it suited exactly the taste of the emergent Second Republic and was bought by the state in June 1849. Courbet immediately followed this up with more scenes of life at Ornans —the burial of his grandfather, his father and his farmhands on their way to market, the stonebreakers at work beside the road.

These are the three pictures, which, shown at the 1850–1851 Salon, made Courbet at thirty-one a famous painter. Their subject matter lent itself to a political interpretation, and Courbet was prepared to go along with this. He had painted *Les casseurs de pierres (The Stonebreakers)* [4] simply because he felt sorry for the men breaking stones, but his friend Proudhon called it the first socialist picture: 'a satire on our industrial civilization which constantly invents wonderful machines to perform all kinds of labour and yet is unable to liberate man from the most back-breaking toil. . .' . Courbet was ready to put his art at the service of the new revolution. In 1851 he declared 'I am not only a socialist, but also a democrat and a republican, and above all a realist—that is, a sincere friend of the real truth'.

It was Proudhon who suggested the subject for Courbet's second large painting, *Pompiers courant à une incendie (Firemen running to a fire)*.[5] But this was never finished, because the coup d'état of December 1851 put an end to any idea of an officially-supported democratic art. As Louis Napoleon got his grip tighter and tighter on the reins of power, so Courbet's friends were driven into prison, like Proudhon, or into exile, like Max Buchon. Courbet would have suffered the same fate, but he had a hidden protector in the Comte de Morny; and a painter's political views were taken less seriously than a literary man's.

Courbet was left in 1852–53 in an isolated situation, thrown back on his own resources. It was at this time that he met Alfred Bruyas, and out of this relationship was to come *L'atelier du peintre*, the third and greatest of the big paintings; Courbet's declaration of principles and his definitive statement on the subject of modern art.

Alfred Bruyas was two years younger than Courbet. He was born

[2] In the Louvre; 314 × 665 cm. [fig. 6].
[3] In the Musée de Lille; 195 × 257 cm. [fig. 3].
[4] Formerly in Dresden, but destroyed in 1945; 159 × 259 cm. [fig. 4].
[5] In the Petit Palais, Paris; 388 × 580 cm.

at Montpellier, of a family of rich bankers, on 15 August 1821. Of delicate health—he was consumptive—he never married, and was able to devote his life to art. He studied painting in Montpellier, and then in 1846 he went to Rome where he decided on his vocation—he would be a collector of modern art. He liked to establish personal relationships with the artists whose work he bought, and one way of doing this was to have them paint his portrait. There are no less than sixteen portraits of Bruyas in the donation that he made to the local museum in Montpellier in 1869, some eight years before his death in 1876.

Bruyas first patronized Montpellier-born artists, like young Auguste Cabanel, who painted his portrait in Rome in 1846, and Auguste Glaize, who painted both his portrait and his picture gallery in 1848. . . . His own taste developed very rapidly, and he was soon prepared to buy the most extreme modern art, whatever people might think. He bought five important Cabanels, painted between 1848 and 1852, but his preferred painter in these years was the now almost forgotten Octave Tassaert (1800–76). He owned sixteen Tassaerts, all of them probably painted between 1850 and 1853, and as we shall see several of them may have a connection with Courbet's *Atelier*.

By 1852 Bruyas's tastes were growing more refined. He bought his first Delacroix from a lottery in this year—the small 1849 version of the *Femmes d'Alger*—'Le plus coquet et le plus fleuri de Delacroix', Baudelaire called it. Two more purchases immediately followed—*Daniel dans la fosse aux lions*, of 1849 in 1852 and *Michelange dans son atelier*, of 1850 in 1853. Then Bruyas commissioned his portrait for 1,000 francs. It was being painted in Paris in April 1853: Delacroix, it is said, saw Bruyas as the type of Shakespearean hero.

Perhaps at the very moment Delacroix was finishing the Bruyas portrait, on 16 May 1853, the Salon opened. As in 1852, each artist was limited to three pictures; Courbet showed *La Fileuse endormie*, part genre, part portrait of his sister Zélie, asleep at a spinning wheel, and two pictures which may have been intended to demonstrate what the realist nude should look like—the wrestling male figures of *Les Lutteurs*, and the pair of female *Baigneuses* [fig. 13], in a state of disrobing.

The Baigneuses, a large picture 8 feet high, was an immediate centre of controversy. This was what Courbet expected: 'it upsets people a little' he told his parents two days before the Salon opened, 'though since I left you I have added a cloth round the haunches'. This was not enough however, for on the next day at the private view Napoleon III struck the picture with his riding crop. Courbet's only regret was that he hadn't used a thinner canvas—had the Emperor damaged the picture he would have sued him.

Delacroix's more considered criticism of the picture is well known, and one may wonder whether his qualified enthusiasm may not have aroused Bruyas's interest. At all events, Bruyas bought both the *Baigneuses* and the *Fileuse endormie,* and as he had done for Cabanel, Glaize and Tassaert commissioned a portrait of himself and asked to buy a portrait of the artist.

So far as I know, this was the first meeting of Courbet and Bruyas. But finding they had much in common, they immediately became intimates, and they dominated each other's lives for the next eighteen months, to the relative exclusion I believe of other friends.

The portrait that Courbet painted of Bruyas in the Summer of 1853 . . . , probably immediately after the opening of the Salon, gives a clue as to the nature of their relationship. Bruyas's right hand rests on a green book which bears the inscription: *Étude sur l'Art-moderne. Solution. A. Bruyas.* In other words, Courbet now felt he had an ally in the rich young collector, with whose aid he could complete the revolution of modern art that he had initiated with the *Enterrement,* '. . . my beginning and my declaration of principles' as Courbet was to call it in a letter to Bruyas a few months later.

It is important to try to understand Courbet's ideas. They may be somewhat incoherent, and difficult to piece together from the evidence of his writings and paintings, but one has to try to reconstruct as exactly as possible the sequence of events over the next eighteen months. For one must ask why Courbet thought he had found the answer to modern are—even his use of the words 'l'Art moderne' has a new meaning to it— and whether this apparently preposterous claim can be sustained.

The situation is unfortunately complicated by the somewhat slipshod way in which some evidence has been presented to us. The crucial letters written by Courbet to Bruyas for example are very badly edited and the order as published is demonstrably far from correct. Further research is needed, but I will tentatively suggest some new dates, and the sequence of events can be summarized as follows:

On 22 May 1853, a week after the Salon opened, it was announced that there would be no Salon in 1854, but that a major art exhibition would be staged as part of the proposed Exposition Universelle. This was to be the French answer to the great exhibition of 1851, and perhaps because there had been no painting at the Crystal Palace, a special international art show was planned in which certain established artists were to be allowed to exhibit a retrospective group of works. To make the exhibition more attractive to the public the government were prepared to commission major new works from some of the younger painters.

It was in this connection that the director of the Beaux-Arts, the Comte de Nieuwerkerque, invited Courbet to lunch and began to try

to convert him to a more politically amenable frame of mind.[6] In his excited letter to Bruyas, Courbet tells us what happened: 'He went on to say that the Government regretted I was so isolated, that I must change my ideas. . . . the Government would like me to paint a picture in my most vigorous manner for the exhibition of 1855 . . . and that he would require by way of conditions that I should present a sketch, and that when the picture was finished it would be submitted to a group of artists chosen by me and to a committee selected by himself.

'You can imagine the rage into which such a proposal threw me. I replied at once that I did not understand a word he said, since he claimed to represent a Government and I did not consider myself in any way a part of that Government, that I was a Government too and that I challenged his to do anything whatever for mine that I could accept. I went on to say that to me his Government seemed just like any private citizen, that if they found any pictures pleasing they were at liberty to purchase them, and that I asked only one thing, that they should grant freedom to the art in their exhibition and not use their budget of 300,000 francs to favour 3,000 artists opposed to me.

'I added that I was the only judge of my own work, that I was not only a painter but also a man, that I painted not to produce art for art's sake but rather *to establish my intellectual freedom*, that through the study of traditional art I had finally broken away from it, and that I alone, of all contemporary French artists, had the ability to express and represent in an original manner both *my personality and my social environment.*'

It was hardly surprising that Courbet's violent reaction should have amazed Nieuwerkerque:

'He asked me again if I intended to send nothing to the exhibition. I answered that I never entered competitions because I did not recognize judges . . . but that I hoped (perhaps) to organize an exhibition of my own, as a rival to theirs, which would bring in 40,000 francs in cash which I should certainly not earn from theirs. I reminded him that he owed me 15,000 francs for the entrance fees collected on my pictures at previous Salons. . . .'

In this long letter to Bruyas, Courbet remains at a high pitch of excitement. The enormity of what he had done had perhaps only just come home to him. As he had said at the beginning:

'I have burnt my boats. I have declared war on society. I have insulted everyone who treated me scurvily. And now I am alone against

[6] Riat says this took place in December 1854: this is impossible. It *may* have been December 1853; a few months earlier would be more probable. I quote as elsewhere the translation of the letter in Mack, pp. 108–112, with some slight modifications.

society. One must conquer or die. . . . But I am growing more and
more certain that I shall triumph, for there are two of us and perhaps
at the present time only six or eight others that I know of who have all
arrived at the same conclusion by different paths . . . I am as certain
as I am of my own existence that within a year we shall number a
million.'

For the moment, Courbet and Bruyas needed each other. Courbet
was at work on 'five or six pictures which will probably be finished by
Spring' but, he told Bruyas:

'You are more important than I am, for you possess the means I
have always lacked and shall always lack. With your background, your
intelligence, your courage, and your financial resources you can rescue
us while we are alive and enable us to save a century of time . . . I
shall finish what I have undertaken as soon as possible and on my way
back to Paris I shall visit you at Montpellier if you are still there. If you
are in Paris we will look for a gallery together if we decide to hold
an exhibition.'

It is not possible to discuss in detail all the points that arise from
this letter. In his political thinking, Courbet is certainly influenced by
his friend Proudhon, then in prison, and he could most accurately be
described as an anarchist. He is against the Government ('I am a Gov-
ernment too'), and against any kind of social organization which is seen
as restricting the free development of an artistic personality. It is the
necessary relationship between modern art and this political view which
is important here. Courbet has thought his position through: in his
attitude to tradition—the art of the past, to academies, to the whole idea
of teaching art, he was entirely consistent, and one can quote impressively
from his own writings to confirm this.

Courbet's immediate problem in 1853 however was an exhibition—
how was he to show his pictures to the public which was prepared to
pay to see them? The whole question of public exhibition must have
concerned him, because it is evident that this is now the raison d'être
of painting. After the collapse of the Second Republic Courbet could
not expect state patronage. He must have realized his privileged posi-
tion. Friends like Proudhon and Max Buchon had been imprisoned or
hounded into exile, and he was lucky not to be in the same predicament.
Instead he was courted by the imperial establishment, and this accounts
for Courbet's staying out of gaol, for Nieuwerkerque's invitation—and
for Courbet's final succumbing in the 'sixties.

In 1853 however it was plain that another state purchase was un-
likely, and Courbet's whole attitude towards the idea of selling his
pictures was a reluctant one. He was much more interested in exhibi-
tions, and by his own optimistic calculations no doubt thought that he

could live off the proceeds. He was accepting every opportunity of showing his work in the provinces and abroad. The real problem was what to do in Paris, where capital was needed to stage the sort of exhibition that would attract the public. It was here that Bruyas provided the solution.

This is what Courbet is talking about in a letter that was written from Ornans, probably very early in 1854 because Courbet talks of hunting in the snow. The plan is to make an:

'Exposition de la peinture du maître Courbet et de la Galerie Bruyas.'

No doubt Courbet was exploiting Bruyas's desire to show his collection of modern art in Paris, but what was wrong with combining it with a one-man exhibition of his own? Had he not just agreed to let Bruyas buy his favourite and most admired self portrait, *L'homme à la pipe* [cover illustration], which he claimed he had refused to Louis Napoleon for 2,000 francs at the 1851 Salon?

'We are going to lay our plans and proceed to the great burial.' Courbet told Bruyas. 'You must admit that the part of a grave digger is a good one, and that ridding the earth of all that rubbish isn't without its charms! 40,000 francs, that's something to dream about. We shall have to lease some ground from the municipality, just opposite their big exhibition. I can just see an enormous pavillion held up by a column in the middle, with wooden walls . . . and guards . . . and a cloakroom for sticks and umbrellas . . . I'm sure we shall get back our 40,000 francs—even though we are speculating on nothing but hatred and jealousy.'

In a later letter, written in May 1854, just before Courbet left Ornans to spend the Summer with Bruyas in Montpellier, he talks about 'the work that we are going to do together'. In particular he was thinking of self portraiture: this is the only indication of his plans for the Summer. *L'homme à la pipe* has just arrived back from exhibition in Germany, and he is going to bring it with him:

'I was struck on seeing it. It's a terrific element in our solution. It's the portrait of a fanatic, an ascetic, a man disillusioned with the rubbish that made up his education, and now trying to live in harmony with his principles. I have painted many self portraits in my life, corresponding to the changes in my state of mind. In a word, I have written my autobiography.'

Courbet then describes a sequence of four self portraits, no doubt with the exhibition in mind—the dying man; the man filled with ideas and absolute love in the manner of Goethe, George Sand etc; the man with a pipe. Then he adds:

'One more remains to be done, and that's the man sure of his prin-

ciples, the free man. . . . Yes my dear friend, I hope to achieve a unique miracle in my life, I hope to live by my art all my life, without deviating by a hair's breadth from my principles, without ever having lied to my conscience, without ever having painted a picture as big as my hand to please anybody, or for a sale.

'I've always told my friends who were concerned for me not to worry . . . I am sure to find men who will understand me. . . . And now I've found you! It was inevitable, for it was not ourselves who met, but our solution. . . .'

Courbet arrived at Montpellier at the end of May and stayed in the south until September. Unfortunately we do not know as much as one would like to know about this crucial visit, and one is reduced to speculation. There is no more talk about the Courbet-Galerie Bruyas exhibition, and one presumes the loan of 40,000 francs was not forthcoming. Perhaps it was Bruyas père who made this decision on meeting Courbet.

Despite this disappointment Courbet was very happy at Montpellier, and the experience of the bright light of the Midi revolutionized his painting. He worked hard: at least a dozen works date from these months. More relevant, I believe he planned the *Atelier* with Bruyas at this time. Apart from the general references to self protraiture, there is no hint of painting any such picture at an earlier date, and on his return from Montpellier he must have begun work at once. Further one needs only to consider what Courbet in fact painted in Montpellier; what pictures he saw; and what his common interests with his hospitable host must have been.

The most important work painted at Montpellier was *Le Rencontre* [fig. 14], the picture celebrating Courbet's arrival. This was commissioned by Bruyas for his gallery: it measures approximately four feet by five. It is a painting of a moment in time: the coach departs, and one could almost calculate the hour from the sharpness of Courbet's shadow (Bruyas and his servant Calas stand in the shade and have no shadows). The exact place is also identifiable—the road to Cette, some miles outside Montpellier near the Villa Mey, the Bruyas country house; in the background are the Cévennes mountains. It is a picture far lighter in tone than anything Courbet had painted, and the colour key is higher.

These remarks are equally true for Courbet's first seascapes. The most characteristic is the one in which Courbet includes himself greeting the Mediterranean—*Les Bords de la mer à Palavas*. . . . In a letter written at this time to the socialist writer, Jules Vallès, he apostrophizes the Mediterranean in the manner of the picture: 'O sea, your voice is tremendous, but it will never succeed in drowning out the voice of fame as it shouts my name to the whole world.'

Now it is characteristic that it should be this Palavas seascape, which includes the figure of Courbet, that Bruyas kept for his gallery. For Bruyas was no realist: he liked his pictures to have a symbolical meaning. He was also obsessed with the idea of portraiture, and evidently hoped to immortalize himself by commissioning portraits from his artist friends. Apart from *La Rencontre,* he had Courbet paint two more small portraits of himself, and then the projected *self* portrait as a free man sure of his principles. The format of all three is identical to that of the much earlier *L'homme à la pipe* [cover illustration], which Courbet had brought with him for Bruyas. This picture, Courbet tells us, they call *Christ à la pipe* at Montpellier, and the sacrilegious joke is significant because Bruyas had apparently had himself painted wearing a crown of thorns, so that both painter and collector had presumed to identify themselves with Christ.

Courbet's own longstanding interest in self-portraiture is of course notorious, but it is not simply a question of his finding his own appearance irresistible, or of himself providing a free model. The scale and nature of self portraiture in the early 19th century is a matter still to be explored thoroughly. If one leaves aside the fancy-dress genre portraits like the *Cellist* and the *Sculptor,* there is still a basic division between what I will call the physiognomical and the environmental portrait. One can see this by comparing *L'homme à la pipe* with the even earlier *Courbet au chien noir.*[7] In the one case, exclusively a study of the head, which as we have seen is extremely expressive of a mood and the personality of the sitter. In the other, all the appurtenances are significant—the pet dog, the walking stick, the book, the favourite piece of landscape in the valley of Bonnevaux near Ornans, perhaps even the fact that Courbet sits at the entrance of the cave of Plaisir-Fontaine has some psychological (even unconscious) relevance.

One can pursue this basic distinction in the portraiture and self portraiture of other earlier artists, on whose work Courbet must have based his ideas. In David for example—compare the Louvre *Self Portrait* with the *Portrait of Dr Leroy* of 1783 in Montpellier. Or consider, more to Courbet's taste, the Géricault *Aliénés.* There was a new interest in Géricault since the 1848 revolution. Bruyas owned what were supposed to be five Géricaults, including a *Portrait of Lord Byron;* one of his Montpellier friends, Soulas, published a book called *Physionomies Littéraires* in 1855, so there was evidently interest in the physiognomical approach to portraiture in Montpellier in 1854. Indeed Courbet's small portraits of himself and Bruyas bear this out.

But it is the environmental portrait that concerns me, because this

[7] In the Petit Palais.

is I think the category to which the *Atelier* belongs. Courbet had used this approach in painting the two literary men who in 1848 certainly revolutionized his thinking. The portrait of Baudelaire [fig. 2], probably done in 1848, shows Baudelaire at work, with his pen, inkwell, blotter, papers and book on a table.[8] The face itself might almost be anonymous. A Champfleury portrait, date uncertain, was used for a book published in 1859 [9] and is in some ways more curious: in vignette form we have Champfleury, garlanded with laurel and surrounded by references to the many sides of his activity—not only writing now but also reading, making music and even eating.

The increasing importance of seeing the person portrayed in his milieu was widely recognized, and can be paralleled at this time in France in literature and in the writing of history—think of the development from Balzac to Flaubert and then Zola; or from Michelet to Taine. As the anti-heroic attitude gains ground, so the importance of the individual declines. (In painting this step is to be found in Degas, where his friend the bassoonist, Desiré Dihau, is lost in his membership of the opera orchestra.)

But Courbet, and the *Atelier* in particular, marks a peak in the development, the moment where the artist alone is allowed to play the role of hero. In the *Apotheosis of Homer* of 1827, Ingres could proclaim the greatness of art, and its superiority over all other forms of human activity, but he did not quite dare to put himself in the centre of the picture. This is what Courbet does, not out of overweening egotism, but to liberate the artist, and I think one begins to see with what complete success.

An enormous number of sources have been proposed for the conception and composition of the *Atelier,* particularly by Hélène Adhémar and by a German scholar, Matthias Winner.[10] Madame Adhémar points to a conjunction between the long tradition of artists' paintings of themselves in their studios, and the early nineteenth century pictures of famous artists at work. These latter romantic reconstructions were still very much in demand at the time of the *Atelier* and had reached the popular print market—for example Madame Adhémar published Napoleon Thomas's *Leonardo showing the Gioconda to Raphael,* a lithogravure of 1853.

Dr. Winner links the *Atelier* with sixteenth and seventeenth century paintings made to express an artistic theory in pictorial terms, but he

[8] It is interesting to note that Bruyas later (in 1874) bought the Baudelaire portrait for his gallery.

[9] Champfleury: *Les Amis de la Nature,* Paris 1859. Frontispiece engraved by Bracquemond after Courbet.

[10] See the references at the end of this lecture.

admits Courbet may have been ignorant of such work. And this raises an important point. The sort of source hunting that Winner pursues may be continued almost indefinitely; but one needs to ask: what really influenced Courbet in the composition and subject of the *Atelier?*

I would propose four primary sources. Firstly the two painters Courbet admired most, Rembrandt and Velasquez. Rembrandt is particularly important for the *Atelier*. To say that he is 'not only the pictorial but also the spiritual godfather of this work' as Werner Hofmann does in his book on nineteenth century art is perhaps going too far. But Hofmann I think goes altogether too far in his interpretation of the picture, eloquent though it is. There is surely a connection between the *Atelier* and what was then perhaps Rembrandt's most famous work, the 100 guilder print, with Christ in the centre, and the Pharisees on one side, and the people of Christ on the other. And I think Hofmann is right in suggesting that Courbet might have been interested in a book published in Paris in 1850 by Alfred Dumesnil, called *La Foi nouvelle cherchée dans l'art de Rembrandt à Beethoven.*

Rembrandt has a co-progenitor in Velasquez, because the influence of *Las Meninas* is equally important for Courbet. It is not just a question of construction, handling, feeling for tone and colour, the whole sense of space. The *subject* of Velasquez's picture is the painter painting a royal portrait, but as with the *Atelier,* this is only the beginning of a series of speculations about the very nature of art.

Courbet certainly knew Velasquez's picture from reproduction. He may even have had a photograph of it by 1854—he was a keen seller of photographs of his own work, and Aaron Scharf has all but identified the photograph of a posed academic nude which he used for the nude in the *Atelier.*[11] The major Courbet painting that immediately precedes the *Atelier* and the *Rencontre,* the *Cribleuses de Blé,* done at Ornans in the Winter of 1853–4, is plainly related in subject and style to Velasquez's *Hilanderos (The Tapestry Weavers);* and the mysterious space construction of Velasquez evidently fascinated Courbet as it did Manet.

The second primary source is the direct influence of lesser figures. We know that Courbet greatly admired seventeenth century Dutch art, which had the democratic quality he wanted his own painting to possess. But he told Silvestre; 'Ostade, Craesbecke me séduisent'. One can understand the taste for Ostade whose work Courbet knew well from the Louvre (seven works, including the *Schoolteacher,* which provides a general source for Courbet's urchins more relevant than Spanish beggar children).[12] Craesbecke is more puzzling—a rather obscure artist, he had

[11] As Scharf points out, it was Bruyas who provided Courbet with the photograph.
[12] There were also three pictures in the Rijksmuseum, one of *The Painter's Workshop* which Courbet had perhaps seen in 1847.

no work in the Rijksmuseum when Courbet went to Amsterdam in 1847, and nothing in Brussels, which Courbet visited in 1851 when the *Stonebreakers* was on exhibition. There was however one (and one only) Craesbecke in the Louvre, of the artist painting a portrait, and this must explain Courbet's enthusiasm.

The third group of primary sources for the *Atelier* relate to the early nineteenth century taste for enormous pictures—I think particularly of David's *Sacre*, Ingres' *Homer*, and Couture's *Romains de la Décadence*, the sensation of the 1847 Salon. All are as large or larger than any of Courbet's pictures, and Courbet must have been well aware of them, evn if they were not altogether to his taste.

The fourth direct sources may be found in Bruyas's own collection at Montpellier. As we have seen already he was the proud owner of Delacroix's second version of the *Femmes d'Alger*, and more relevant, of *Michelangelo in his studio*, of 1850. There are however, three more works of little artistic significance belonging to Bruyas that should be mentioned. One is August Glaize's picture of the *Interieur du cabinet de M. Bruyas* . . . commissioned, as already mentioned, by Bruyas in 1848: it shows M. Bruyas, his father, and his Montpellier friends (three gentlemen and a lady, seated) looking at a landscape on an easel.

And then there are two pictures by Octave Tassaert, Bruyas's favourite modern painter before Courbet came on the scene in 1853.[13] Bruyas owned no less than sixteen Tassaerts, all done between 1850 and 1853 and presumably the bulk of his work at this time, and one can surely presume that Courbet would have been interested to see them. Particularly so when one discovers that the most recent Tassaert, a work of 1853, was called *L'Atelier du Peintre*. . . . It shows Bruyas sitting in the middle of Tassaert's painting room. The painter, palette in hand, is on the left: a servant sits on a divan in the background. On the wall above hangs Tassaert's *Suicide;* by the chimney on the right, leaning against the wall is *Ciel et Enfer*.

This large painting . . . also has some slight relevance for the composition of Courbet's *Atelier*. It shows in the top center a young girl torn between good and evil. Below are the vices—nude women driven into the mouth of a monster who drags them into a flaming abyss. Above angels are receiving young girls, resurrected, into heaven.

Now the interesting thing is that Tassaert's *Ciel et Enfer* was actually commissioned by Bruyas, and that the young girl in the middle

[13] Tassaert is an obscure and shadowy artist, whose relations with Courbet badly needs investigation. A bad painter, best remembered because Baudelaire admired his erotica (*v. Salon de 1846*), he had a realist phase which may be partly under Courbet's influence.

was his mistress, presumably suffering this agonizing personal dilemma. We know exactly what Courbet thought about the painting of angels, and one can imagine the conversation he had with Bruyas about *Ciel et Enfer*. Nevertheless the correspondences between Courbet's *Atelier* and Tassaert's two pictures, both probably dictated in composition and subject by Bruyas, makes one wonder just what part Bruyas played in the evolution of Courbet's picture. He had a taste for symbols, as we have seen, and when he came to publish a volume in his gallery he asked Jules Laurens to design a large and complicated lithograph, characterizing the important events of his life.

This is not the sort of taste much evident in Courbet before he had met Bruyas, and indeed it is not much in evidence after the *Atelier* had been exhibited in 1855. The supposition then is that the general subject and composition of the *Atelier* were suggested by Bruyas, who no doubt expected to play a more prominent role in the picture than Courbet was eventually to allow him. His interpretation of the subject was not quite what Courbet was to make of it.

At all events, when Courbet, after recovering from cholera and then jaundice, was well enough to start work on the big picture at Ornans in November 1854 he knew what he wanted to do. His problem was lack of time—he had regretfully given up the idea of a special exhibition, and was going to submit his work to the special jury of Exposition Universelle. It had to be in Paris by 1 March 1855, and Courbet had embarked on a picture as big as the *Enterrement à Ornans*. In a mood of mixed elation and despondency he writes to Bruyas in November 1854:

'I've had so many torments since I saw you. My life is so hard I begin to think my moral faculties are wearing out. Under the laughing mask you know, I hide regrets, bitterness and a sadness that grips my heart like a vampire. In the society we live in, you don't have to go far to find emptiness. There are so many fools—it's so discouraging that one hesitates to develop one's intelligence for fear of finding oneself absolutely alone. . . . In spite of everything I have succeeded in making the sketch for my picture and now it's been entirely transferred in outline to the canvas which is twenty feet long and twelve high. It'll be the most amazing picture you can imagine. There are thirty life size figures in it. It's the moral and physical history of my studio. These are all the people who serve me and who share in my action. In the background of the picture are to be seen the *Baigneuses* and the *Retour de la Foire* [fig. 5]. On my easel, I shall do a landscape in which there will be a miller and his asses carrying sacks to the mill. I shall call that: "First series," for I hope to make all of society pass through my studio, and get to know and love my likes and dislikes.'

The sketch that Courbet mentions no longer exists—indeed there

are very few preliminary studies or drawings of any kind. Courbet evidently preferred to work directly on the picture making changes as he went—for example he removed the figures from the landscape on the easel, and didn't include the two big pictures in the background, though perhaps one can just discern the landscape (not the figures) of the *Retour de la Foire*.

The exception to this practice was Courbet's use of what we might call documentary material, especially for the likenesses in the picture. He certainly made use of photographs (for the nude pose), popular prints (for the figure of Proudhon), other people's work (Baudelaire's drawing of his mistress), and, most important, his own earlier work for almost all the portrait heads in the right half of the picture. He was tied to the poses of these earlier works.

All this is well documented in the literature, especially by Madame Adhémar, and I do not want to go into this now. It is time that we had a closer look at the picture itself.

The composition is very simple, to the point of naïvety—which was a quality that Courbet (like Baudelaire) admired and tried to introduce into his work. His friend Champfleury wrote a history of popular art, and the boy drawing at his feet marks the beginning of a serious interest in child art. It is compared favourably with the discarded trappings of Romantic art. Courbet had to paint the picture in a long, narrow room— he couldn't get away from the painting. He divided the composition into three equal parts, corresponding to the picture's ideological structure, and arranged the figures in a kind of casual grouping—the sort of arrangement he so admired from Rembrandt and Velasquez. It is left to colour, tone and texture to unify the picture. As in Velasquez, the space of the picture is not clearly defined. A sense of pictorial space is built up by a pattern of light and shadow. The background seems to consist of an arrangement of abstract planes. Figures seem to fade into the background, giving an almost dream-like effect. This suits Courbet's idea, for there is no pretence made that all these people could be gathered into the studio at the same time. It is this lack of realism, in the narrow sense, that was to disconcert Courbet's friends. The only 'real' thing in the picture, paradoxically enough, seems to be the painting on the easel. The painter too, and the boy, the cat and the model have a reality that other figures lack: but everything is relative to the picture of nature.

The execution of the picture supports this impression. It is on the whole very thinly painted—Courbet had to work quickly and didn't have time to do more than brush in certain passages. The paint has certainly sunk into the canvas, and only in parts does one get the feeling

for matière and texture so characteristic of Courbet. Once it had been exhibited in 1855, Courbet never wanted to touch it again.

The classic description of the *Atelier* is contained in Courbet's letter to Champfleury of January 1855. The two men were by then drifting apart, but Courbet's debt to Champfleury was enormous, and this is recognized by Champfleury's position of prominence in the *Atelier*. The very nature of the letter (which I want to quote at length) suggests that Champfleury didn't know what Courbet had been doing in recent months, and that Courbet wanted to break the news to him and warn him of the somewhat changed nature of his art.

Courbet made some alterations to the picture after he had written to Champfleury: in particular, he added the seated Huntsman as a pendant to Champfleury himself. And he didn't have time to complete the background details as he had planned.

This is what Courbet says in his letter to Champfleury of January 1855:

'In spite of being on the edge of hypochondria I have undertaken an immense painting, twenty feet long by twelve high—perhaps larger than the *Burial,* which will prove to you that I am not yet dead, or realism either, for this is realism. It is the moral and physical history of my studio.

'First part: Here are people who serve me, support my idea and sustain my action. Here are people who thrive on life and those who thrive on death; it is society at its best, its worst, and its average; in short it is my way of seeing society in its interests and passions; it is the people who come to my studio to be painted . . . the picture hasn't a title,[14] but I'll try to describe it.

'The scene is laid in my studio in Paris. The picture is divided into two parts. I am in the centre, painting; on the right all the shareholders, that is my friends, the workers, the art collectors. On the left, the other world of trivialities—the common people, the misery, poverty, wealth, the exploited, the exploiter; those who thrive on death . . .

'I will enumerate the figures beginning at the extreme left. At the edge of the canvas is a Jew I saw in England as he was making his way through the swarming traffic of the London streets, reverently carrying a casket on his right arm and covering it with his left hand—he seemed to be saying: "It is I who am on the right track," he had an ivory complexion, a long beard, a turban and a long black gown that trailed on the ground. Behind him is a self satisfied curé with a red face. In front of them is a poor weather-beaten old man, a republican veteran of the '93 campaigns . . . ninety years of age, holding a begging bag in his hand

[14] Sister Juliette refers to it as *L'Epopée du Peintre* (*The painter's epic*).

and dressed in old patched white linen. He is looking at the romantic cast offs at his feet (he is pitied by the Jew).

'Next come a huntsman, a reaper, a hercules (a strong man), a queue-rouge, a pedlar of clothes and laces, a labourer's wife, a labourer, an undertaker's mute, a skull on a newspaper, an Irishwoman suckling a child, a lay figure. The Irishwoman is also an English product. I met this woman in the streets of London; her only garments were a black straw hat, a torn green veil, a frayed black shawl under which her arm held a naked baby. The pedlar presides over the whole group: he displays his tawdry rubbish to everybody, and all show the greatest interest, each in his own way. Behind him a guitar and a plumed hat occupy the foreground.

'Second part: Then come the canvas on my easel and myself painting, showing the Assyrian profile of my head. Behind my chair stands a nude female model; she is leaning against the back of my chair as she watches me paint for a moment; her clothes are on the floor in the foreground; then a white cat near my chair.

'Next to this woman is Promayet with his violin under his arm, as he is posed in the portrait he sent me. Next to him are Bruyas, Cuénot, Buchon, Proudhon (I should like to see the philosopher Proudhon, who looks at things as we do: if he would sit for me I should be pleased; if you see him, ask him if I may count on him).'

'Then comes your turn in the foreground; you are sitting on a stool with your legs crossed and a hat on your knees. Beside you, still nearer the front, is a woman of fashion, elegant dressed, with her husband. Then at the far right, sitting on a table, is Baudelaire reading a large book; next to him is a negress looking at herself very coquettishly in a mirror. At the back, in the window embrasure can be seen a pair of lovers whispering to each other of love; one is seated on a hammock; above the window are voluminous draperies of green cloth; against the wall are some plaster casts, a shelf holding a statue of a little girl, a lamp, and a few pots; also the backs of canvases, a screen, and nothing more except a great bare wall . . . I've explained all this so badly, and the wrong way round. I should have started with Baudelaire, but it would take too long to begin again.

'The people who want to pass judgment on this, will have to make of it what they can . . .' [15]

Théophile Silvestre, a contemporary critic who knew Courbet, adds a few more authentic details to the interpretation. He says that the nude model personifies Truth; the elegant couple are visitors to the studio; the embracing lovers signify *l'amour libre*. On the other side of the picture,

[15] Translation adapted from that provided by Mack, pp. 128–30.

the huntsman and two farm labourers represent the healthy country life; the worker is an unemployed member of the proletariat. The Jew, merchant, clowns, curé and undertakers all live off the credulity of the world. The hat and dagger in the dust are emblems of Romantic poetry. The skull on the newspapers is the artist's reply to the attacks in the press, or the translation of Proudhon's maxim: 'Newspapers are cemeteries of ideas.'

The subsequent history of the *Atelier* is well known. Courbet had to ask for a fortnight's grace to finish the picture, and he had enough support in high places to have his request granted. But the jury of the Exposition Universelle, when it came to consider Courbet's group of works submitted in April 1855, decided not entirely unreasonably that it couldn't accept the two big pictures—the *Enterrement* [fig. 6] as well as the *Atelier*.

Courbet was extremely upset, but with Bruyas's help he took up the idea of a separate one-man show, and the Pavilion of Realism was opened on 28 June 1855, on a site adjacent to the exhibition. The public reception was lukewarm, with many considering the whole thing a joke in bad taste, and Courbet's public reputation was now markedly in decline. Some of his closest friends, like Champfleury, were now more sure than ever that Courbet had gone off the track since the *Enterrement*. They couldn't understand what Courbet was after in the *Atelier*. 'I see in him plenty of talent, a craftsman-painter talent, but nothing more' wrote Champfleury to Buchon on 16 April 1856. It was the idea of an "allegorie réelle,' a picture set in a period of time, that so puzzled them.

One of the few people to admire the *Atelier* was Delacroix. He wrote in his Journal for 3 August 1855: 'They have rejected one of the most outstanding paintings of the times, but he is too sturdy to be discouraged by so slight a setback.' Unfortunately this was not quite true. Courbet was never so ambitious again in his choice of subject, or scale of composition. But his work after 1855 is pure painting, and (with few exceptions) excludes moral and intellectual judgments. Courbet is concerned with visual sensations, the how of painting, not the what—how the artist sees a still life, a landscape, a portrait, and this is a new and different kind of painting.

The *Atelier* was rolled up and returned to Courbet's studio. During his lifetime it appeared at only two exhibitions—at Bordeaux in 1865 and at Vienna in 1873. It did not reappear in Paris until the Courbet sale of 1881 and the retrospective of 1882. It had relatively few admirers. Degas was a bidder when it came up for sale again in 1897. After some years of indecision it was bought by public subscription for the Louvre in 1920.

The *Atelier* is still a difficult picture, but it is easier for us now to appreciate its importance and its historical significance. It is the modern

artist's declaration of independence, of absolute freedom to create what he wants to create. In the picture Courbet relates everything to himself, but not in exclusively an egotistical sense. With the possible exception of *Las Meninas*, for the first time in the history of art we have a work in which the artist and the activity of creating art becomes the subject. As Courbet said (in 1853): 'I paint to establish my intellectual freedom . . . to express my personality and my social environment'—for he does not deny the artist's responsibility to society at large. After the *Atelier* the way is clear for the complete rethinking of art initiated by Manet and the impressionists and carried through to a climax in the years immediately before the 1914 war. The impetus of this development remains with us today; and we look back at something which we call 'modern art,' and which does seem in some essential way different from the art of earlier times. Courbet claimed to have discovered the 'final form of art' (1861): he may not have found the solution, but he certainly pointed the way. With the *Atelier*, more than with any other single picture, we are at the threshold of modern art.

BIBLIOGRAPHIC REFERENCES

Riat Georges Riat: *Gustave Courbet, peintre* (Paris 1906).
Mack Gerstle Mack: *Gustave Courbet* (New York & London 1951).
Courthion Pierre Courthion: *Courbet raconté par lui-même et par ses amis* (Geneva, volume 1 1948, volume 2 1950).
Hofmann Werner Hofmann: *Art in the Nineteenth Century* (New York & London 1961).
Adhémar René Huyghe, Germain Bazin & Helene Adhémar: *Courbet, L'Atelier du Peintre* (Paris 1944).
Winner Matthias Winner: *Gemalte Kunsttheorie* (Jahrbuch der Berliner Museen 1962, N.F. 4 pp. 150–85).
Scharf Aaron Scharf: *Art and Photography* (London 1968).

Biographical Data

1819	Jean-Désiré-Gustave Courbet is born at Ornans, a little village in the Jura mountains. Only son of Eléanor-Régis Courbet and Sylvie Oudot.
1831	Pupil of the Little Seminary (secondary school) at Ornans, where he studies drawing with "Father" Beau (also spelled Baud), a former student of Gros.
1837	Student at the Royal College of Besançon. Takes drawing and painting lessons from a local painter, Charles-Antoine Flajoulot (also spelled Flageoulot; 1774–1840).
1839	Makes four lithographed illustrations for a collection of poems published by his friend, Max Buchon.
1840	Moves to Paris, where he enrolls as a law student. Before long, however, he abandons his law studies to devote himself to painting. Instead of taking lessons from a reputable art teacher, he studies the works of the old masters in the museums and draws and paints after live models in the "liberal" Académie Suisse.
1844	His *Self-Portrait with Black Dog* is exhibited at the Salon.
1847	Travels to Holland on the invitation of the Dutch art dealer, van Wisselingh. Visits the major Dutch museums. Moves to the Rue Hautefeuille, where he is to stay until 1871.
1848	Becomes a habitué of the Brasserie Andler in the Rue Hautefeuille. Meets there regularly with such artists, writers, and philosophers as Bonvin, Baudelaire, Champfleury, Duranty, Silvestre, and Proudhon.
1849	Exhibits seven paintings at the Salon. Scores a success with the *Afterdinner at Ornans,* which is bought by the State and sent to the museum of Lille.
1850–1851	Exhibits nine paintings at the combined Salon for these two years; included are his early masterpieces, the *Stonebreakers,* the *Peasants of Flagey Returning from the Fair,* and the *Funeral at Ornans,* which shocked the Parisian public.

1852 *Young Ladies from the Village* is exhibited at the Salon. Even before the opening of the Salon, the painting is bought by the Duc de Morny, half-brother of Napoleon III. First exhibit abroad in Frankfurt (Germany).

1853 *The Bathers,* the *Sleeping Spinner,* and the *Wrestlers* are exhibited at the Salon. The two first-mentioned paintings are bought by Alfred Bruyas, a rich art-lover from Montpellier, who is to become Courbet's life-long Maecenas.

1854 Salon for this year is cancelled. Courbet paints the *Grain-Sifters.* Visits Alfred Bruyas in Montpellier (May–September). Paints the *Meeting* in commemoration of this visit.

1855 Private exhibition in the "Pavilion of Realism," constructed at the artist's own expense. *Pièce de résistance* of the exhibition is the *Studio.*

1857 Exhibits six paintings at the Salon, including the *Young Ladies on the Banks of the Seine.* Second stay with Alfred Bruyas.

1858 Departs for Germany in September. Begins a series of hunting scenes.

1859 Returns from Germany in February. Meets with Boudin in Honfleur, on the Normandie coast. Organize a "Feast of Realism" in his studio.

1860 Exhibits in Paris, Montpellier, Besançon, and Paris. Befriends Castagnary, his future biographer.

1861 Exhibits five paintings at the Salon, four of which represent animal scenes. Opens an atelier to train young art students but closes it again after a few months.

1862 Is invited by Etienne Baudry to come to Saintonge, where he stays for the greater part of the year, painting landscapes, portraits, and still lifes. Begins the *Return from the Conference.*

1863 The *Return from the Conference* is refused by the Salon because of its anti-clerical tenor.

1864 The *Awakening* is rejected by the Salon on the ground of the painting's alleged indecency. Courbet stays with Max Buchon at Salins and with the Jolicler family at Pontarlier.

1865 Death of Courbet's friend, Proudhon. Paints the posthumous *Portrait of Proudhon and his Family.* Spends several months at Trouville, on the Normandie coast, where he meets with Monet and Whistler.

1866 Scores a triumph at the Salon with the *Covert of the Roe Deer* and the *Woman with Parrot.* Spends some time at Deauville, on the Normandie coast.

1867 Second private exhibition in a pavilion at the Rond-Point de l'Alma, where he exhibits over a hundred paintings, in addition to drawings and sculpture.

1868 *Alms of a Beggar* and a hunting scene are exhibited at the Salon. Additional exhibits at Le Havre, Gand (Belgium), and Besançon.

1869 *Mort of the Stag* and *Siesta during Haymaking Time* are ex-

hibited at the Salon. Courbet spends some time at Etretat, on the Normandic coast, and paints several seascapes. Travels to Germany, where he is decorated by the King of Bavaria. Returns to France via Switzerland.

1870 Exhibits two seascapes at the Salon. Refuses the nomination to the rank of Chevalier of the Legion of Honor. After the proclamation of the Third Republic on September 4, Courbet is elected president of the Federal Commission of Artists to safeguard works of art.

1871 Elected to the Commune in April. Is accused of participation in the demolition of the Vendôme column (May 16) and arrested (June 7). After a trial, he is condemned to six months in prison and a fine. Serves his term in the prison of Sainte-Pélagie, but falls ill and is transferred to a hospital in Neuilly.

1872 Finishes his term in March. The paintings he sends to the Salon are refused, clearly for political reasons.

1873 Courbet's case is resumed. He is condemned to pay the expenses of the reconstruction of the Vendôme column. His property is confiscated and he takes refuge in Switzerland, where he settles at La Tour-de-Peilz, a little village near Vevey.

1877 Courbet dies on December 31 and is buried in La Tour-de-Peilz.

Notes on the Contributors

Jules-Antoine Castagnary (1830–1888). Lawyer, politician, and art critic. Befriended Courbet in 1860 and became his life-long supporter. Planned to write a major biography of Courbet but did not finish this project because of his untimely death. His extensive and often interesting notes for this biography are kept in the Bibliothèque Nationale in Paris.

Théophile Silvestre (1823–1876). Author, journalist, and art critic. Contributed to various papers and for some time owned the journal, *Le Nain Jaune*. A habitué of the Brasserie Andler, Silvestre had plenty of opportunity to observe Courbet from close-by, which enabled him to present a very true profile of the artist in his *Histoire des artistes vivants*.

Alexandre Schanne (1823–1887). Artist, musician, and writer. An active member of the Parisian Bohemia in his youth (he was the prototype of "Schaunard" in Henri Murger's *Scènes de la vie de Bohème*), Schanne later renounced the arts and took over his father's toy factory. At the end of his life he jotted down his youthful memories in his *Souvenirs de Schaunard* (1886).

Emile Bouvier (b. 1886). Educator, writer, and journalist. Studied literature in Paris and taught at the University of Montpellier until 1948. Also worked for various government agencies. Wrote extensively, both on literature and politics. *La bataille réaliste*, from which the excerpt in this volume was taken, was his first major book.

Klaus Berger (b. 1901). A native of Berlin, Berger studied at German universities under Wölfflin and Aby Warburg. He came to the United States in 1941, and has been teaching art history and criticism at Northwestern University and the University of Kansas (as University Distinguished Professor). His publications include about seventy-five articles in addition to books on Géricault, Odilon Redon, and French Master Drawings.

George Boas (b. 1891). Philosopher. Studied at Brown University, Harvard, and the University of California, where he received a doctorate in philosophy. Taught at the University of California and at Johns Hopkins University in Baltimore. Frequent contributor to *Harper's Magazine* and the *Atlantic*

Monthly, and author of a large number of books dealing with various aspects of philosophy, particularly esthetics.

Pierre-Barthélmy Courthion (b. 1902). Writer, critic, and art historian. Studied in Geneva and Paris. Published large number of books on French art and served as chief editor of two important book series, *Le Cri de la France* and *Les Grands Artistes racontés par eux-mêmes et leurs amis.* Also directed art documentaries on Ingres and Rouault.

Kenneth Mackenzie Clark (b. 1903). Art Historian. Studied in Winchester and Oxford (Trinity College). Worked for two years with Bernard Berenson in Florence, then became keeper of the Department of Fine Arts of the Ashmolean Museum in Oxford and subsequently Director of the National Gallery in London (1934–1945). After the war, he was Slade Professor of Fine Art at Oxford (1946–1950 and 1961–1962). Author of several books on such divergent subjects as *The Gothic Revival* (1929), *Landscape into Art* (1949), *The Nude* (1955), and *Rembrandt and the Italian Renaissance.* Well-known for his film series, *Civilization.*

Bernard Dorival (b. 1914). Museum curator and writer. Studied at the Ecole Normale Supérieure in Paris. Curator of the Musée de l'Art Moderne between 1941 and 1965, then chief curator from 1965–1968. Published several articles and books, mostly on nineteenth- and twentieth-century art.

Charles Sterling (b. 1901). Art historian. Received a law degree in his home country, Poland, then studied art history in Germany, England, and France. Member of the curatorial staff of the Louvre between 1930 and 1940. During the war, he was Senior Research Fellow at the Metropolitan Museum of Art in New York. He was curator of the Department of Paintings in the Louvre from 1945 to 1962, then professor at New York University until 1968. Organizer of important exhibitions, author of several books and articles, and co-author of museum catalogues of both the Louvre and the Metropolitan Museum of Art.

Joseph-Maximilien ("Max") Buchon (1818–1869). Poet, novelist, and journalist. Childhood friend of Courbet, who illustrated his first published volume of poems (1839). Turned republican and subsequently socialist in the 1840s and contributed to various leftist newspapers, such as Proudhon's *Le Peuple.* Persecuted by the imperial government as editor of the *Démocrate Salinois,* Buchon, in 1852, took refuge in Switzerland, where he translated several German books into French. Back in France in 1857, he contributed to the *Revue des deux mondes.* In addition, he published several volumes of poems and realistic novels.

Champfleury [Jules-Antoine-Félix Husson] (1821–1889). Writer and journalist. Born in the countryside, Champfleury, as a young man he moved to Paris, determined to become a writer. Member of the Bohemian circle, he met Courbet in the 1840s and became a warm defender of his early works, which he discussed in various newspaper articles, one of which is reprinted in this volume. Aside from his journalistic work, Champfleury wrote pantomimes, theatrical pieces, and a large number of realistic novels. In the 1860s he broke with Courbet and his Bohemian past, and from then on he published a series of semi-scholarly books on caricatures, folk art, the Le Nain brothers, ceramics,

and so on. In 1872 he was made curator of the Musee de Sèvres and in this quality he published his most substantial work, the *Bibliographie Céramique*.

Pierre-Joseph Proudhon (1809–1865). Socialist philosopher and journalist. Born in a poor family at Besançon, Proudhon received only a scattered formal education, which he supplemented by a great deal of independent reading. He moved to Paris in 1847 and successively issued a number of socialist newspapers. He also published brochures and books dealing with socio-political problems. He met Courbet shortly after his arrival in Paris and remained his friend until his death. Proudhon's *Du principe de l'art et de sa destination sociale,* published posthumously in 1865, may be seen as the fruit of discussions held between the author and Courbet.

Linda Nochlin Pommer (b. 1931). Art historian. Studied at Vassar College, Columbia University, and New York University (Ph.D.). Teaches at Vassar College and at Hunter College in New York. Author on various articles and books, dealing mainly with Courbet and French Realism.

Timothy J. Clark (b. 1943). Art historian. Studied history at Cambridge University and art history in London and Paris. Taught at Essex University, Camberwell School of Art, and the University of California at Los Angeles. Interested in devising a Marxist, that is, radically historical account of artistic production. Published two major books on Courbet and French Realism, *Image of the People* and *The Absolute Bourgeois.*

Ferdinand-Victor-Eugène Delacroix (1798–1863). Leading Romantic artist in France. Author of such famous paintings as *Dante and Virgil in Hell,* the *Massacre at Chios,* the *Death of Sardanapalus,* and *Liberty on the Barricades.* Delacroix's ideas about art are well formulated in his lengthy journal and in his correspondence.

Werner Hofmann (b. 1928). Art historian and museum director. Studied in Vienna and Paris. Director of, successively, the Museum of the Twentieth Century in Vienna and the Kunsthalle in Hamburg. Taught at Columbia University in New York. Published widely in the field of nineteenth- and twentieth-century art.

Alan Bowness. Art historian. Reader in the History of Art at the Courtauld Institute of Art, University of London. Arranged several exhibitions for the Arts Council of Great Britain and published a number of books, including *Modern Sculpture, Gauguin, Matisse Nudes, Modern European Art,* among others.

Selected Bibliography

ABE, Y. "Un *Enterrement à Ornans* et l'habit noir baudelairien." *Etudes de langue et littérature françaises (Bulletin de la Société japonaise de langue et littérature françaises),* 1 (1962), pp. 29–41.

ALEXANDER, ROBERT L. "Courbet and Assyrian Sculpture." *Art Bulletin,* 47 (1965), pp. 447–452.

AMIS DE COURBET, Bulletins of the *Société des.* Paris/Ornans, 1947–

ARAGON, LOUIS. *L'Exemple de Courbet.* Paris: Editions Cercle d'art, 1952.

BAILLODS, JULES. *Courbet vivant.* Neuchâtel: Société des Amis de Courbet, 1940.

BALTIMORE MUSEUM OF ART, *An Exhibition of Paintings by Courbet.* 1938.

BAUDRY, ETIENNE. *Le Camp des Bourgeois.* Illustrations de Gustave Courbet. 1868.

BAUZON, LOUIS. "Documents inédits sur Courbet." *L'Art,* 40 (1886), pp. 237–242.

BENEDITE, LÉONCE. *Gustave Courbet.* Philadelphia: J. B. Lippincott; London: William Heinemann, 1913.

BERGER, KLAUS. "Courbet in his Century." *Gazette des Beaux-Arts,* 24 (1943), pp. 19–40.

BERGERAT, EMILE. *Sauvons Courbet.* Paris: Lemerre, 1871.

BESANÇON, MUSÉE DES BEAUX-ARTS, *Exposition Gustave Courbet, 1819–1877.* 1952.

BOAS, GEORGE, ed. *Courbet and the Naturalistic Movement.* New York: Russell & Russell, 1967.

BONNIOT, ROGER. *Gustave Courbet en Saintonge, 1862–1863.* Paris: C. Klincksieck, 1973.

BOREL, PIERRE ed. *Le roman de Gustave Courbet, d'après une correspondance originale du grand peintre.* Paris: R. Chiberre, 1922.

———. *Lettres de Gustave Courbet à Alfred Bruyas.* Genève: Pierre Cailler, 1951.

BOUDAILLE, GEORGES. *Gustave Courbet, Painter in Protest.* Greenwich, Conn.: New York Graphic Society, 1969.

BOUVIER, EMILE. *La bataille réaliste, 1844–1857.* Paris: Fontemoing, 1913.

BOWNESS, ALAN. *Courbet's "Atelier du peintre."* Fiftieth Charlton lecture on art. Newcastle upon Tyne: University of Newcastle upon Tyne, 1972.

BRUNESOEUR, RENÉ. *Muséum contemporain: Gustave Courbet.* Paris: Robe, 1866.

BRUNO, JEAN (Dr. Blondon). *Les misères des gueux.* Paris: Librairie Internationale, 1872.

BRUNO, MAX. *Le Réalisme.* Neuchâtel: J. Attinger, 1856.

CASTAGNARY, JULES. "Fragments d'un livre sur Courbet." *Gazette des Beaux-Arts,* 5 (1911), pp. 1–20; 6 (1911), pp. 488–497; 7 (1912), pp. 19–30.

––––––. *Gustave Courbet et la colonne Vendôme. Plaidoyer pour un ami mort.*

CHAMPFLEURY (JULES HUSSON). *Grandes figures d'hier et d'aujourd'hui.* Paris: Poulet-Malassis et de Broise, 1861.

––––––. *Le réalisme.* Paris: Michel-Lévy, 1857.

––––––. *Souvenirs et portraits de jeunesse.* Paris: E. Dentu, 1872.

CHAMSON, ANDRÉ. *Gustave Courbet.* Paris: Flammarion, 1955.

CHIRICO, GIORGIO DE. *Gustave Courbet.* Rome: Editions de Valori Plastici, 1925.

CHOURY, MAURICE. *Bonjour, Monsieur Courbet!* Paris: Editions sociales, 1969.

CLARK, TIMOTHY J. "A Bourgeois Dance of Death." *Burlington Magazine,* 111 (1969), pp. 208–212; 286–290.

––––––. *Image of the People; Gustave Courbet and the Second French Republic 1848–1851.* Greenwich, Conn.: New York Graphic Society, 1973.

CLAUDET, MAX. *Souvenirs, Gustave Courbet.* Paris: Dubuisson, 1878.

COURBET, GUSTAVE. *Autographes sur l'exposé du tableau La Rencontre (de G. Courbet). Salon 1855.* Paris: Plon, 1856.

(COURBET, GUSTAVE). *Les curés en goguette.* Avec six dessins de Gustave Courbet. Brussels: A. Lacroix, Verboeckhoven et Cie, 1868.

––––––. *La mort de Jeannot.* Avec quatre dessins de Gustave Courbet. Brussels: A. Lacroix, Verboeckhoven et Cie, 1868.

––––––. "Lettres inédites à Bruyas, de Courbet et de sa famille." *L'Olivier,* Sept./Oct., 1913.

COURBET, GUSTAVE. *Lettres à l'armée allemande et aux artistes allemands, lues a l'Athénée, dans la séance du 20 Octobre, 1870.* Paris, 1870.

Courbet documents, collected by E. Moreau-Nélaton and Georges Riat (originally owned by Castagnary, Bernard Prost, and the family of Courbet). Paris, Bibliothèque Nationale, Cabinet des Estampes.

COURTHION, PIERRE, *Courbet.* Paris: Librairie Floury, 1931.

––––––, ed. *Courbet raconté par lui-même et par ses amis.* 2 vols. Genève: Pierre Cailler, 1948–50.

DELVAU, ALFRED. *Histoire anecdotique des cafés et cabarets de Paris.* Paris: E. Dentu, 1862.

DURBE, DARIO. *Courbet e il realismo Francese.* Milano: Fratelli Fabbri, 1969.

DURET, THEODORE. *Courbet.* Paris: Bernheim Jeune et Cie, 1918.

––––––. *Les peintres français en 1867.* Paris: Dentu, 1867.

ESTIGNARD, A. *G. Courbet, sa vie et ses oeuvres*. Besançon: Delagrange, 1896.

FERMIGIER, ANDRE. *Courbet, étude biographique et critique*. Genève: Skira, 1971.

FERNIER, ROBERT. *Gustave Courbet*. New York/Washington: Frederick A. Praeger, 1969.

FONTAINAS, ANDRE. *Courbet*. Paris: Librairie de France, 1927.

FOSCA, FRANÇOIS. *Courbet*. Paris. Albert Skira, 1940.

GAZIER, GEORGES. *Gustave Courbet, l'homme et l'oeuvre*. Besançon: Cariage, 1906.

GOLDMAN, "Realist Iconography: Intent and Criticism." *Journal of Aesthetics*, 18, pp. 183–188.

GROS-KOST, *Courbet. Souvenirs Intimes*. Paris: Derveaux, 1880.

GUICHARD, M. *Les doctrines de M. Courbet, peintre*. Paris: Poulet-Malassis, 1862.

HERBERT, R. L. "City vs. Country: the Rural Image in French Painting from Millet to Gauguin." *Artform*, 8 (1970), pp. 45–55.

HUYGHE, RENÉ; BAZIN, GERMAIN; and ADHÉMAR, HÉLÈNE. *Courbet, l'atelier du peintre, allégorie réelle, 1855*. Tours: Editions des musées nationaux (Plon), 1944.

IDEVILLE, HENRI D'. *Notes et documents sur la vie et l'oeuvre de Courbet*. Paris: Heymann et Pérois, 1878.

KAHN, GUSTAVE. *Courbet*. Paris: Floury, 1931.

KASCHNITZ, MARIE-LOUISE. *Gustave Courbet*. Baden-Baden: Woldemar Klein Verlag, 1949.

LA RUE, JEAN (Jules Vallès). "Courbet et Enterrement de Courbet." *Le Réveil*, Jan. 6/7, 1878.

LAZAR, BÉLA. *Courbet et son influence à l'étranger*. Paris: Floury, 1911.

LÉGER, CHARLES. *Au pays de Gustave Courbet*. Meudon: chez l'auteur, 1910.

———. "Baudelaire et Courbet." *Beaux-Arts*, 1939, pp. 5 *et seq.*

———. "Les chansons de Courbet." *Arts*, September 24, 1947, pp. 1 *et seq.*

———. *Courbet*. Paris: G. Crès et Cie, 1929.

———. *Courbet et son temps*. Paris: Editions Universelles, 1948.

———. "Courbet et Victor Hugo, d'après des lettres inédites." *Gazette des Beaux-Arts*, 4 (1921), pp. 353–363.

———. *Courbet selon les caricatures et les images*. Paris: Rosenberg, 1920.

———. "Courbet, ses amis et ses élèves." *Mercure de France*, 1928, pp. 5–41.

LEMONNIER, CAMILLE. *G. Courbet et son oeuvre*. Paris: Lemerre, 1878.

LINDSAY, JACK. *Gustave Courbet, his Life and Art*. Bath: Adams & Dart, 1973.

London, Marlborough Fine Art Ltd. *Courbet*. Exhibition catalogue, 1953.

Lyon, Musée des Beaux-Arts. *Courbet*. Exhibition catalogue, 1954.

MACK, GERSTLE. *Gustave Courbet*. New York: Alfred A. Knopf, 1951.

MACORLAN, PIERRE. *Courbet*. Paris: Editions du Dimanche, 1951.

MALVANO, LAURA. *Courbet*. Milan: Fabbri, 1966.

MEIER-GRAEFE, JULIUS. *Corot und Courbet: ein Beitrag zur Entwicklungsgeschichte der Modernen Malerei*. Leipzig: Insel-Verlag, 1905.

MIRECOURT, EUGÈNE DE. *Les contemporains: Champfleury, Courbet.* Paris: Librairie des contemporains, 1870.

MUTHER, RICHARD. *Courbet.* Berlin: Marquardt, 1909.

NAEF, HANS. *Courbet.* Bern: Alfred Scherz Verlag, 1947.

New York, Metropolitan Museum of Art. *Loan Exhibition of the Works of Gustave Courbet.* 1919.

New York, Paul Rosenberg & Co. *Loan Exhibition of Paintings by Gustave Courbet. 1819–1877.* 1956.

New York, Wildenstein & Co. *A Loan Exhibition of Gustave Courbet.* 1948.

NICOLSON, BENEDICT. "Courbet at the Marlborough Gallery." *Burlington Magazine,* 95, (1953), pp. 246–249.

———. "Courbet's *L'Aumône d'un mendiant.*" *Burlington Magazine,* 104 (1962), pp. 73–74.

———. *Courbet: The Studio of the Painter.* London: Allen Lane, 1973.

NOCHLIN, LINDA. *The Development and Nature of Realism in the Work of Gustave Courbet: a Study of the Style and its Social and Artistic Background.* New York: Garland Publishing, Inc., 1975.

———. "Gustave Courbet's *Meeting:* a Portrait of the Artist as a Wandering Jew." *Art Bulletin,* 49 (1967), pp. 209–222.

———. "Gustave Courbet's *Toilette de la mariée.*" *Art Quarterly,* 34 (1971), pp. 30–54.

———. "Innovation and Tradition in Courbet's *Burial at Ornans.*" *Essays in Honor of Walter Friedlaender, Marsyas,* Suppl. 2 (1965), pp. 119–126.

Ornans, Hotel de Ville. *Gustave Courbet.* Exhibition Catalogue, 1962.

Paris, (private pavilion). *Exhibition de 40 tableaux et 4 dessins de M. Gustave Courbet.* 1855.

———. *Catalogue des oeuvres de Gustave Courbet exposées au Rond-Point de l'Alma.* 1867.

Paris, Bernheim Jeune. *Exposition Courbet,* 1917.

Paris, Ecole des Beaux-Arts. *Exposition des oeuvres de Gustave Courbet.* 1882.

Paris, Galerie Alfred Daber. *Courbet. Exposition du 130e anniversaire de sa naissance.* 1949.

Paris, Galerie Claude Aubry. *Courbet dans les collections privées françaises.* Exhibition catalogue, 1966.

Paris, Musée du Louvre. *Autoportraits de Courbet.* Exhibition catalogue. 1973.

Paris, Palais des Beaux-Arts. *G. Courbet.* Exhibition catalogue, 1955.

Paris, Petit Palais. *Exposition Gustave Courbet,* 1929.

Paris, Salon d'Automne (Grand Palais). *Exposition rétrospective d'oeuvres de Courbet.* 1906.

Philadelphia Museum of Art. *Gustave Courbet, 1819–1877.* Exhibition catalogue, 1959.

PROUDHON, PIERRE-JOSEPH. *Du principe de l'art et de sa destination sociale.* Paris: Garnier, 1865.

RIAT, GEORGES. *Gustave Courbet.* Paris: H. Floury, 1906.

Rome, Villa Medici. *Gustave Courbet.* Exhibition catalogue, 1969.

SALVISBERG, PAUL. *Courbet und der moderne Impressionnismus in der Französischen Malerei.* Stuttgart, 1884.

SCHAPIRO, MEYER. "Courbet and Popular Imagery: an Essay on Realism and Naiveté." *Journal of the Warburg and Courtauld Institutes,* 4 (1941), pp. 164–191.

SCHANNE, ALEXANDRE. *Souvenirs de Schaunard.* Paris: Charpentier, 1886.

SCHARF, AARON. *Art and Photography.* London: Allen Lane, 1969.

SEDGWICK, JOHN POPHAM, JR. *Courbet's Evolution.* Unpublished Ph.D. thesis. Cambridge: Harvard University, Department of Fine Arts, 1954.

SILVESTRE, THÉOPHILE. *L'Histoire des artistes vivants, études d'après nature.* Paris: Blanchard, 1856.

La Tour-de-Peilz. *Exposition Gustave Courbet.* 1950.

TRAZ, GEORGES DE, ed. *Courbet.* Paris: A. Skira, 1940.

TROUBAT, JULES AUGUSTE. *Une amitié à la d'Arthez: Champfleury, Courbet, Max Buchon.* Paris: L. Duc, 1900.

————. *Plume et Pinceau.* Paris: Lisieux, 1878.

WINNER, MATTHIAS. "Gemalte Kunsttheorie: zu Gustave Courbets *Allégorie réelle* und der Tradition." *Jahrbuch der Berliner Museen,* 4 (1962), pp. 160–185.

ZAHAR, MARCEL. *Gustave Courbet.* Paris: Flammarion, 1950.

ZÜRICH, KUNSTHAUS, *Gustave Courbet.* Exhibition catalogue, 1935–1936.

INDEX

INDEX